WILL BARNET

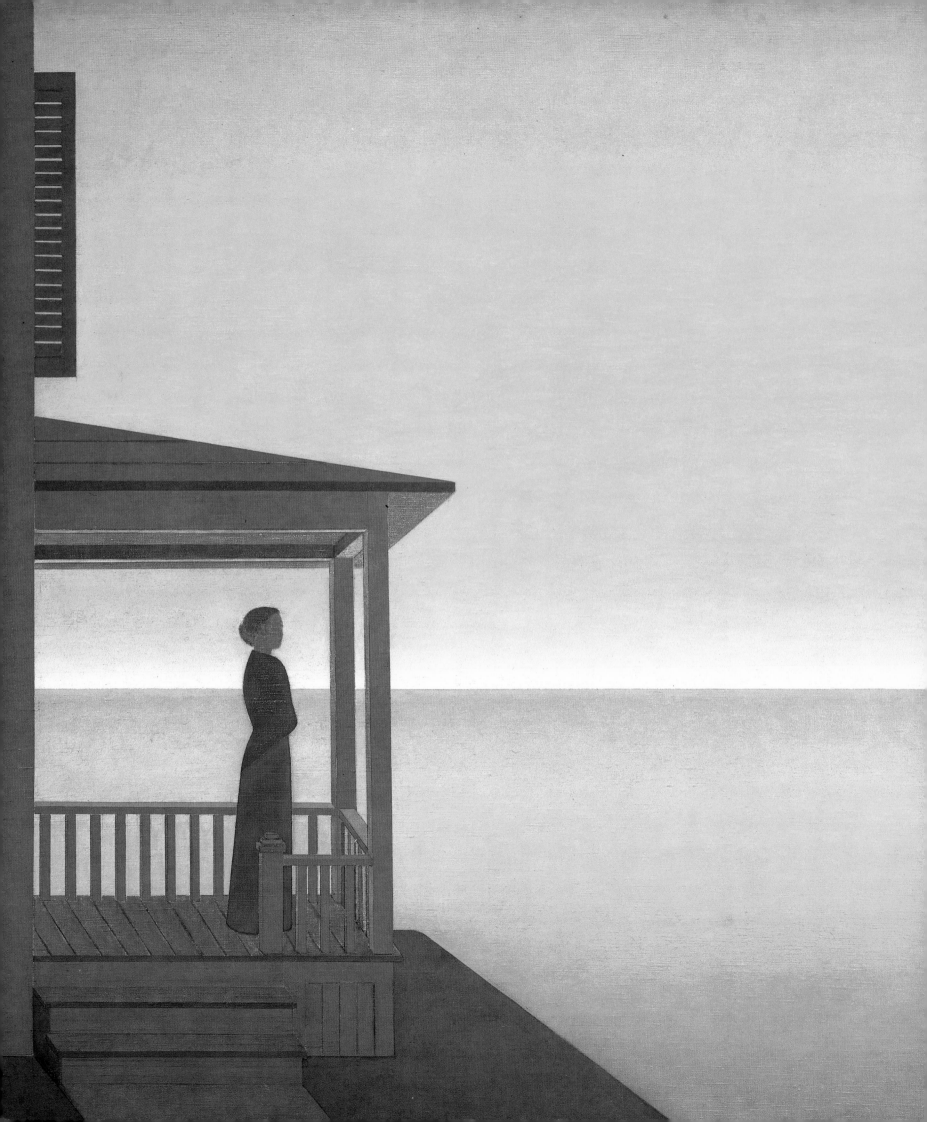

BY ROBERT DOTY

WILL BARNET

**HARRY N. ABRAMS, INC.,
PUBLISHERS, NEW YORK**

For my wife, Joan

Project Manager: Darlene Geis
Editor: Lory Frankel
Designer: Darilyn Lowe
Rights and Reproductions: Barbara Lyons

Library of Congress Cataloging in Publication Data
Doty, Robert M.
 Will Barnet.

 Bibliography: p.
 Includes index.
 1. Barnet, Will, 1984- . I. Barnet, Will, 1911-
II. Title.
ND237. B264D6 1984 759.13 84-396
ISBN 0-8109-0731-3

Introduction © 1984 James Thomas Flexner
Illustrations © 1984 Will Barnet

Printed and bound in Japan

Title Page: EARLY MORNING. 1972. Oil on canvas, 57½ × 57¾".
Private collection

CONTENTS

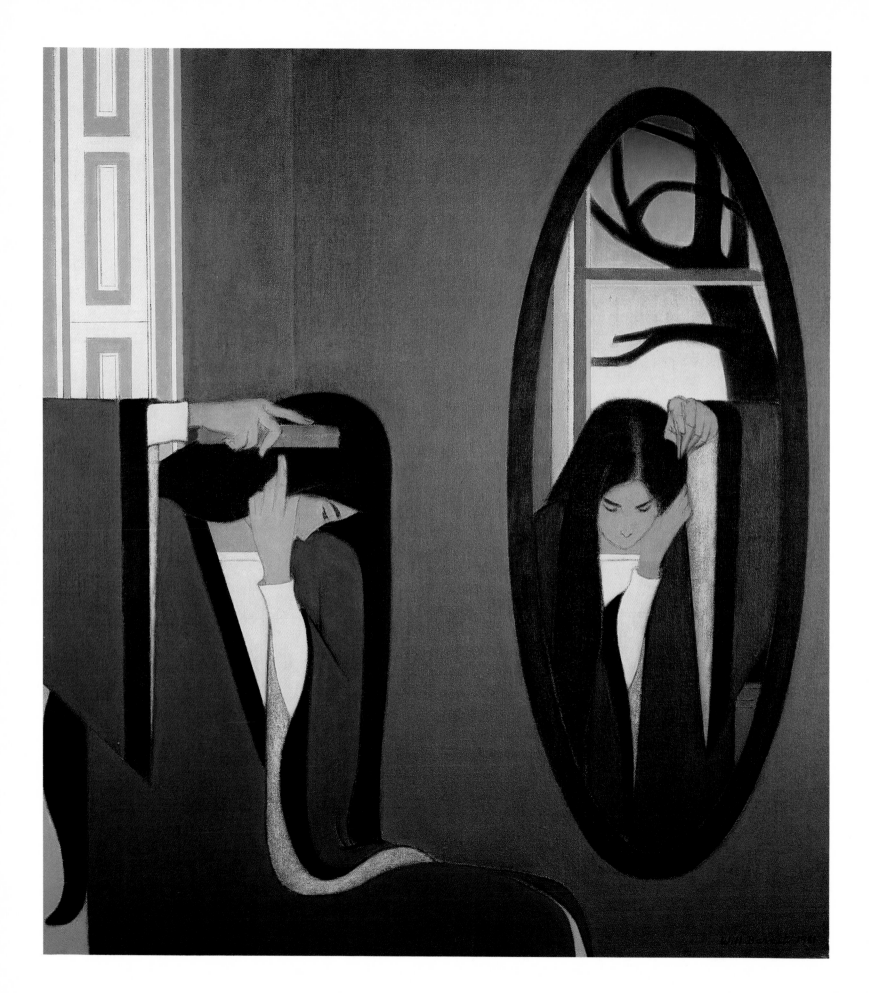

ACKNOWLEDGMENTS

My gratitude and appreciation for assistance in many ways go to: Maria Graubart, Librarian, the Currier Gallery of Art, and Theresa Toy, Librarian, Manchester Public Library, who helped to compile the bibliography; Lawrence Campbell, the Art Students League; Konrad G. Kuchel, the American Federation of Arts; Sylvan Cole, the Associated American Artists Gallery, who supplied information and suggestions; Robert F. Brown, Area Director, New England, Archives of American Art, who opened the resources of the archives and directed me to the Barnet material in the George Arents Research Library, Syracuse University; Mrs. Walter Gellhorn, for the information that she recorded in a series of interviews with the artist for the Oral History Research Office, Columbia University in the City of New York; Janice Loeb Levitt and Peter Barnet, for pioneering the efforts to gather and organize the artist's own writings, lectures, and thoughts about his work; Paul Doty, for sharing his studies in the history of Transcendentalism; and especially to the artist himself. He has already donated most of his personal papers to the Archives of American Art, and he opened all the remaining files and documents in his possession for the preparation of this monograph. He has been generous in sharing time and ideas, as he has done so often during his lifetime. It has been a privilege to work with Will Barnet, to reflect on his art, and, it is hoped, by avoiding labels and presenting a comprehensive review of his thoughts, to make his work more accessible to a wider audience.

Lawrence A. Fleischman of Kennedy Galleries has supported and encouraged the project. In the offices of Harry N. Abrams, Inc., Hugh Levin, Darlene Geis, Lory Frankel, Darilyn Lowe, and Barbara Lyons have helped to keep the project moving smoothly and efficiently. The publication of this book is scheduled to coincide with a retrospective of Barnet's work that will be held at the Currier Gallery of Art, Manchester, New Hampshire, in the summer of 1984, and will then travel throughout the United States and Canada. In October 1984, the Kennedy Galleries in New York will hold an exhibition of current work.

R. M. D.

Opposite: COMBING. 1981. Oil on canvas, 39½ x 35½". Private collection

WILL BARNET, AMERICAN ARTIST

by James Thomas Flexner

Will Barnet and I have long been good friends. I greatly admire his pictures and he has kind opinions of my books. Feeling himself very much an American artist, he naturally thought of me to write the introduction to this book because I am an American historian who has written extensively on American painting.

I have always sought, in writing about artists, to find what I consider the inevitable interrelation of the work with its creator's personality and experiences. Will and I had had many previous talks, but always on a purely convivial level. So we agreed to get together for a more serious interview.

We met in his high-ceilinged studio in the National Arts Club on Gramercy Park in New York. Knowing that Will receives constant phone calls, I had made it a condition that he remove the receiver from the hook. (Several calls slipped in while I took off my hat and coat and got settled—it was too early for the drink he offered me—and then he did remove the receiver.) He did this a little regretfully, I judged, as if he were feeling rather shy. But once we got talking, he entered into the conversation with an enthusiasm that matched my own.

My first question concerned certain recurring subjects in his work: Why were so many of the female figures in his paintings topped with his wife Elena's face (easily recognizable because of her distinctively slanted, brilliant turquoise eyes)? He answered that he considered family relationships fundamental to human existence. Even in the semirepresentational paintings of his earlier days, although the figures verged on the abstract, they had represented his first wife and their three sons. Subsequently, his growing daughter, Ona Willa, had been a favorite subject.

He often included cats, he explained, not only because he sees their curves as echoing those of a recumbent woman, but because cats had long inhabited his households. Why parrots? His father had bought parrots from sailors back from tropical seas. Domestic associations, he

added, although not directly communicated to his viewers, brought, because of his feelings, a warmth to his images.

This raised an obvious question: Had his childhood been characterized by warmth? As recounted in the main text of this volume, Barnet's parents migrated from Eastern Europe. They had brought with them to America three children: two daughters and a son. But the American-born Will was so much younger than his three imported siblings that he was, in effect, an only child.

It has been common in the history of the United States for children in poorer immigrant families to be offered during their upbringing little sustenance from the European cultures from which their parents had fled. Young Will had to find roots for himself in the New World.

Will's mother, although sickly, provided her son with an alcove, so to speak, of warmth and understanding. It cannot be a coincidence that Will's paintings again and again celebrate the relationship between mother and child. From his domestic paintings, men are almost without exception excluded. Yet the male presence is very much there: the painter himself viewing the scene with deep emotion from outside the picture space.

Cut off from most ancestral traditions, growing up among overworked poor from many lands, Will wandered abroad in Beverly, Massachusetts, where he was raised, and there discovered a handsome and rich environment, deeply imbued with the traditions and history of the nation into which he had been born. Beverly had a fleet of seafaring ships, often moored at the wharves that Will frequented. Situated across a narrow inlet from picturesque Salem, Beverly too had once been a whaling community, and there the time-ripened mansions still stood, built by merchants whose fortunes had been earned in what seemed to the boy a world of dreams. Because the great houses abutted on the shore, there was opened to the wanderer along the waterfront such an intimate view as could never be glimpsed from the street. By climbing over rocks and threading his way through reaches of sand, Will could partake visually of the gracious life of the privileged inhabitants. He remembers "beautiful ladies strolling through gardens adorned with statuary."

Not long after he was old enough to get around by himself, Will came on what seemed almost a fairy palace. Miraculously, he found himself not excluded but welcomed. He could climb the marble steps to a rotunda that gave access to rooms built of marble. In the Beverly Public Library there was a chamber especially devoted to children. Here he became particularly fascinated, so he remembers, with boys' stories laid in New England's past: tales of the Pilgrims, the Green Mountain Boys. Reading Hawthorne's *The House of the Seven Gables*, he was even able to visit the house itself, it was that nearby.

Barnet told me that he had become an artist at the age of eight: he set up his studio in the family cellar. When the little boy confided to the librarians that he was an artist, they gave him full use of a room that con-

10

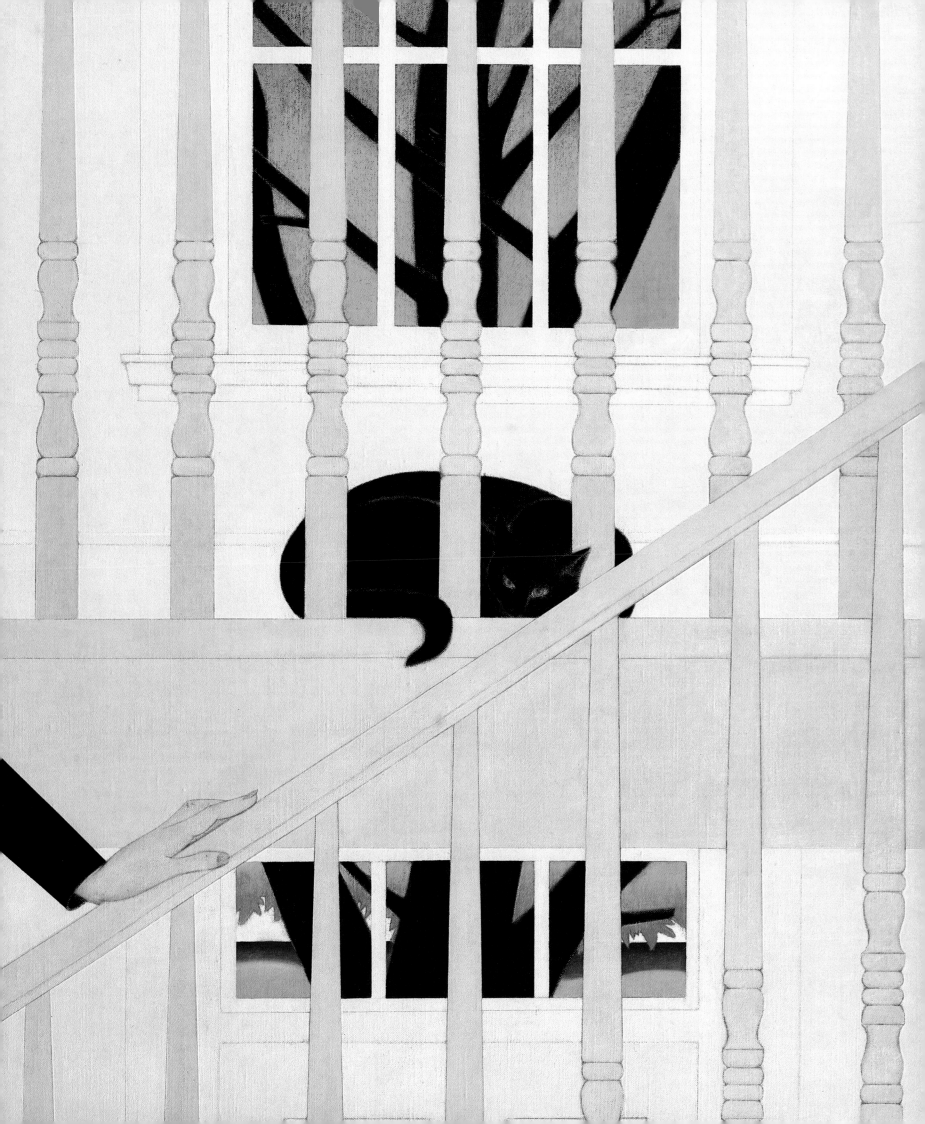

tained portfolios of old master reproductions. There were also "great books on each period of art history," Will remembers. This room, closed to the general public, served Barnet as "an inner sanctum where I spent my youth in company with the old masters."

Barnet likes to recall the many artists and cultures—European, Japanese, Oriental, primitive—whose influence shaped his work. It is a significant aspect of his career that he came to know these styles almost altogether on American soil. He did not cross the ocean to Europe until he was in his forties. In this he harked back, although not consciously, to the practice of artists of the Hudson River School, who, when they at last went to Europe, went as full-fledged professionals rather than, as was the practice after the Civil War, beginning their studies in European ateliers.

Barnet's base became the Art Students League in New York, America's most effective art school, which urged on its pupils no single consistent style. Although he won scholarships, he needed further income, and he fell into another American tradition by turning for his livelihood to a craft side of art. Almost all the members of the Hudson River School had begun artistic life as engravers: Winslow Homer had earned his first fame making drawings for woodcuts.

Barnet made his living as an expert printer of lithographs. He soon became the official printer for the Art Students League. And, naturally, he also made lithographs of his own, which he found he could sell for fifteen or twenty dollars. This was during the very depths of the Great Depression, when many American artists, particularly Barnet's contemporaries, lost their faith in American society and institutions. Barnet remembers that he voted for Franklin Delano Roosevelt in 1932 as he wanted a president who could get things done within the American system. Few of his lithographs—remarkably few, considering how moving was the result—dealt with the tragedies wreaked on individuals by the Depression. In *Conflict*, he depicted with horror the brutality of street fighting without making any value distinction between the antagonists.

Barnet responded to the spirit of the times by finding his subject matter in the unexalted lives of ordinary New Yorkers. He refers to these lithographs as "social statements," but neither barbed satire nor angry humor accord with Will's temperament. Will is most conscious of the influence of Daumier, but the prints seem to be in the benign tradition of the Ash Can School, although gaiety and lyricism have given way to a gentle melancholy suited to Depression times.

When Barnet married and began fathering children, his own life merged with the lives of the tenement dwellers around him. His most cramped scene of the tenement life, *Makeshift Kitchen*, shows a woman, her tiny room festooned with laundry, using as a kitchen table a board balanced across the bathtub. She wears a neat black dress protected with an apron. She is his wife. Barnet here communicates the domestic warmth of cheerfully resourceful Bohemian living rather than any sense of social outrage.

Remembering that the Hudson River School artists as engravers had relied on black-and-white values and later used those values as the underpinnings of their paintings, I asked Barnet what effect the technique of lithography had on his later work. He replied that it had been a hindrance, because of the concentration on detail that it demanded. But another aspect of printmaking, which he took up in the late 1930s, taught him very valuable lessons. This was the woodcut, a medium that did much for Winslow Homer. Working with the large masses of the woodcut enabled Barnet to translate these forms into large painting planes.

Barnet increasingly moved away from the depiction of realistic space, substituting "a compressed space based purely on the rectangle." When I asked him why he had discarded the illusionistic depth that has been used by realistic painters, he replied that in order to dominate the image completely, it was necessary to recognize that the canvas was flat and that the vertical and horizontal tensions create the basic structure of the painting. In searching out shapes and positions that formed a relationship, Barnet eliminated recognizable images. The shapes were surrogates for emotions which he labored to communicate through the totality of the image.

As I compared the chronology of Barnet's life with that of his art, I became aware that the abandonment of images as they exist in nature coincided with the breakup of his first marriage, and his return to figurative subjects followed his marriage to Elena and the birth of their daughter. His new wife had re-created for him that most potent human force, the family.

Barnet now applied to figurative art "the language of painting," of harmony, balance, and tension, which he had developed through working with geometric forms in his abstract works. The result is visual paradox, a convincing realism that yet is not real. Without any loss of verisimilitude, human figures, cats, or birds are two-dimensional structures. A single stretch of color, imperceptibly modulated, covers from edge to edge his forms, whether large or small. Planes are compressed, one upon another, without any sense of violating space: a cat may, indeed, sit with comfortable assurance on a stoop that is two-dimensional. Major images are often widely separated, are not connected with one another by any of the normal expedients of composition. Often there is nothing between them but what appears to be blank space. And yet the total picture locks into a harmony that is all the more exciting to the viewer because the means are not communicated. Nothing in Barnet's pictures is arbitrary—although the adjustments are not apparent. "The viewer," so the artist himself says, "does not have to understand; he feels."

To achieve a compositional scheme can take Barnet a decade. "Not emotion," he states, "but feeling grows with working time." He makes innumerable drawings, which to my eyes are handsome works of art, but which he rarely lets out of his hands because he regards them as only preparatory studies. (A few of them, happily, have found their way into

13

this book.) The poses, the outlines implying masses, the costumes worn by his characters have to be universal, of no particular time or place, and adjusted again and again in order to achieve "intimacy without description." "Just to paint a picture," Barnet summarizes, "is not enough for me."

My favorites among his compositions are those that hark back to his childhood spent on the edge of the sea in an old whaling town: pictures of female figures staring out over the water from wharves, porches, or the captains' walks on the roofs of houses. These canvases have been variously interpreted, the obvious gloss being to conclude that the women are watching for approaching sails bringing their men home from long voyages. But most women in this situation would be conversing with one another. In Barnet's pictures each stands, even when in a throng, utterly isolated and alone. Barnet feels that direct communication between the protagonists in any of his pictures would trivialize his work into anecdote. His female figures remain abstract symbols but possess a stronger symbolic significance because they clearly connote the human condition.

Barnet thus explains his ocean pictures: "I was involved with the new problem of trying to deal with the sky, ocean, and great distances. I felt the need to come to grips with the radiant light found in the atmosphere without being realistic or literary. I want to disassociate from normal activity the relationship between the figure and nature, and deal instead with the mysterious poetry of the two. I want to give the sense of great distances, yet keep the paintings two-dimensional."

The resulting compositions contrast the infinity of a symbolic ocean with human hopes, strivings, and mysterious destiny. In this, Barnet has an obvious affinity with an earlier painter from a Massachusetts whaling town. Albert Pinkham Ryder also brought his compositions to maturity with great deliberation, allowing them (as he put it) "to ripen under the sunlight of the years as they come and go." Like Barnet, he gradually made the minute adjustments on which the effect would rely.

Yet there are differences as significant as the similarities. Ryder was a full-blown romantic: his semi-abstract shapes of sail and cloud call up Wagnerian overtones. But in Barnet's compositions there is nothing explosive, nor is there anything vague or relaxed. With the austere beauty of mathematical formulation he makes us experience the interplay between the personal and the universal.

James Thomas Flexner

I ALONE IN THE CROWD

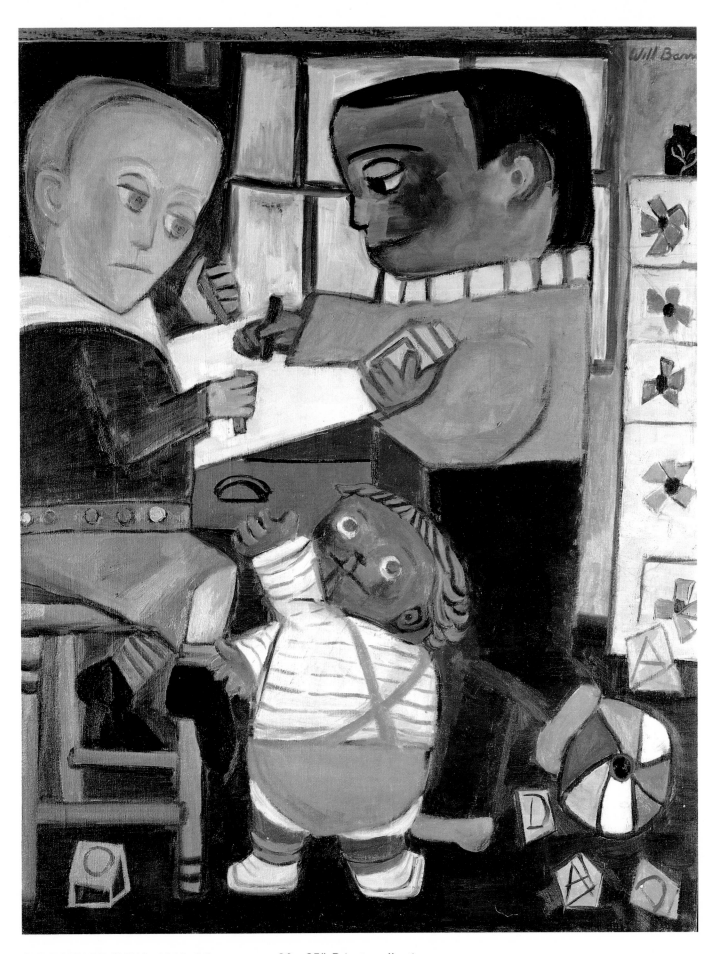

CHILDREN DRAWING. 1946. Oil on canvas, 30 × 25″. Private collection

I ALONE IN THE CROWD

Painter, printmaker, draftsman—Will Barnet is all of these. The pictures he has created over more than half a century constitute a personal and cultural record of a life in art. His attitudes, ambitions, and intentions have been tempered by the demands of family life, the necessity of making a living, and the myths and ideologies of America in the mid-twentieth century. The shifting of the ideals and forces that dominate society cause a perpetual redefinition of significant subject matter, and perceptions become conceptions as aesthetic concerns continually change with an accumulating knowledge of styles, techniques, and interests. Barnet's work is distinguished by a coherent and rational development; ideas follow each other inevitably, technique complements subject until the evolution of an idea is complete. The apparent logic of such continuity obscures the fact that many decisions had to be made along the way, many concepts formed and discarded, many choices made and rejected. Barnet was never a solitary man, but he knows the loneliness of making the decisions that lead finally to acceptance or rejection. Rather than becoming part of a cohesive tendency in the art of his time, he has always worked alone, developing his own individual vision. He never took anything for granted and always maintained the personal conviction and courage that have nurtured his life and art.

Barnet is selective to a degree, showing affinities for masters whose work he has studied with reverence and gratitude. In his pictures, his writings, and his teaching, he has continually and generously acknowledged his debt to many artists, including Rembrandt, El Greco, Daumier, Vermeer, Gris, Cézanne, Kandinsky, as well as the Byzantine and native American cultures. In his desire to forge another link in the history of art he has also proved that a knowledge of history and tradition offers the freedom to find new methods, new styles. He perceives the history of art as a trove of attitudes and devices, which he has adapted to his own unique purposes. He pondered the traditions that were germane to his time and place. He did not revolt. Instead, he sorted out the values and ideas that were viable for him in a contemporary context. His accom-

17

plishment in this regard is even more remarkable because much recent art has emerged from a vehement and dramatic renunciation of all ties and associations with its antecedents.

Artists who look backward run the very high risk of censure for not reflecting their own time, yet history also shows that many of the great masters learned from predecessors whom they admired and whose methods and subjects they adopted as their own. Barnet learned from Rembrandt, Ingres, and Daumier that the human figure is an eternal source of subject matter. From the artists of Byzantium and the early Renaissance, from Cézanne, Gris, and Picasso, he learned how to structure pictorial elements to create a unified image. More recently, he has moved into the current of American romantic painting, the procession of visionaries such as Albert P. Ryder and Arthur B. Davies. But through it all, he has been steadfast in finding his own way. His paintings and prints about people, his clarity in revealing the act of painting, his allegorical themes, always made with a high quality of line, a coherent basic structure, a precise choice of color, are distinctively his own. With these attributes, Barnet has produced a relatively small but highly distinguished body of work which will endure through the ages.

Barnet has never been a fashionable artist, lionized by critics, museum curators, and collectors, nor has his work attracted followers who copied his style or appropriated his subject matter. Nonetheless, he has had many students who are grateful to him for teaching picture-making as a logical and orderly process. He remains an inspiration for his unswerving dedication to being a leader who finds his own solutions outside the course charted by the tastemakers. During a period when a new academy discouraged many artists and historians from questioning their beliefs in the accepted course of art and criticism, Barnet made independent decisions about the need for images that represented philosophical statements or humanitarian values. His work cannot be easily identified with any movement or trend. Indeed, his highly individualistic temperament and outlook have kept him free of labels and alliances, and his work has been excluded from many exhibitions that review recent modes and fashions in American painting and printmaking.

Barnet's penchant for mystical and symbolical overtones, for an art that transcends the ordinary, has not harmonized neatly with the emerging creed of the American vision, which is seen either as an empirical realism or as a process that puts a premium on the methods of the artist. Confronted with the dominance of intellect and the objective fact over spirit and the intuitive act, Barnet turned away from an art devoid of humanism to a renewed faith in the individual. That an art such as Barnet's should have come to fruition and survived in the midst of the merchandizing that swept over art in postwar America is one of the great triumphs of modern sensibility. Barnet has always gone beyond the limitations of modern art because his work affirms a faith in life.

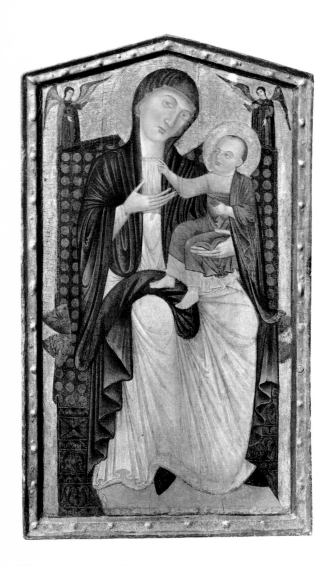

Painter unknown (late-thirteenth-century Italian): MADONNA AND CHILD. Tempera on wood, 60½ × 36″. The Metropolitan Museum of Art, New York. Gift of George Blumenthal, 1941

II TEACHERS AND SOCIAL STATEMENTS

II TEACHERS AND SOCIAL STATEMENTS

America was born on the coast of New England, a seafaring world of sailing ships, cargoes, wharves, fishing nets, and lobster pots. Later, as commerce expanded to meet the demands of a growing population, came factories and mills. Host to immigrants from many lands, this was a country that subscribed to values such as perseverance, rigor, ingenuity, fortitude, courage, and loyalty. Nature was benevolent in summer, cruel in winter, and sometimes treacherous. There was a harvest to be had from both the land and the sea. Towns and cities were built principally of wood, and the grand structures—churches, town halls, schools— were garnished with towering spires, massive porticoes, and elegant columns. Shingled roofs, clapboard siding, and picket fences denoted a more vernacular type of building. Because education was highly valued, libraries and colleges spread throughout New England. Learning and hard work were equally respected, and both were considered the road to prosperity and happiness. In this region, where a man was known for how well he worked, opportunities were plentiful for immigrants with skills and trades.

When Will Barnet entered life in 1911, New England was a place of strong traditions and flourishing commerce. Sailing ships still tied up at the docks in the town of Beverly, Massachusetts, where Barnet's father, Noah, worked as a skilled mechanic at United Shoe Machinery. This factory was the main business in the town. The people who worked there were immigrants from Ireland, England, Eastern Europe, and French Canada. Noah Barnet had served as a cavalryman in the tsarist army, learned the trade of blacksmith, and fathered three children before seeking a better life in America. Hard work and long hours at the factory were the conditions of his life. He built a house for his family and a hothouse for the tropical plants he loved to grow. His feeling for nature and its creatures led him to keep cats and rare birds, which he obtained from sailors whose ships from South America docked in Boston. He was a man who enjoyed the company of others. By contrast, his wife, Sarah, a sensitive woman with a keen mind, was introspective and given to brooding. Since

his father spent so much time at work, it was Sarah who guided her youngest son through childhood.

As a boy, Barnet roamed the streets of Beverly, climbed the hills, and watched the ships sailing into harbor. It was a lonely existence. Barnet did not lack for opportunities to be a part of the neighborhood life—he was an enthusiastic and good baseball player—but he found few real friends who could share his interests and thoughts. He sensed the indifference of his peers to anyone who wanted to be alone to read and think. He preferred to spend his time drawing and, with a pad hidden in his back pocket, he would furtively seek out hiding places where he could sketch unobserved.

The early years in school were pleasant but unfulfilling. Long conversations with his mother helped. His own motivation kept him going as the yearning to be an artist grew stronger. He knew that he wanted to record, to set down on paper, personal experiences, feelings, and thoughts with pencil or pen. He read constantly, and his desire for more books led him to the Beverly Public Library. He was delighted with the beauty of a building adorned with columns, mosaics, and reproductions of paintings, and with the riches he found within its walls, tales of adventure illustrated by Howard Pyle and N. C. Wyeth. The world of fantasy became more exciting to Barnet than the real world. He had found more stimulation in literature than he could get from family and school.

By chance one day he wandered into the library's art section and took down a book with a drawing by Watteau on the cover. Enchanted, he looked further and discovered books about Rembrandt, Turner, Daumier, and a massive *History of Art* by Elie Faure. The library staff responded to his needs and gave him access to what he later described as "the upper rooms on the third floor where they had all these massive art books. Great big volumes on all the masters. I used to bury myself in those rooms day after day. It was practically my whole life. That's where my first yearning for art began." This growing awareness of an artistic heritage coincided with youthful worries about the fragility of life and immortality. Will had already told his parents he was going to be an artist, and now he was convinced that a career in art would be the way to do something significant with his life.

By the age of twelve, he had set up a studio in the basement of his parents' house. He made drawings of the family, painted portraits of the household cats, and occasionally painted pictures of lighthouses. Life in school was uneventful, except for an opportunity to paint the sets for a play done in the manner of the Japanese theater. His interests expanded to include the rich mixture of objects collected by sailors and sea captains that the Peabody Museum, in the neighboring town of Salem, had on display, as well as the portraits of colonial merchants and officials in the Essex Institute, also in Salem. At an early age he had his first job in Salem, teaching drawing to children at a settlement house. But still Barnet missed having contact with people of similar interests. He began

to take the train to Boston, where he became a frequent visitor to the Museum of Fine Arts. Every chance he could get, he walked the streets of the venerable city, visiting art galleries and bookshops, purchasing reproductions of works by Daumier and Rembrandt. Although he also liked Watteau, Millet, Modigliani, and Ryder, it was the two great humanists who gripped his attention: Daumier he admired for his handling of form and the way in which his line defined mass and conveyed character; in Rembrandt, whose portraits evoked an especially strong response in Barnet, he found a depth of perception and an empathy for humanity that was to stay with him all his life.

In the last years of high school, Will grew increasingly unhappy and decided to leave. His father would have preferred that his son choose a profession, but he did not stand in his way and gave the boy what little support he could. In 1927, Barnet enrolled in the School of the Museum of Fine Arts in Boston, where classes were conducted after the manner of the European art schools. Barnet studied anatomy, color theory, drawing, art history, drawing from the cast and from life under strict supervision and with very high standards of excellence. The training was exacting and held to rigid codes for creating the most perfect rendering of an object or image. The discipline required is described by R. H. I. Gammell, a Boston artist who also studied at the school, in *Art in Transition: A Century of the Museum School:* "The method cannot be profitably used, or even dimly apprehended, until the diligent student has undergone several years of intelligently supervised training whereby his visual perception has become sufficiently sensitized and many ancillary skills have been acquired. The procedure . . . is only serviceable in conjunction with a well-developed grasp of form and tonal values. It comes within reach of an advanced student, if at all, only as the ultimate efflorescence of a long systematized order of study pursued under the guidance of a very accomplished artist."

Barnet's favorite instructor was Philip L. Hale, who had studied with Claude Monet and worked in the Impressionist style but taught a rigorous technique of depicting the human form on paper. He had written a book on Vermeer and was also knowledgeable about the work of Ingres. Both of these artists, and David as well, were introduced as exemplars for the students. Barnet devoured Hale's book on Vermeer and spent long hours drawing from casts and models. It was an education based on a hard discipline that built a very solid foundation in the techniques of drawing and painting, emphasizing the importance of creating an exact reproduction of what was perceived. Although Barnet stood up to the rigors of the training, his resentment at the deficiencies of the system grew. He challenged Hale to explain how the study of a single figure related to a larger composition. Hale dismissed his question with a vague prescription for painting a scene from Roman history. Although he had absorbed the work of the artists admired by his teachers, Barnet wanted to know more about such European artists as Daumier and Van Gogh or

such Americans as George Bellows. He drew from morning to night. Although he did some paintings of Beverly Beach, his real interest was stirred by the streets of Boston, from Scollay Square to the docks. He sketched poor people, laborers digging up the streets, fruit markets, dockworkers, and ships being built. The sense of humanity that he shared with Daumier was overpowering. In his thesis, on El Greco's *Portrait of a Poet*, he responded to the presence of the sitter, and realized that the artist had made him immortal by recording his personality so vividly on canvas. He continued to haunt the Museum of Fine Arts, where he copied paintings by the masters in an effort to understand their structure and technique. After several good years at the Museum School, he decided it was time to move on.

The Art Students League of New York was founded in 1875 by students from the National Academy of Design who decided to establish an independent school. For more than a century, it has been a place where artists and students meet to discuss, exchange, and absorb a continuous flow of ideas and information about the visual arts. The distinguished members of its faculty are legion and its students have done much to enrich the cultural life of America. The lack of a highly structured curriculum—the student is free to choose what he wants to study and with whom—has created an atmosphere of freedom in which the talented student readily develops.

It was in the pages of *Arts Magazine*, to which the Beverly Public Library subscribed, that Barnet discovered an advertisement for the League. He applied for and won a scholarship (he later learned that the chairman of the scholarship committee was Reginald Marsh). His Boston teacher, Philip Hale, was reluctant to see him leave the Museum School, and his parents were even less enthusiastic about his move to New York, but they consented. Barnet planned to study with Jules Pascin, who, in his eyes, represented some of the modern theories of painting in Europe. On a hot August night, Barnet boarded a bus for New York. Not long after he arrived, he learned that Pascin had died by his own hand a few weeks earlier. Barnet was bitterly disappointed, but quickly made a decision that radically altered his career. Once more the work and life of Daumier came to his mind. He enrolled in a lithography workshop to learn printmaking and he began to think of making a living by drawing cartoons. He reasoned that since lithography was to be his trade, the newspapers presented a market for his work.

The graphics department at the League had been founded in 1922 by Joseph Pennell. He subsequently hired Charles Locke, a painter and printmaker, who became Barnet's instructor. The young artist flung himself into the study of lithography, etching, and woodcutting, acquiring all the techniques he could absorb and experimenting constantly. He was delighted with the free and open life at the League and he became so skillful with plates and press that soon he was doing work for other art-

ists. In 1934, he became the official printer at the League and did all the impressions for the graphics workshop.

Barnet did not relinquish the idea of being a cartoonist. He liked satire and in Daumier, to whose work he was devoted, he found an excellent model. He sent out satirical prints and began to get some response from editors who needed illustrations of life in the Midwest. He also painted signs and continued to do lithography at the League. He wandered the streets of New York, a city caught in the grip of the Depression, and saw poverty everywhere. His lonely childhood and a strong social consciousness inherited from his Uncle Harry in Boston made Barnet intensely aware of the human condition. He walked from Harlem down to Fulton Street. He knew the shacks of "Hooverville" on the Lower East Side, and the theaters of 42nd Street. He slept in Central Park and made sketches of girls and sailors at a popular meeting place. He was doing small paintings, but lithography was cheaper and he enjoyed drawing on the stone.

The first major segment of Barnet's work is a body of prints produced between 1932 and 1942. Many are documents of time and place, while others reveal an emotional response to poverty and destitution. Barnet was very much aware of the political turmoil of the period, but he never let his work become a vehicle for propaganda. He never preached. Although an image from 1934 is entitled *Conflict*, the surging mass of figures in the picture is not a record of a specific event but rather an exercise in the interrelation of forms and shapes. He was briefly part of the Graphic Art Division of the Works Progress Administration Federal Art Project, for which he printed several of his own works as well as those of other artists. He was personally acquainted with the Mexican artists and political activists José Clemente Orozco and Diego Rivera, and, in fact, he printed lithographs for Orozco. But he made no political commitments himself.

The early works are images that convey information about people and their environment. However, realism was never Barnet's goal, although much of his work has retained some aspect of reality. During the 1930s his pictorial style shifted from time to time as he explored new means of evoking mood or placing emphasis. He exploited the special characteristics of his mediums, deploying the wide range of tonal values on the lithographic stone or the sharp contrasts of black and white in a woodcut. He learned to break away from the laws of perspective in favor of planes that distorted the picture space. His attention to form grew stronger, as he began modeling figures in solid black. His compositional design was simple and straightforward; it could transform the harsh realities of a factory district into a harmonious assemblage of forms in space. But he was never a landscape artist; humanity was the subject of his art.

Concepts learned in Boston at the Museum School were changing. Looking back, he wrote: "In struggling to present these figures, I wasn't so concerned with beautiful line. So at the very beginning I began to draw

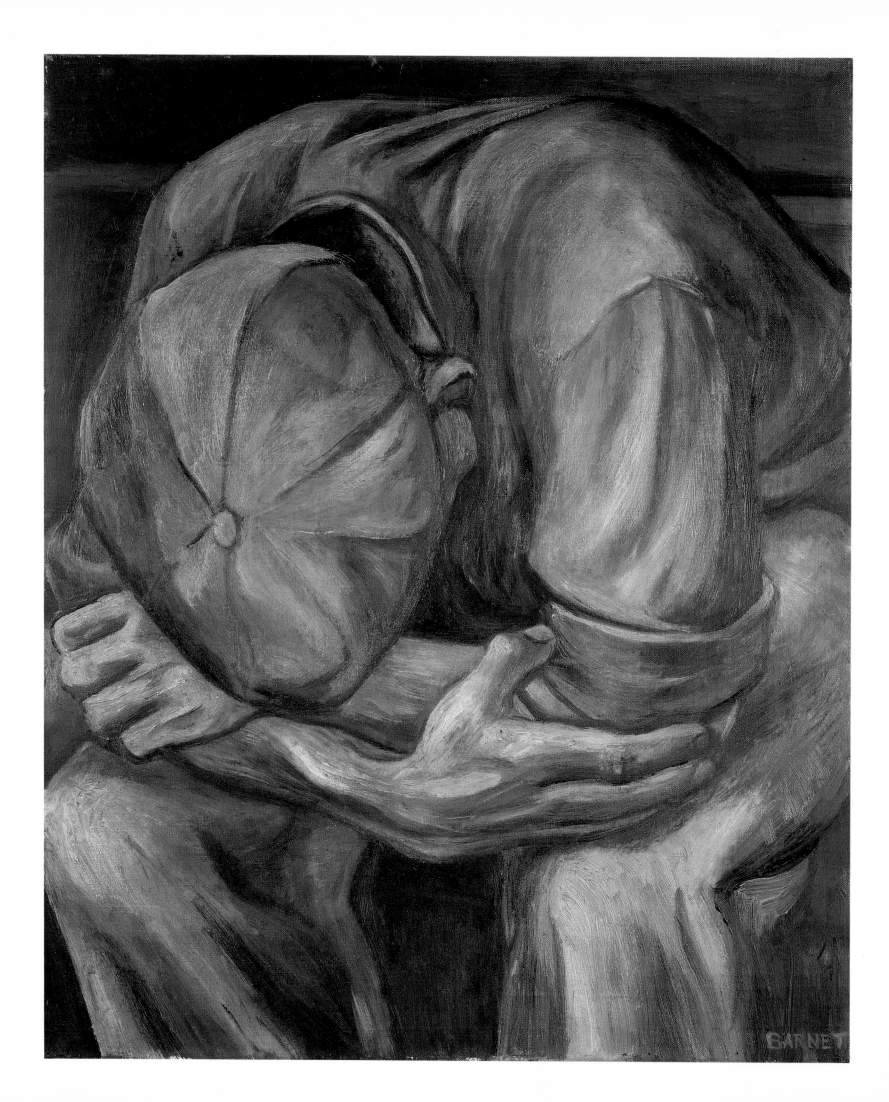

those figures in mass. . . . Mass interested me more than line. Line is an easier method to show that something is going in one direction or another. One can put it down very quickly. The hardest thing is to take that line and make it into something that is contained." The prints Barnet made in the 1930s, the first appearing in 1932, reveal an artist in search of new ideas but always building on the art of the past. It was a period of transition and adjustment for Barnet—as well as for the country.

The desire to observe, record, and preserve had been the reason for Barnet's art in the formative years. But that was not enough. His training at the Museum School had left him dissatisfied. He realized that the traditional academic methods demanded an isolated approach in which the student was taught to single out an object for rendering. Barnet vowed that someday he would teach people to see and record a total world: the relation of objects to each other and to the space that they occupied.

That opportunity was not long in coming. In 1936, Barnet was given the post of instructor in graphics at the Art Students League. It was the beginning of a teaching career that has lasted his professional life. At first he taught all the various techniques of printmaking, but his interest in painting also became a part of his shared knowledge.

I would treat a stone just like a canvas . . . I used wash and scrubbing and all kinds of techniques that no one else was using at that time. . . . I felt that all the great graphic work was done by painters. . . . I was much freer than most graphic artists . . . in graphics I was trying to express myself as a painter . . . in my graphics classes I actually taught painting in a sense. I used to give lectures on Juan Gris . . . I liked the close values and the compactness of some of his things. I also liked the dynamic movements in them. I used to talk about him a great deal and the result was that many people came to study composition with me more than graphic art.

Barnet did invent some very innovative techniques—painting directly on the stone, when other lithographers were working strictly with crayon, and making etchings by painting with acid on aquatint. But technical problems quickly became secondary to the importance of composition and the necessity for the proper relationship of forms, on which he lectured with fervor. Barnet was developing as both an artist and teacher, searching for the concepts that would inform his own mature work.

Ideas were plentiful in New York during the 1930s. The critic Thomas Craven was singing the praises of Thomas Hart Benton, Grant Wood, John Steuart Curry, and proclaimed a new school of regionalist painting in America. Artists fleeing the rise of the Nazis in Europe brought with them new ideas about art. Some sought to reduce painting and sculpture to the essence of their means, pure color and form, while others, infatuated with the world of the subconscious, strove to fashion images from dreams.

Opposite: IDLE HANDS. 1935. Oil on canvas, 36 × 26". Collection Fannie J. Klein, New York

25

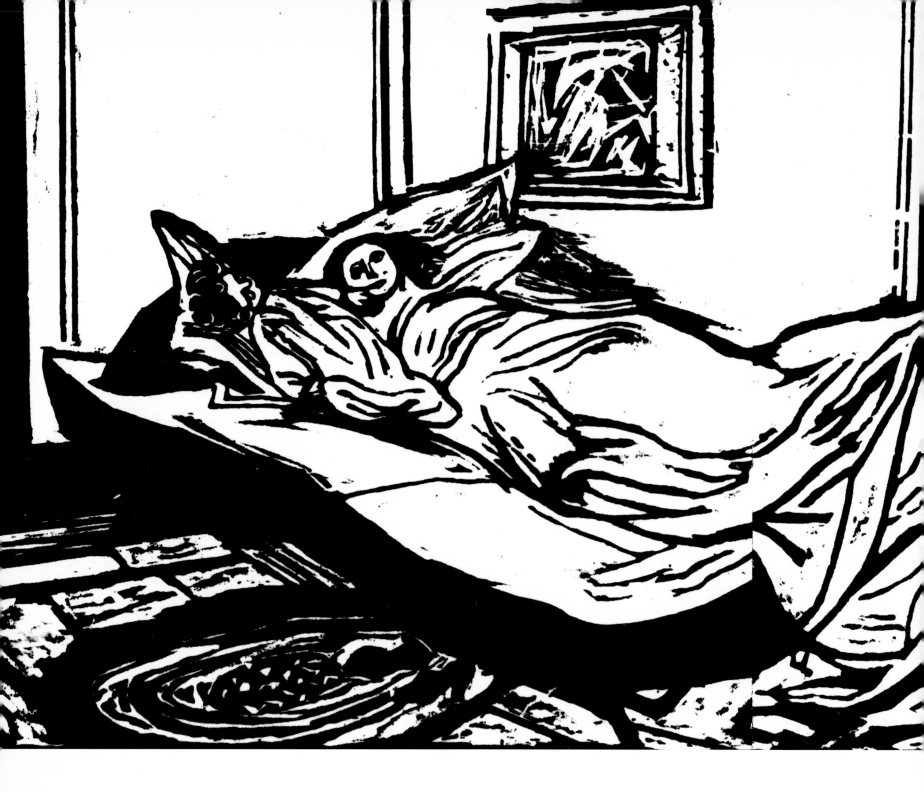

The young Barnet was exposed to all the newest idioms. For a time, he shared a studio with the painter George Swinden, who worked in the mode of the Constructivists, purifying color and form. Museums, galleries, and bookshops were unfailing resources for information and revelations. Barnet went to exhibitions, met other artists, and read constantly. During this stimulating period, his knowledge of the options available to the modern artist expanded with each new experience, although eventually he rejected movements such as Surrealism and Constructivism. He foraged for themes and images that had not only personal relevance but also the potential to become the material of his composition while he

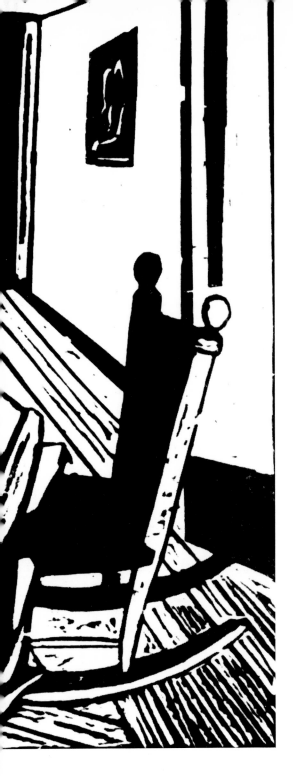

Left: EARLY MORNING. 1939. Woodcut, 9 × 15¾″

SLEEPING WOMAN. 1935. Pencil on paper, 25 × 30″.
Private collection

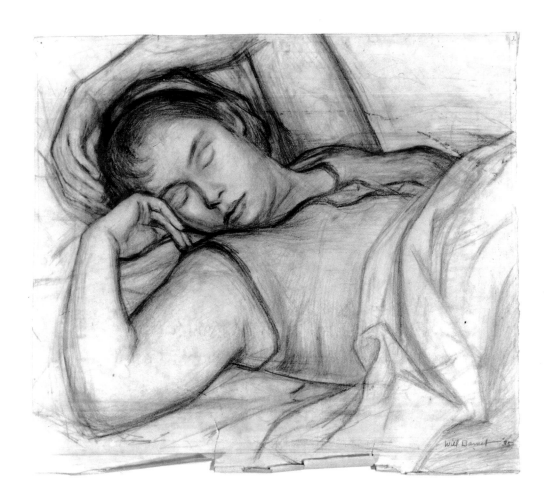

wrestled with the anatomy of the canvas and the plate. Through his association with Orozco he transferred his admiration for Daumier to an artist with a more modern style. At the same time, he was studying medieval art and early Italian painters like Giotto. In the work of Giotto and Orozco, Barnet was attracted to the way both achieved a sense of solidity in their forms.

When Barnet first came to New York, Charles Locke introduced him to the work of the French painter Nicolas Poussin and the ways in which he brought complex scenes to a logical and harmonious conclusion. An exhibition in 1929 at the new Museum of Modern Art had brought the

paintings of Van Gogh, Gauguin, Seurat, and Cézanne to the attention of the American public. The modern art of Europe greatly appealed to the young artist, and Barnet looked at all the work he could find, becoming familiar with the Cubists and comparing them to masters such as Chardin. He realized that the bridge between them was a common regard for form. The affinity between artists over the years became even clearer as he studied the work of Cézanne and the Post-Impressionists. Cézanne's search for order and a restructuring of Impressionism became very significant, but even more important was Cézanne's belief that his painting was closely related to tradition. In the art of the past Barnet found a sense of logic and structure that was to become his own foundation for solving the problem of rendering form on a two-dimensional surface. Issues concerning problems of content and technique were considered in the broadest possible way and were always placed in relationship to a traditional precedent in the history of art. Barnet had begun a drive to express clarity and order through a mastery of composition, which would afford both himself and his students the means to expand their ideas fully.

Barnet's burgeoning success as a teacher paralleled the progress of his own work as an artist. He was determined to give his students all that he had been denied in art school, and the fulfillment of that challenge lay in the planned approach to organizing the picture. Meanwhile, his own search for content was leading toward images that recorded a sustained personal experience, the facts, emotions, and circumstances of his day-to-day existence. Barnet was exhibiting more frequently, and his prints had begun to attract some critical attention.

In 1935, Barnet married Mary Sinclair, a painter studying at the Art Students League. The human figure had always been an element of his imagery, but usually as part of the social environment. Now, toward the end of the thirties, his urge to document the conditions of the poor gave way to a concern for the intimate relationships of people. His wife and their three sons became the prevailing source of subject matter for his etchings, lithographs, and woodcuts. These prints are not only records of his family life but also expressions of deep emotions about the conditions of childhood. He found a prototype for this work in the Dutch artist Vermeer, who "took a small corner of a room and made a world from it."

In 1939 he printed *Early Morning*, a woodcut that depicted his wife awakening in their small apartment. But the figure is only a part of a complex arrangement of shapes within a space that expands dramatically. It is an image that departs from the normal perception of architectural forms in order to emphasize the feeling of stretching, of awakening. It was a major shift in the pictorial means that Barnet usually employed: "I had practically eliminated the idea of light and dark or shadow changes, such as you find in some of my earlier work, modeling, in other words. And I had these pure white areas—white walls, white spaces that are operating organically as forces. For the white has a tremendous power to it. The black has a tremendous power because there is just so

much of it. In other words, the amount of white to the amount of black is very important in terms of which one is going to dominate and become a dynamic force." The use of uncovered portions of the image, areas untouched by the ink, as forms in themselves is characteristic of the manner in which Barnet scrupulously planned the construction of each picture.

Barnet was searching, experimenting, trying to find the means to make pictures that were particularly his own. He continued to study and absorb the content of older cultures. Gothic, Byzantine, and African art offered models for a rigidly controlled content that still conveyed powerful emotions. He was beginning to make images based on the actuality of personal relationships and drawn according to his belief in the need for constant attention to the organization of the inherent forms. He made order out of chaos, choosing a subject to summarize strong emotions and building a tightly structured image in order to stabilize everything that was diffuse. What he wanted the picture to contain was the essence of deeply felt emotions stirred by his own impulses and experience, while the way in which the picture was made depended entirely on the organization of its disparate parts into a carefully planned and unified whole.

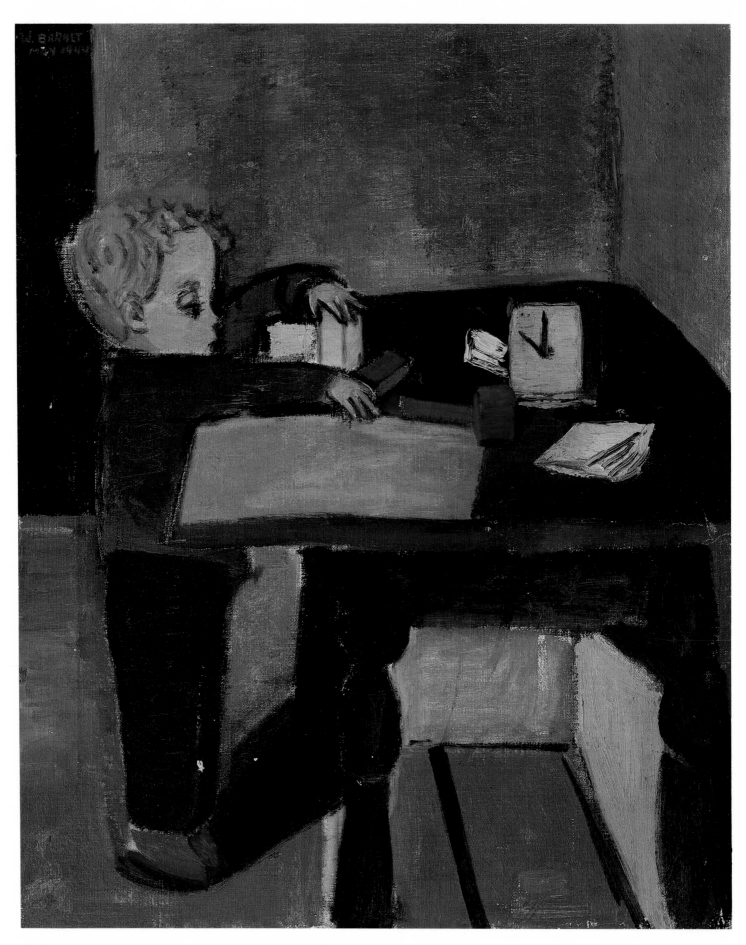

CHILD AND CLOCK. 1944. Oil on canvas, 22 × 18″. Guheen Fine Arts Gallery,
Montana State University, Bozeman

III THE INTIMATE PERIOD

III THE INTIMATE PERIOD

After his first son, Peter, was born in 1938, the family became Barnet's subject matter exclusively. He made a print of mother and child, a theme to which he would return many times. As two other sons, Richard and Todd, became members of the household, he made many paintings and drawings trying to capture the spirit of children in action. He felt that he knew the family better than any other subject, and that it was real, immediate, close at hand. Although they lived in a cramped and confining railroad flat, he enjoyed their closeness and sensed that he could universalize the experience of family life. He was fascinated by the children: the symbolism of their gestures, the intensity of their emotions, and the changing range of scale between them and their surroundings. The intimate world of the family had replaced the larger world of the city streets. But the deep concern for humanity continued and grew stronger.

In 1950, Barnet's work was published in a monograph with an introduction by the novelist James T. Farrell, who, responding to the personal element in the paintings, wrote:

> *His human beings are caught in moments when they are natural and unposed. On their faces we see sadness, absorption and concentration in what they are doing or else in thoughts and moods which come to them in moments of respite before or after they engage in characteristic activities. . . . The streets, the parks, the homes in which men, women and children work, live, brood and play interest him. This world is important to him because it is filled with the normal activities of human beings. Children's toys, kitchen floors, beds and other objects are, on the one hand seen with rare clarity, and on the other, they are rendered as part of the materials of human life.*

Barnet was working directly from life, observing for a long time, choosing possibilities, and then making hundreds of sketches. He let himself associate freely with a multitude of ideas, finally selecting one and making it permanent in a painting or print. He worked with what he saw and

felt. His home was the universe, its inhabitants his children—a subject both intimate and grand. It would command Barnet's attention throughout his career.

In 1939, Barnet produced a woodcut entitled *Under the Table*, an image based on his son Peter's early adventures. Six years later he returned to the same image in the painting *Child's View*. Barnet describes the process of creating the picture:

> *A child looks out from its low sheltered position into a space so vast that table legs become like cathedral spires. At least, by identifying with the child, I imagined it that way and conceived of finding equivalents in a painting for this sensation of space. In my first rough sketch a number of distracting elements blocked the flow of space that would express this conception. Working on the canvas, however, I found ways of releasing the needed movements. I first created a unity between the child and table by joining them at the extremities. I strengthened the upward thrust of the table by bringing in a parallel light rectangle at the left and by eliminating the top, with its objects. Against these verticals, the horizontal extension of the room was clarified by the lines of molding which imply a corner. I replaced the vague shadows under the table with a light yellow which consolidates child and floor. Although I began with the light yellows and blues associated with children, I determined subsequent colors by the needs of the picture. Thus the table became a rich cherry red, a color dense enough to give body to the slender table-leg shapes that framed the child. Each change prepared a path for the eye which now enters the picture at the bottom, stretches across (the ball helps here) and soars up unimpeded along the lines of the table. This largely two-dimensional composition, then, was not imposed as an arrangement but grew out of the search for the essentials of mood.*

The pictures of his wife and children came out of his dominant interest in life and reality. But the desire to try new ideas about rendering form, space, and color was greater than any allegiance to absolute reality. The characterization of people and objects and their relationship both to each other and the picture plane were equally important. Like his contemporaries Arshile Gorky, Balcomb Greene, Mark Rothko, and Barnett Newman, who were also working from the figure at this time, Barnet was seeking new resolutions to the problem of putting more meaning into his art. He shared the goals of a group of artists who called themselves the American Abstract Artists, who sought a more perfect unity in their art through a rigorous control of the relationships between pure color, space, and form within the context of a classical sense of pictorial order.

Content was still a crucial issue. The conversion of real matter into painting matter was subject to evolving and changing concepts about the

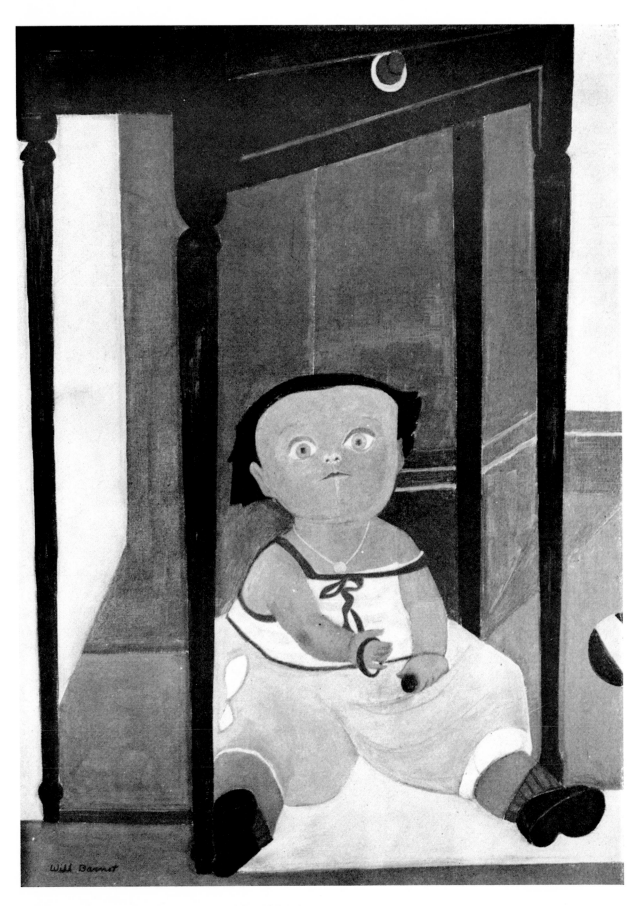

CHILD'S VIEW. 1945. Oil on canvas, 30 × 22″. Whereabouts unknown

traditional roles of form, space, and color. Objects as forms took on a greater presence. Areas between forms became activated as forms were merged or were subjected to unusual juxtapositions. Forms were scaled according to their importance within the structure of the picture rather than conforming with fidelity to actual appearance. The illusion of space became less and less significant as the forms took up more and more pictorial space. Naturalistic light and shade relationships were eliminated. Spaces were flattened. Realistic space and realistic color were banished. Barnet was in full revolt against academic traditions, while holding firmly to the task of capturing the essence of his subject, distorting and adjusting when necessary. He no longer relied solely on the combination of eye and hand, but rather strove consciously for an art based on the power of the mind. Gradually the veracity of the fragmentary slice-of-life image was replaced by a more symbolic representation of the human experience.

By 1946, Barnet had conceived a new vocabulary of form. He still drew constantly, and line was itself an important element, but more and more its principal function was to enclose form. He began to think about a picture with all four members of the family that would summarize the ideas that he felt were valid in making a picture. For a theme he selected a birthday party, because that activity had about it the sense of celebration and ritual. In the painting, all four figures are treated with respect for their individual personalities. On the left, an apprehensive child balances precariously on a ball and holds the edge of the table. The mother occupies a central position, aloof and rather pensive. Next to her, a second child throws his arms wide in a gesture of exuberance. They are grouped around a table beneath which a third child sprawls on the floor and explores the texture of his mother's slipper. It is a unique family portrait, still adhering to the artist's desire to capture the likeness of the individual. But the handling of space, form, and color breaks sharply with tradition. Barnet had taken a radical step toward eliminating illusionistic space. There is a suggestion of shallow space, but essentially the four figures and table occupy a position on the frontal plane of the canvas. He also avoided the accepted method of modeling shapes in space, choosing to present physical substance as a flat plane rather than modulating it by use of light and dark. Color is used expressively, to enhance the overall composition and to complement the emphasis on form. Barnet remembers the trials of making the picture:

> The idea was to experience physical aspects of forms behind a table, under a table, on the side of a table, and then feeling all these forms in relationship to a background. I had no clue at that moment as to just how I would handle it or how I would relate it. I was still in what I call a fragmentary stage. I had a series of fragments. That's not a good state to be in because you feel fragmented inside you. These are very emotional experiences. When you're in that

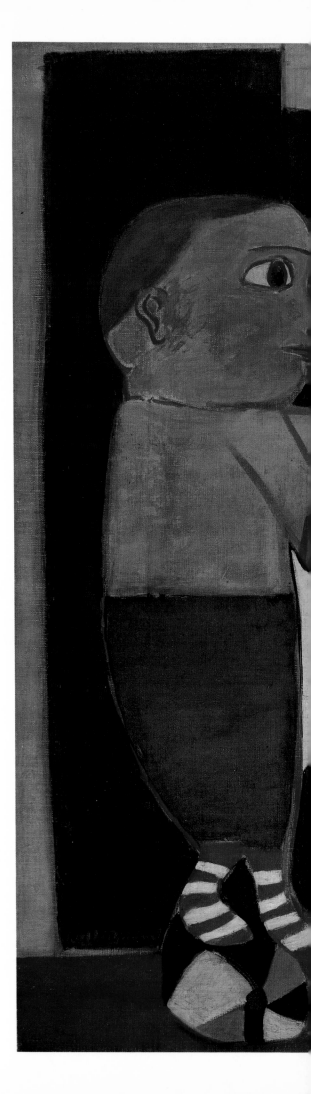

SOFT BOILED EGGS. 1946. Oil on canvas, 36 × 42″. Private collection

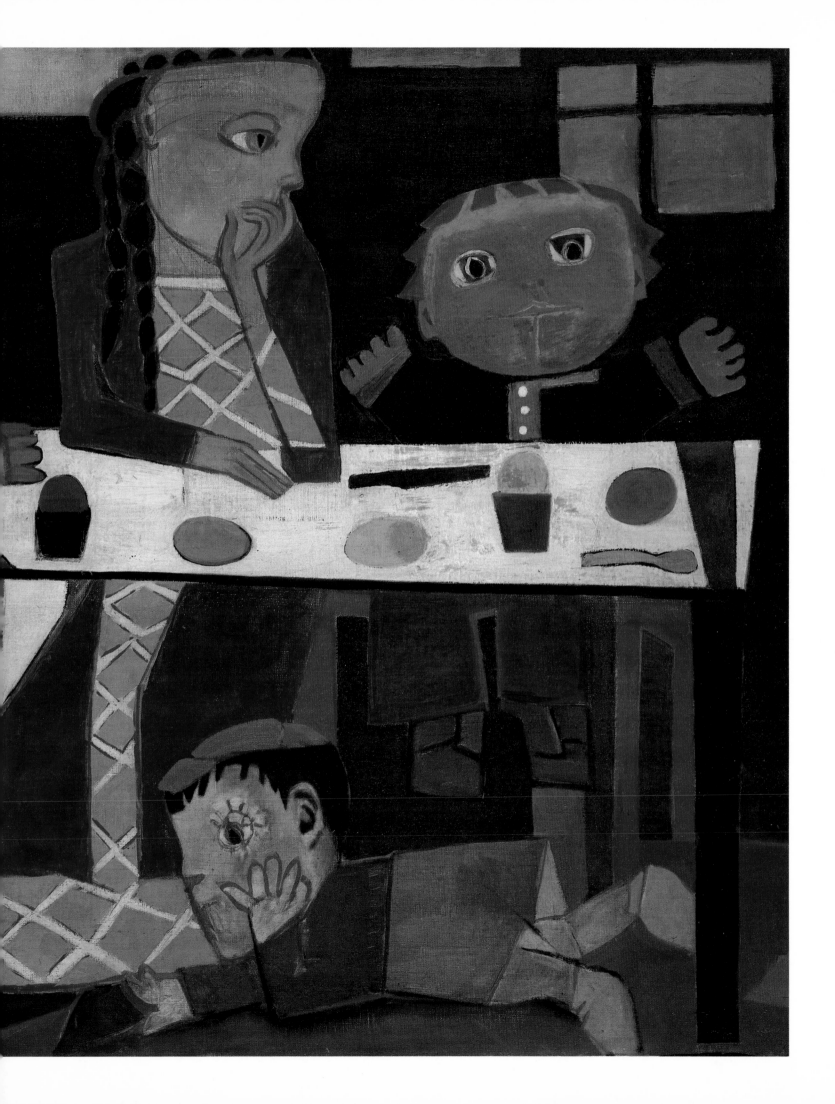

state you worry about whether you are going to be able to put the things together. So I began to make drawings and ideas for it. Then, I would find that they weren't working and then I'd feel unhappiness about it. This took quite a few months. I sketched and drew and composed and nothing was coming of it. Finally, certain ideas began to clarify themselves for me. . . . I had a lot of trouble with the woman because she always remained too far behind the table. And the boy that was underneath the table always remained by himself, isolated. I had physical sensations that weren't being brought together on the canvas. My problem was, in the final analysis, how to get the mother and the child that was underneath the table together. I began to pull the space or perspective of the woman sitting behind the table forward towards the front of the table. Her body was beginning to move from behind to almost the front leg of the table. By bringing her body forward, I related her to the little boy underneath the table and I associated one of his hands so that he touched her on one of the slippers she was wearing. In that way, I had taken two forms and united them into one. Yet they covered a great deal of space. . . . As soon as I felt this kind of sensation of relationship, I became more excited about the picture. . . . I felt if I had gotten this far I could get further. I was having a lot of trouble because it was supposed to be a birthday party and there was supposed to be a big cake on the table. But the cake didn't fit on the table. I was very unhappy about that. So then, I put the painting away for a few weeks and tried to figure out what to do. Then, I came, early one morning, for breakfast. My wife had put a lot of soft-boiled eggs on the table, sort of arbitrarily. When I saw those eggs, I said to myself, "My God, that's the solution!" Because the eggs would not interfere with the horizontal movement of the table, they would become part of that whole plane. Then, the picture began to resolve itself. I still had the young child celebrating the birthday cake. He was celebrating soft-boiled eggs or celebrating anything. It was no longer illustrative. Then the painting became a painting and the story wasn't as important as the painting.

Soft Boiled Eggs, 1946, was a major achievement; it demonstrates that Barnet not only had found a highly personal style but also had become a major American artist. In the same year, he began a long association with the dealer Bertha Schaefer, who gave him a one-man show in her gallery. Barnet's work, as it had been in the past, was again well received by the critics. In *The Art Digest* of February 1, 1946, Margaret Breuning wrote: "Will Barnet's paintings at Bertha Schaefer's Gallery reveal a change in his work; he is getting away from influences previously appreciable in his canvases and arriving at a more personal expression. This change is apparent not only in the higher key of his color, but in a

Opposite: OLD MAN'S AFTERNOON. 1947. Oil on canvas, 28 × 22". Private collection

37

gain in virility of statement. Some of the paintings tend to the abstract; all of them are abstractions of the idea involved, tersely and emphatically set down."

Barnet's work was accepted for showing in the important juried shows organized by the Carnegie Institute and the Corcoran Gallery of Art. The prevailing style in such exhibitions was a romantic realism, which took as its subject matter common objects and the most ordinary scenes of village and city life. There was a lingering interest in regionalism, which prized the virtues of the good life on the land. The political and social commentary that had been fostered by the dark days of the Depression, although still present, was declining in the face of a reviving economy. Barnet's early work with the figure stood its own ground in such company.

The artist continued to change and improve. By rejecting the need to create an illusion of depth and embracing a willingness to emphasize pictorial means, both technical and conceptual, he moved steadfastly and deliberately into the mainstream of modern art. In an unpublished manuscript he wrote: "My search in the late forties was to find forms that belonged to the pure matter of painting itself but which were equivalent to the substance and the forces that I felt in nature. I eliminated realistic space and substituted a painting space based purely on the rectangle: the vertical and horizontal expansion of forms."

The figures became more abstract when they were rendered as geometric shapes. They became symbols of humanity. The two-dimensional aspect of the canvas became stronger. The format of the rectangle was broken up into large vertical and horizontal segments. Color was laid on flat, thereby dispensing with any modeling of shapes. Thus Barnet moved through a process of replacing the semblance of reality with a symbolic abstraction. He was trying to purge himself of the subject, searching for the essence in the act of painting. He returned to the theme of his wife and family in a painting entitled *Family and Pink Table* (also known as *Mary and Sons*), 1948, which he undertook with the intention of resolving the problem of projecting the background into the picture. The picture also deals with the idea of trying to work a form within a form and a form around a form. Details are made subordinate to the large masses, which are either vertical or horizontal. Colors and shapes are determined by form and characterization. Despite the drive to work in a direct approach to pictorial terms, the picture remains ultimately a document about people.

Working to support his family was difficult. Barnet was teaching at the Art Students League, Cooper Union, and the Birch Wathen School, all in New York City. Summers were a relief, a chance to get away. The death of his parents freed him from the necessity of returning to Massachusetts, where earlier his father and the seacoast had provided him with subject matter for prints and paintings. When Barnet rented an old farm near Danbury, he found a new world in the countryside of Connecticut. "I

Opposite: FAMILY AND PINK TABLE (MARY AND SONS). 1948. Oil on canvas, 36 x 28". Private collection

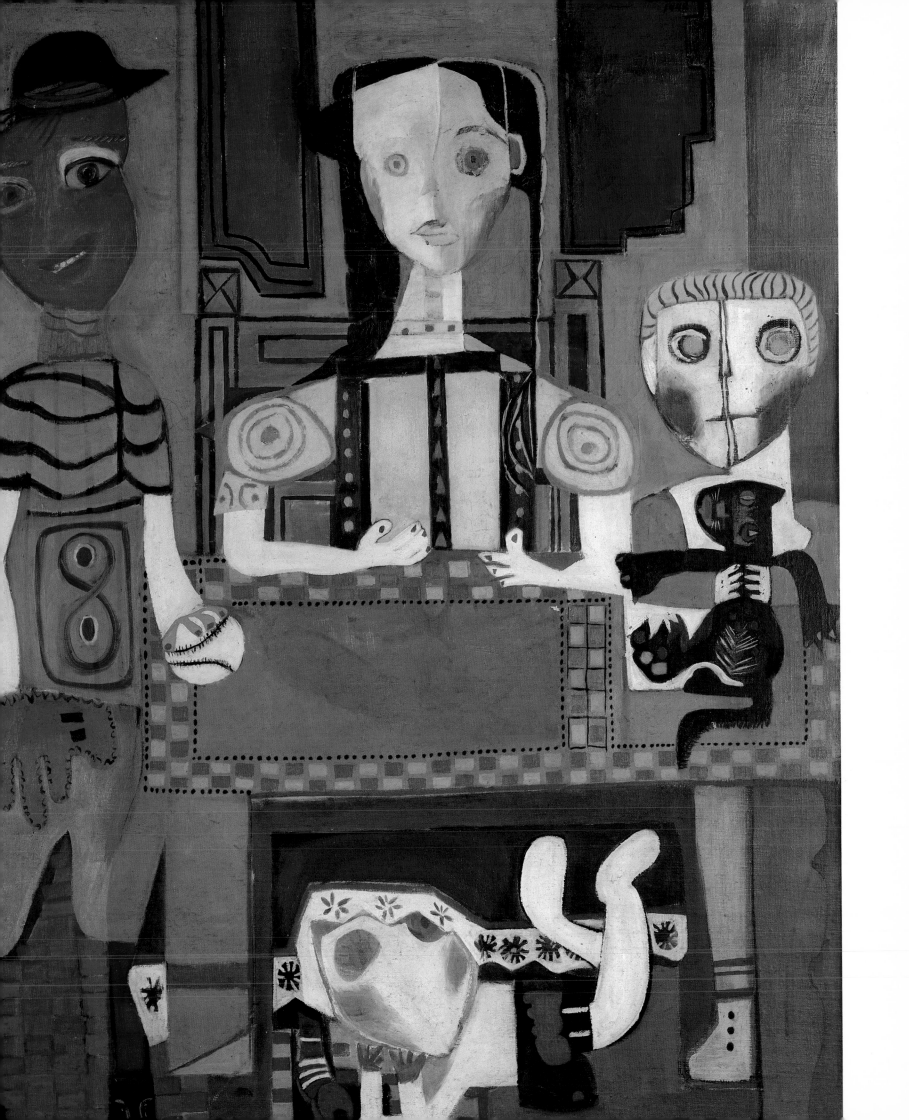

spent a great deal of time living among farmyard animals and birds. I found it exciting the way they walked and how they reacted to each other. I studied them just as I studied the children. And in a sense I got an association between animal life and human life . . . this intense interest and intense study of animal life and insect life . . . refined my work and gave it a very individual form. . . . It was like creating a rich reservoir of material into which I could lay my hands and sharpen the characterization of the forms that were to come."

The process of creating a symbol to represent a real object was consuming his thoughts. In his pictures he dealt with the composition of an image by adhering strictly to the purest application of an artistic syntax. The whole was an assemblage of perfect shapes, intermingled but not jumbled. To retain a sense of order, a series of thin, vertical rectangles divided the canvas and space into compartments or sections. Color was also used to symbolize associations with commonly held experience. He was now far from the literal world, moving through a region where imagination determined appearance. He was dealing successfully, and on his own terms, with the quest for equivalents for his feelings about a personal response to the forces and conditions of nature. In this quest, he was not alone. Arthur G. Dove had already spent years devoted to the same pursuit, and during the late 1940s, artists such as Adolph Gottlieb and Mark Rothko also painted and drew images based on symbolic rather than literal references. Beginning in 1947 and continuing into the early 1950s, Barnet worked on a small number of paintings and prints with titles such as *Cockerel*, 1947, *Rose Dawn*, 1947, *Guinea Hens*, 1948, and *Woodland Lore*, 1947. Although the picture itself was becoming increasingly abstract, the image had its basis in Barnet's reaction to reality.

Woodland Lore explores ideas about what Barnet called

> . . . the many levels of human life. The low position of the turtle, and the guinea hens hiding behind various plants; and the rising form of the tall mother hen with the fly above her. And all the little things fluttering around, the butterflies and all the various intense vegetation. I used a lot of cool forms on the bottom which gave you the feeling of the coolness of the ground as it is hidden by vegetation. And as you rise you get towards the white heat of the sun. I used white as you get to the top, and very warm colors in open spaces where the sun could enter. In a sense, I found colors, compartments, changes equivalent to the experiences I had in nature.

Barnet now commanded the means of expression, the manipulation of form and color, to the extent that he could create major statements about the reality of sensations emanating from an inner consciousness.

He knew that a picture had its own life and needed a certain kind of pictorial language. Art was not just a matter of recording the obvious, nor was it simply depicting a tableau on a stage. He had discovered new

40

SUMMER FAMILY. 1948. Oil on canvas, 34 × 44". Philadelphia Museum of Art.
Fleisher Art Memorial Collection

methods that gave new vitality to the forms he was seeking. The crucial structure was the two-dimensional surface, which carried the meaning of form. Within that area, vertical and horizontal forces controlled the organization of the image. To make that kind of action possible, it was necessary to eschew the traditional method of space description and the conventions it employed—chiaroscuro, modeling, atmosphere—and, instead, to suppress empty or negative spaces such as background and foreground. Barnet studied the work of Matisse, Léger, Kandinsky, Miro, and Picasso, reviewing their ideas about breaking away from the traditional manipulation of form and space and their ways of coping with the outmoded background. Although their innovations were important influences on his own thinking, no one could supply a prototype for the image he sought. He kept coming back to the elimination of line and the importance of mass expressed as a totality. He became keenly aware of edges, and directed his form inward from each of the four sides of the canvas. But stretching mass completely across the surface involved a great risk, which, however, could be avoided by a countermovement, such as a line between two masses. Life in the studio demands many decisions, and Barnet never lacked the courage to confront the problems of picture-making. He never experimented by trial and error. He posed problems and arrived at answers that were the result of a coherent and rational search.

As a child, Barnet had been captivated by the collections of Far Eastern and tribal art housed in the Peabody Museum in Salem, Massachusetts, and in New York he often visited the Museum of Natural History and the Museum of the American Indian. He never abandoned the interest that was awakened in an art that he found mysterious and provocative. He probed further into the history of African, Peruvian, and American Indian art. He realized that the art of the so-called "primitive" cultures could offer suggestions for new ways to organize a composition. He especially liked the motifs of a form within a form and forms with a band in between, which gave a novel spatial effect, a breathing space. Such combinations of forms could take the place of the background. Line became mass, and a tight union with other masses was carefully maintained. This concern with "Indian space" was shared by his friends Peter Busa, Steve Wheeler, Worden Day, and Robert Barrell. Whatever their individual preferences and needs, they were all working with images that depended on the validity of an overall composition that covered the entire surface of the frontal picture plane. Using an old convention as their point of departure, they formulated new structures to represent contemporary ideas.

Working with these new concepts posed new problems. It was no longer desirable or progressive to create the kind of image that had a specific descriptive quality as its essential function. New forms required new images. They had to be the essence of an idea devoid of encumbering details. The resolution of that problem occupied Barnet for several years. The result was two paintings, *Summer Family*, 1948, and

Awakening, 1949. The two pictures, whose flow of ideas overlap, are closely related. Once again, the subject is a family group. Since simplified form was now paramount, not the least of Barnet's problems was how to deal with a multitude of eyes, noses, hands, and feet. In the end, all anatomical features were integrated with the interplay of figures placed out in the open or squeezed between trees, as occurs in *Summer Family*, or given a certain prominence, as in *Awakening*. In both paintings, the figures are shown as symbols of a characteristic feeling. Barnet trod a fine line between a respect for the individual and a commitment to the pure nature of the abstract idea. *Summer Family* is the more linear; *Awakening* still has some lines around forms, but most lines have become bands. The figures in both paintings are recognizable as such, and each has a particular compartment of the picture allocated to it—units in a big structure. The compartment was a device that gave the artist a chance to arrange forms with a maximum of attention to detail and a consequent heightening of emotional content. Barnet describes with great clarity where each thing exists in its own right, and how it exists in relation to the whole composition. Figure and background are part of each other, merged into one facet, and figure plays against figure. *Awakening* is a major picture, both by virtue of its relation to Barnet's development as an artist and its position in the history of American art at midcentury. It is a unique group portrait and a brilliant analogy for the substance of reality, and thus brings an aspect of longstanding tradition into a contemporary context. Barnet upheld the standards of traditional art while immersing himself in the immediacy of the creative act.

A period of transition began in 1949 and continued through 1952. Deep stresses were affecting his family life, and in 1952, he went through a divorce from his wife Mary. Every work of art that Barnet has created is a reflection of his temperament and life experience. Changes in his work are caused as readily by changes in his personal relationships as by his expanding knowledge of art and artists. Barnet was greatly moved by feelings of personal loss, isolation, and loneliness, and for a while he would not undertake any work of major size or significance. However, the work ethic that had been instilled in him by his father was too strong to permit any period of idleness, so he turned to sketching, and made hundreds of studies on the backs of envelopes and other scraps of paper. Although not important in terms of painting, this period did produce a number of watercolors and prints, especially lithographs.

Barnet never indulged in the kind of thinking that placed different values on different mediums; his work ranged from painting to printmaking according to his needs for visual expression. He began to make a multitude of sketches in pencil and charcoal of his family in the woodland setting of their summer home near Danbury, Connecticut. The highly structured approach that was so laboriously developed in *Awakening* gave way to a looser treatment of forms. Atmosphere reentered the image, and the figure was subject to even more reduction in substance.

43

AWAKENING. 1949. Oil on canvas,
42 × 52″. Private collection

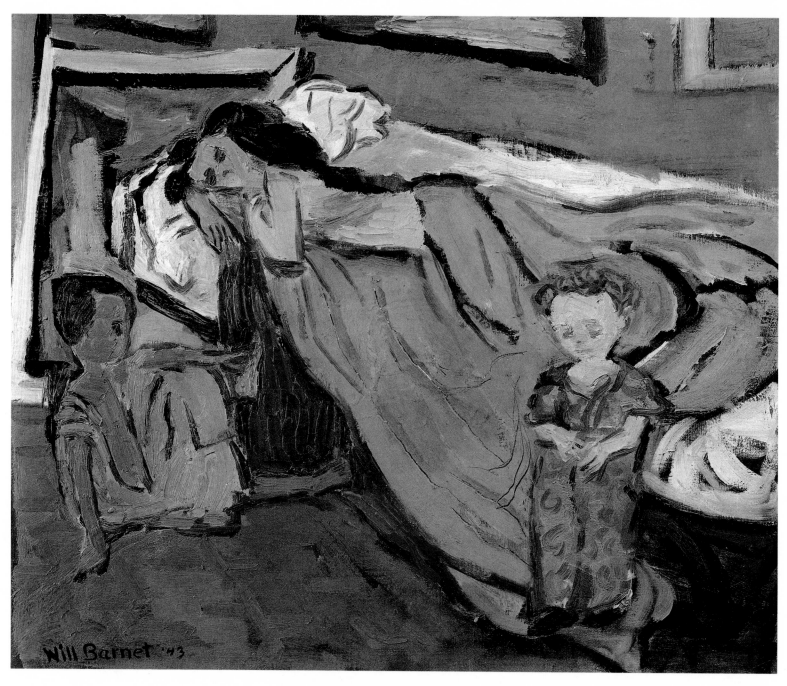

EARLY MORNING. 1943. Oil on canvas,
25 × 30″. Private collection

The image reveals the nervousness and introspection that dominated Barnet's emotions. His children continued to be the source of content, but his feelings for them were wrapped in nostalgia. The print *Memory of Childhood*, 1950, employs a traditional use of forms and a new idea about using sinuous line to hold the image of children at play together.

It was a time for poetic, lyrical images about golden moments of light and the changes of the seasons. Barnet watched his children walk among the flowers and thought of them as one with the natural plants. On paper, he compressed the faces and bodies to create a feeling of unity and weight by the way the forms swell and press in upon each other. He

46

titled this image *Growing Things*, 1952. The lithograph *Child Alone*, printed in 1951,

> *is a picture of a child in an ambivalent position where it neither has its feet on the ground nor can touch the sun. It feels very much alone. I tried in several ways to get across the ambivalent feeling. I divided the picture into two areas of color: gray on one side and warm light on the other. This is accentuated by tree branches spreading from left to right with an immense void in between. A planet or two alleviates the emptiness, but at the same time gives the feeling that the child is in vast space. All of this was done to intensify the impact of the child: alone, symbolically and really. Most people have felt this tremendous loneliness of life, and also a striving to reach or stabilize their position.*

The print is autobiographical, a summary of the trauma and anguish in his own personal and professional life.

The medium of lithography, which once had been Barnet's means of livelihood, now provided the means of salvation. It became the prime vehicle for his ideas, for releasing part of himself. He quotes the descriptive phrase of his colleague Benton Spruance to express his passion for "the petrified velvet of the stone." The years of printing and teaching lithography at the Art Students League had made him a master of the craft. The lithographer draws directly on a piece of flat, smooth limestone with a crayon, a technique ideally suited to Barnet's affinity for drawing. In *Art News* of April 1952, Dorothy Seckler describes the genesis of the print *Fine Friends*, 1952:

> *Watching his seven-year-old son, Toddy, playing around the house with the black cat, Bagdiera, Barnet was struck by the relationship of the two . . . as they alternately romped and rested. In a number of quick, realistic sketches he tried to capture, not a particular pose, but forms that would suggest their sympathetic closeness. Finally certain shapes emerged from this which gave a fanciful but not sentimental direction to the idea, shapes which by being light in weight and at the same time austere in character and drastically simplified, seemed right for the kind of spontaneous development that lithography so ideally offers. . . . The first proof showed the artist that the composition needed revision. The big shapes, he decided, should be pulled apart and their components distributed in the space so that the design was more open and tensions between high and low elements more apparent. In a new drawing, made on tracing paper over the sketch, the cat's head was pushed higher against the upper edge and a space was opened up between the two faces which channels the white, or "squeezes it" as Barnet puts it. This open space seems to exert downward pressure as it continues into the crescent-shaped open-*

CHILD'S WORLD. 1949.
Oil on canvas, 28 × 32".
Private collection

ing that crosses horizontally below. The entire effect is what Barnet calls "a shift." The large shapes appear to push in against each other with a resultant displacing or outward expansion of the spaces around them. The distortions entailed in this kind of change are not without limits though—an eye must remain a "high element," literally high on the stone, because experienced as high in reality; shapes which approach a ground plane, like the extremities of the cat, must be relatively dense. . . . As the finished prints came off the press, the fugue-like interplay of color and tonal elements seemed to satisfy even the exacting expectations of the artist and to justify the painstaking care of each operation. The lively relationship of each motif to the other communicated a mood whose freshness shared elements of the childlike and the austere.

As Barnet began to use color as a substitute for shadow during the 1940s, it became an important element in his painting. Anything dark became light through vivid color. But form still took precedence over color. In the early 1950s, when Barnet did nothing but color lithographs, color was assigned a new and more important role. A wide spectrum of hues—veiled blues, soft pinks, blue whites, green yellows, and more—are charged with conveying messages about the sensations that Barnet projects in every print. These graphics are all the more extraordinary because of the technical problems that Barnet encountered and solved.

Although he was showing regularly at Bertha Schaefer's gallery in New York, Barnet had received little public recognition for his painting. The handful of critics that had reviewed his work generally had described the work on view and offered restrained praise. When the color lithographs were presented at Bertha Schaefer in 1951, they elicited a good critical response. Dore Ashton wrote: "In his first graphic show in 10 years, Barnet proves to be as cultivated and mature a lithographer as he is a painter. . . . In recent works, Barnet has tended to simplify and focus on the dramatic. An interesting comparison between *Child Alone* and *Awareness of Dawn*, printed from the same key block but with entirely different colors and some formal alteration, shows the poetic-imaginative scope of the artist. Above all, Will Barnet is a tender humanist, deeply concerned with the experiences of the perceptive-active individual."

But sales were few. Printmaking had no status in the eyes of the American public and collectors. In addition, there was a new boldness and strength in Barnet's lithographs that made them completely unlike anything else that was being done in the graphic arts at that time. Printmaking was generally thought to be a matter of line and chiaroscuro. Barnet added color and pushed beyond what had been considered the limitations of the medium. He did something technically that no artist had done before, and, in so doing, he established a precedent for the revolution in the graphic arts that was to come in the next decade.

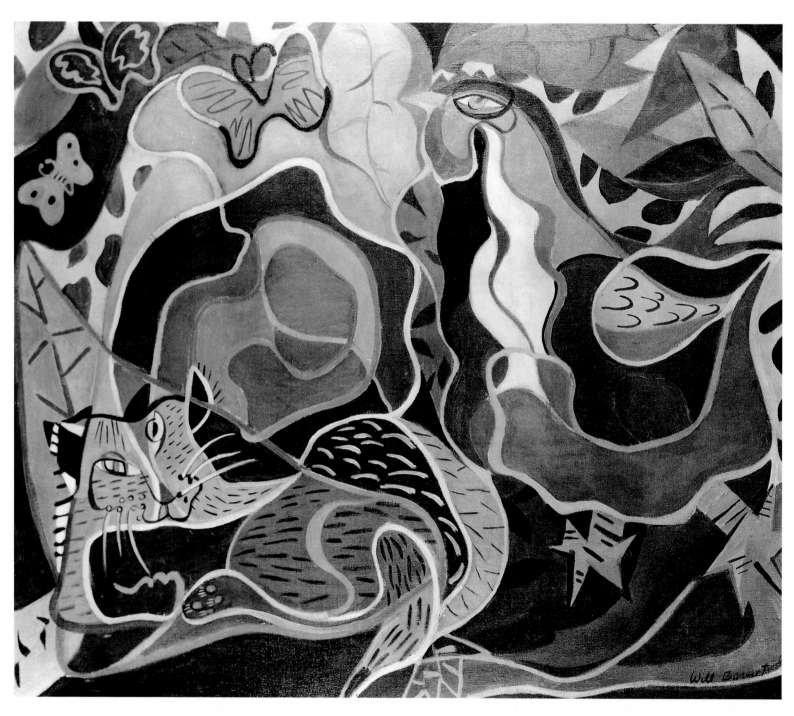

MEMORY OF SUMMER. 1950. Oil on canvas, 36 × 48″. Collection Mr. and Mrs. Phillip Kaplan,
Brookline, Massachusetts

IV TOWARD ABSTRACTION

IV TOWARD ABSTRACTION

For a period of over fifteen years, from the late 1940s to the mid-1960s, Barnet turned away from overt and referential meaning. The pictures came from his mind rather than his eye. He was sustained by a vast reservoir of information about the way to make a picture, an asset that he applied in both his painting and his teaching. He could find a formal idea in just a simple scribble, which then became the starting point for something to enlarge and explore. Sometimes the complete idea for a painting suddenly came to mind and was quickly recorded for further development. Although he never cut himself off completely from direct observation, the formal quality of a picture was now the heart and soul of his imagery. He became entirely concerned with distilling and depicting the essence of his private thoughts in terms of color and form. Nor could he desert the infinite possibilities of subject matter to be found in the human condition. The painting that marks the beginning of this period is entitled *The Cave*, 1953, a portrait of the artist and his son Todd. In order to suggest a struggle to emerge from conflict, Barnet used a heavy, solid line surrounding and containing the symbols for the figures. It is typical of Barnet that even in a time of great change he remains loyal to the theme of the figure.

In 1953, Barnet was married to Elena Ciurlys, a modern dancer with a strong sensitivity to the culture of her native Europe. They traveled abroad together, and the world opened up for Barnet. With the birth of their daughter Ona, a new family was formed. Barnet celebrated this stage in his life by creating a woodcut entitled *The Baltic Madonna*, 1954, a variation on one of his favorite themes, the mother holding a young child. The subject had first appeared in his work in 1940, as an etching entitled *August*. Both prints are tender portraits of a mother and child, statements about security and strength, and studies of forms contained within forms. During 1954, because Barnet was devoting all his attention to the possibilities and problems of abstraction, an image of the fully conceived figure was quite out of place. But the hope of finding a new,

51

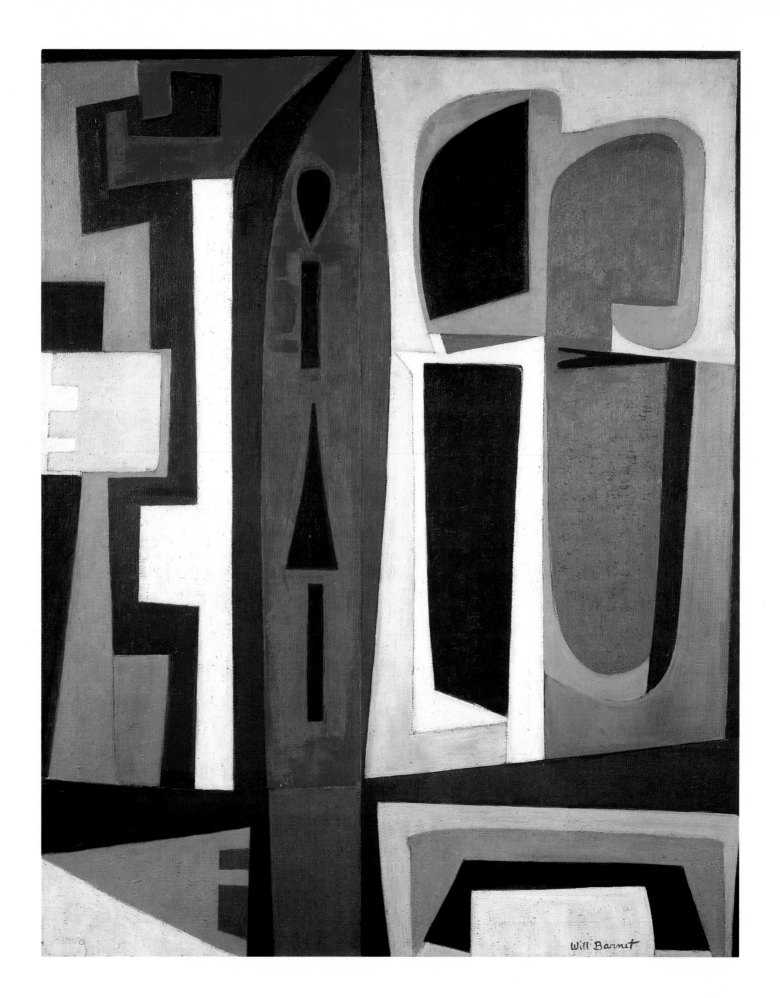

fresh way to portray the human figure lingered in the back of his mind. Eventually he was to do just that, with great success.

Barnet felt strongly that the artist should work not only with things that are close to him but also with subjects to which he has consistently given his complete attention. He could easily take the figure apart and reconstitute it as a series of forms that become an abstract idea. To do that, he devised equivalents, plastic representations of naturalistic forms. He worked on a number of paintings based on this method between 1953 and 1955, eventually discovering that a detail could become a complete form in itself and the dominant feature of the picture.

Barnet employed this device as a method of interrelating human elements as a series of forms. In *Self-Portrait*, 1954, he used the human face as a theme, but spread it out like a landscape, exploiting the idea of expanding a single form into a larger force. Barnet enjoyed working with a sense of movement on the canvas; his notes of the time contain references to "the energy of physical forms and flat surfaces," "the direction of the surface and the object." He avoided static situations by working with forms that suggested movement through changes in relations of scale and through the manner in which they were juxtaposed, supporting or threatening, in this way creating structures held in balanced tension, in which movement is potential rather than actual.

Color was also a means of inciting action on the canvas. *Fourth of July*—which was actually finished on Independence Day, 1954—began as a simple study of three figures. But the artist wanted to express a feeling of jubilation, and soon the excitement of color took command. Barnet was preoccupied with red and the sense of expansion it gave, and then blue to contain the red, and white to relieve the intensity of both. Color had become a physical reality in itself, and the resulting image was a show of exuberant strength. These color relationships in his imagery, as well as the preponderance of form on the overall ground of the canvas, would lead to a highly successful synthesis of the spiritual aspect of mood and the physical structure in the creation of a painting.

The idea of dismembering the body and distributing it throughout the whole picture was behind the painting *Male and Female*, 1954. Proportions were changed—sometimes a head was made small and a torso huge—in the service of the symbol and the plastic concept. What makes it all work together is the tension between vertical and horizontal masses. Barnet was fascinated with parallels between the human body and the concept of structure. He liked the thickness of the human form, its solidity and the elements of its mass. In an essay written for the anthology *The World of Abstract Art* (New York, 1957), he wrote: "Man's physical symmetry is a source of inspiration to the artist. . . . It becomes the structure of the picture, and the structure of the picture becomes the human form. There are no voids, there is no atmosphere, except the drama and the purity with which the painter gives the canvas its life." These theories come full force in the painting entitled *Janus and the White Vertebra*,

Opposite: MALE AND FEMALE. 1954. Oil on canvas, 40 x 32″. Whitney Museum of American Art, New York. Anonymous gift through the Federation of Modern Painters and Sculptors, Inc.

53

which Barnet finished in 1955. His forms are now solid and impenetrable presences, their shapes both curvilinear and geometric, alluding to physical and psychological meanings. Barnet considered it one of his most successful pictures. He wrote:

> *My conception of* White Vertebra *grew out of my memory of a figure glimpsed in the shadowy background of a woods. I was aware of the firm, upright silhouette and of a face turned towards me. I never departed from this image as the core of my mood. In the one sketch I made for this picture I was able to compress the thinking and feeling that formerly required dozens of drawings. Actually my greatest task, creatively, was to find and adjust the colors that would perfectly express my mood. The vertical white band which gives the picture its name is like a main supporting beam in a structure. Shifting slightly from center it forces the eye to measure and grasp the power of the upright form and by contrast heightens the impact of the spreading forms of the head and the weight of the pelvic region. Arms at the side are reduced to elements of a corresponding scale, in softer shapes; and the beginnings of legs at the bottom are compressed into a rectangle that supports the other forms within the space. I used a strong dark red against the whites for the main part of the figure, purple for the shadowed part of the head and yellow for the lighter side. The static warm greens I chose for the background because of its association with the woods, had to be adjusted many times before it functioned as I intended it to . . . as an anchor for the other more active forms.*

This picture, with its strong plastic order and great clarity, is the work of a mature artist, firmly in command of his craft and determined to use his artistic energy to convey meaning within the image. Through the application of his ideas and concepts about painting and guided by an instinct for order and control, Barnet brings serenity out of chaos.

The solutions that Barnet arrived at in his own paintings were passed along to his students at the Art Students League and Cooper Union. Moreover, during the 1950s and beyond, he often traveled to guest teaching assignments in colleges and universities throughout the United States and Canada. He considered this a significant activity and he put considerable energy into it, sharing his theories and resources with his students, many of whom went on to positions of importance in the art world. While not all of them agreed with him, there were many who successfully applied his principles to their own work.

Barnet's pictures were often derived from feelings about his environment. In the earlier work, the city streets, the interior of his apartment, and the countryside near his summer place had been resources for the settings of his imagery. In 1955, he moved to New York's East Side. The change awakened a new interest in landscape and cityscape, not as a

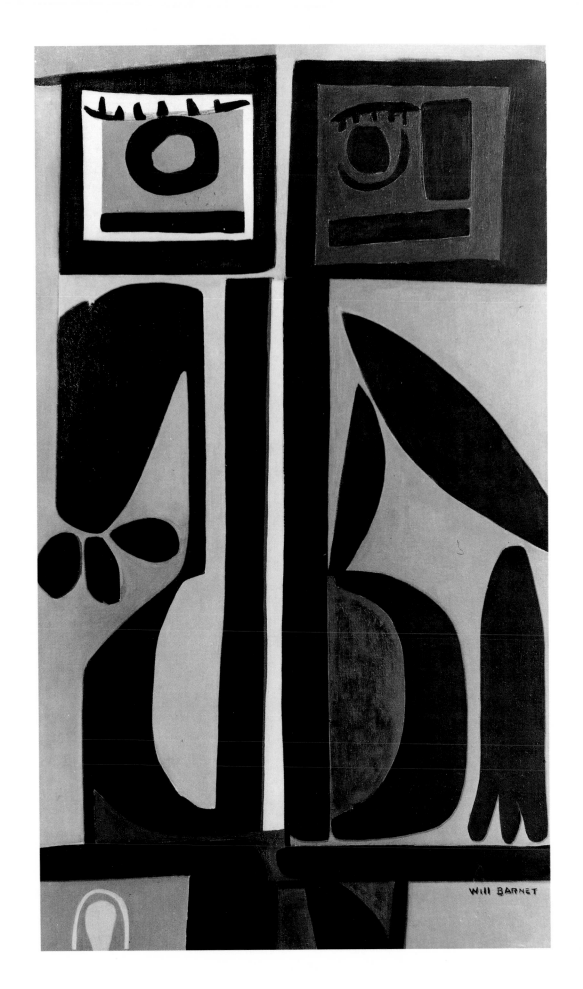

JANUS AND THE WHITE
VERTEBRA. 1955. Oil on canvas,
41⅛ × 23⅞″. Private collection

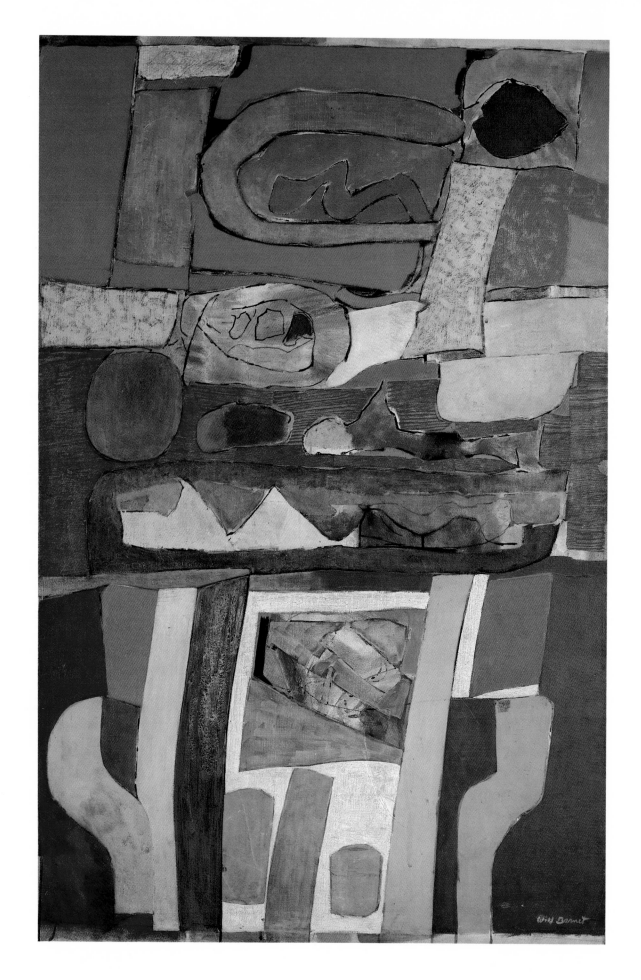

background but as an area that itself commanded abstract forces and subject matter. Thus, *The City*, 1955, is a response to his new outlook, as well as a reaction to a long period (from 1932 to 1952) of working with the figure. In this painting, red shapes are surrounded by white bands—buildings standing with air and space around them.

Silver Day, 1956, began as a sketch in New York, but was finished in Provincetown, Massachusetts, where Barnet spent the summer of 1956. Its light colors and more rounded forms suggest the effect of working in the natural environment, although it is composed in a manner that is closer to the pictures associated with the figure. The experience of living surrounded by sand dunes, sea, and open sky became the cue for a second experience in New York, where a vista opens up on an avenue. *Clear Day*, 1957, brought together people, sky, and clouds in a series of high and low forms, which are arranged on the canvas as though they were seen from a great height. There is a suggestion of earthbound waves, which push up and lift human apprehension into the clouds above, a more lyrical and joyous spirit than had ever before entered Barnet's work. Man's relation to the land, the ocean, the sky was again the subject in *Province by the Sea*, 1957, in which forms occupy their own compartments, reinforcing the natural order of strata and levels. It was a larger picture than those Barnet had done before, and the scale adds to the spacious quality.

The years in Provincetown laid the groundwork for more landscape painting in the late 1950s and into the 1960s. In 1958 and 1959, Barnet taught at the summer session of the University of Minnesota at Duluth. Quarters were provided for Barnet and his family in a house on the shore of Lake Superior. Once again, the artist found living with open sky and water an extraordinary experience. He made hundreds of drawings and watercolors of the sun, the moon, and the horizon. He sat for hours and hours, enveloped by the intensity of the light on the water in the daytime and by the darkness at night. One of the paintings from this period, *Big Duluth*, 1959–60, is a majestic and powerful landscape. The compartment is introduced again as a means of organizing the picture, with a circular sun shape in the upper division and forms representing earth, waves, and people in the lower part. Nature, its elements, and man's relation to the whole are epitomized in this image.

A companion piece, *Little Duluth*, 1959–60, was intended to have a more buoyant quality, depicting a nature that could be enjoyed. Barnet returned to pictorial incident in *The Wave*, 1960, which he painted as an image of man overpowered by the forces of nature. *Dark Image*, 1960, was inspired by an intimacy with the sky at night. Using twelve coats of black paint, Barnet attempted to achieve a density and degree of darkness in which varying shades of black cloak forms that evoke the perils of the night. These are works that hark back to the discovery of the American landscape in the nineteenth century. There is wonder at the grandeur of nature and the fact that man can exist within its conflicting parameters

Opposite: ORANGE AND GREEN SPACE. 1958. Oil and collage on canvas, 51 x 33". Private collection

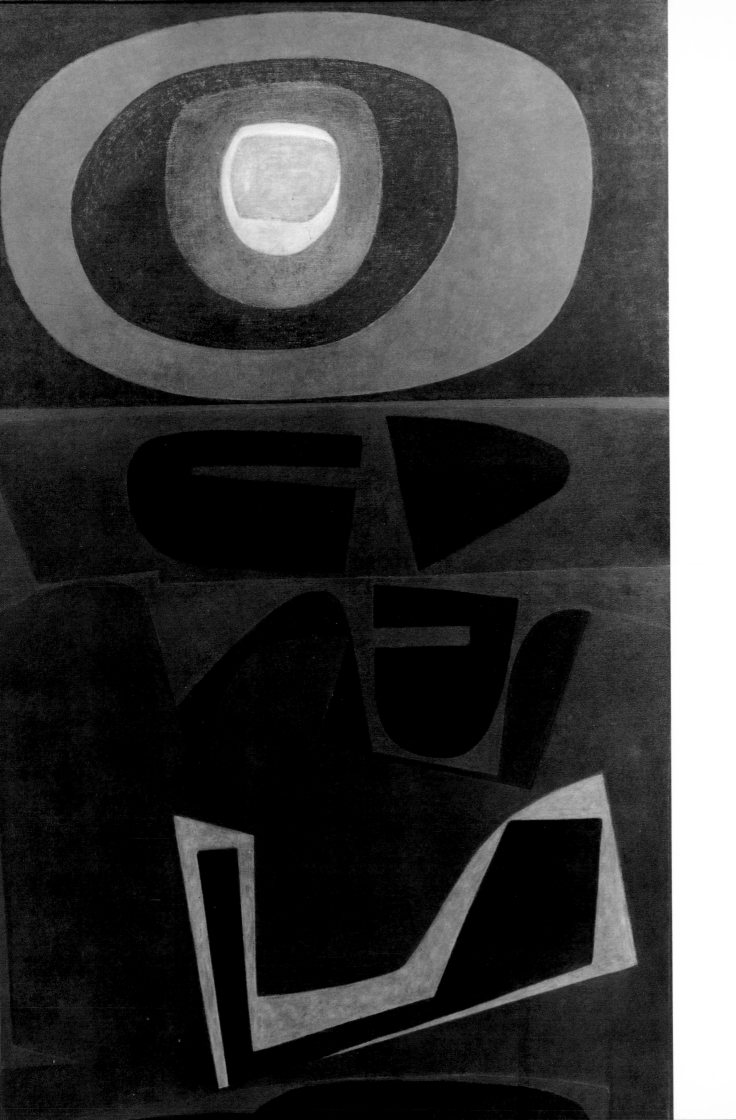

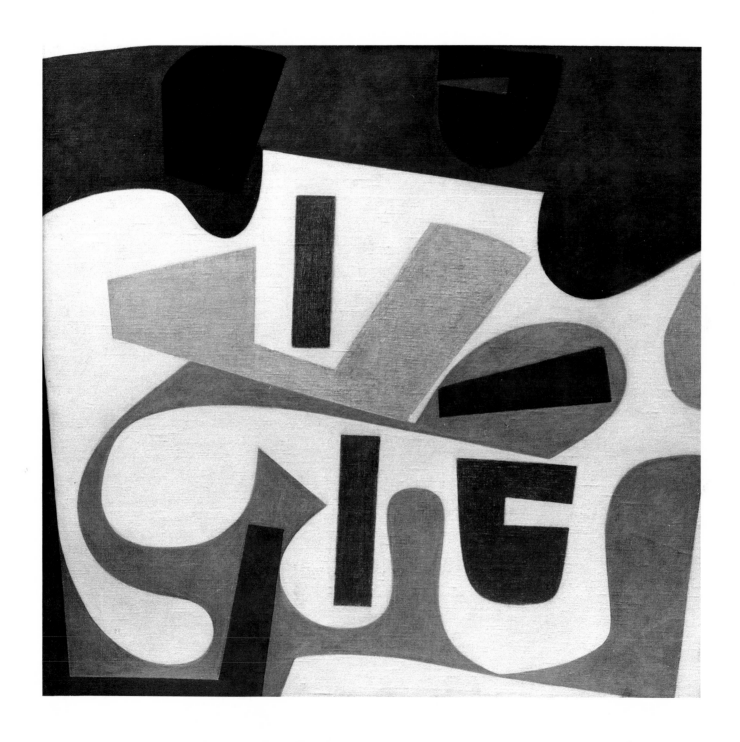

LITTLE DULUTH. 1959–60. Oil on canvas, 55 × 55″. The
Solomon R. Guggenheim Museum, New York

Opposite: BIG DULUTH. 1959–60. Oil on canvas, 85 × 50½″.
Tweed Museum of Art, University of Minnesota, Duluth

of violence and peace. Barnet saw landscape as an arena for working out private mythologies about the forces of nature and their existence as universal truths and values. He implicitly encouraged speculation about a higher spiritual order inherent in the vast spaces of the land, water, and sky, letting his ambitions surge toward a content that verges on the exalted.

Another request to teach during the summer of 1963 took Barnet to Spokane, Washington. A waterfall near the city later became the subject of a painting entitled *Impulse*, 1964, which locks the power of the rushing water into a tightly controlled arrangement of attenuated geometric forms. The tension of forces held together by a repetition of vertical forms is repeated in the painting and print *Compression—Spokane*, 1964. *Great Spokane*, 1965, is a picture about action, expanding and contracting forms, shifting masses, line stretched to a breaking point, all suggesting an organism continuously unfolding itself into a new state

Opposite: GOLDEN ANGULATION. 1965. Oil on canvas, 51¼ × 42¼". The Whitney Museum of American Art, New York. Gift of Mr. and Mrs. Leonard S. Field

COMPRESSION—SPOKANE. 1964. Oil on canvas, 51½ × 81". The Solomon R. Guggenheim Museum, New York

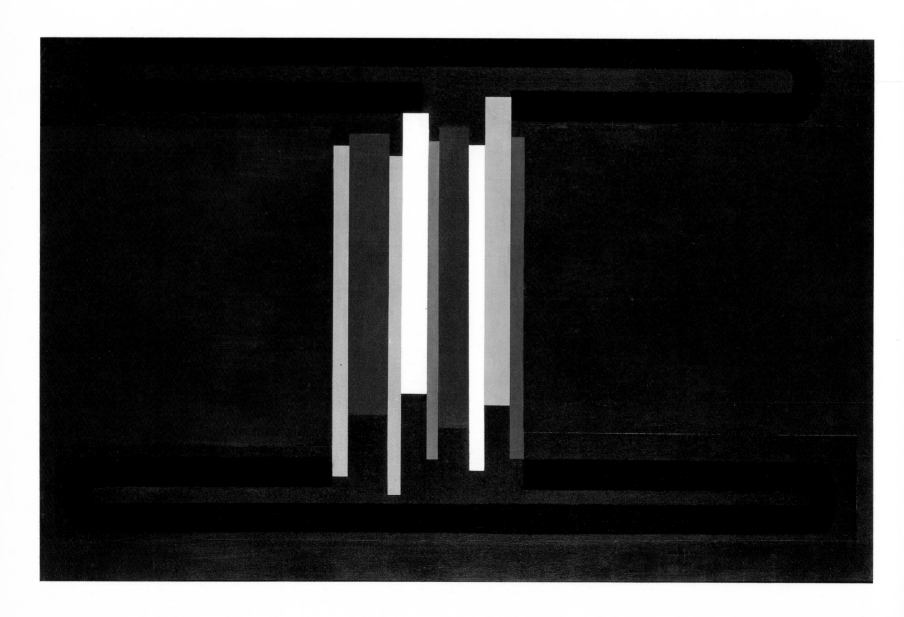

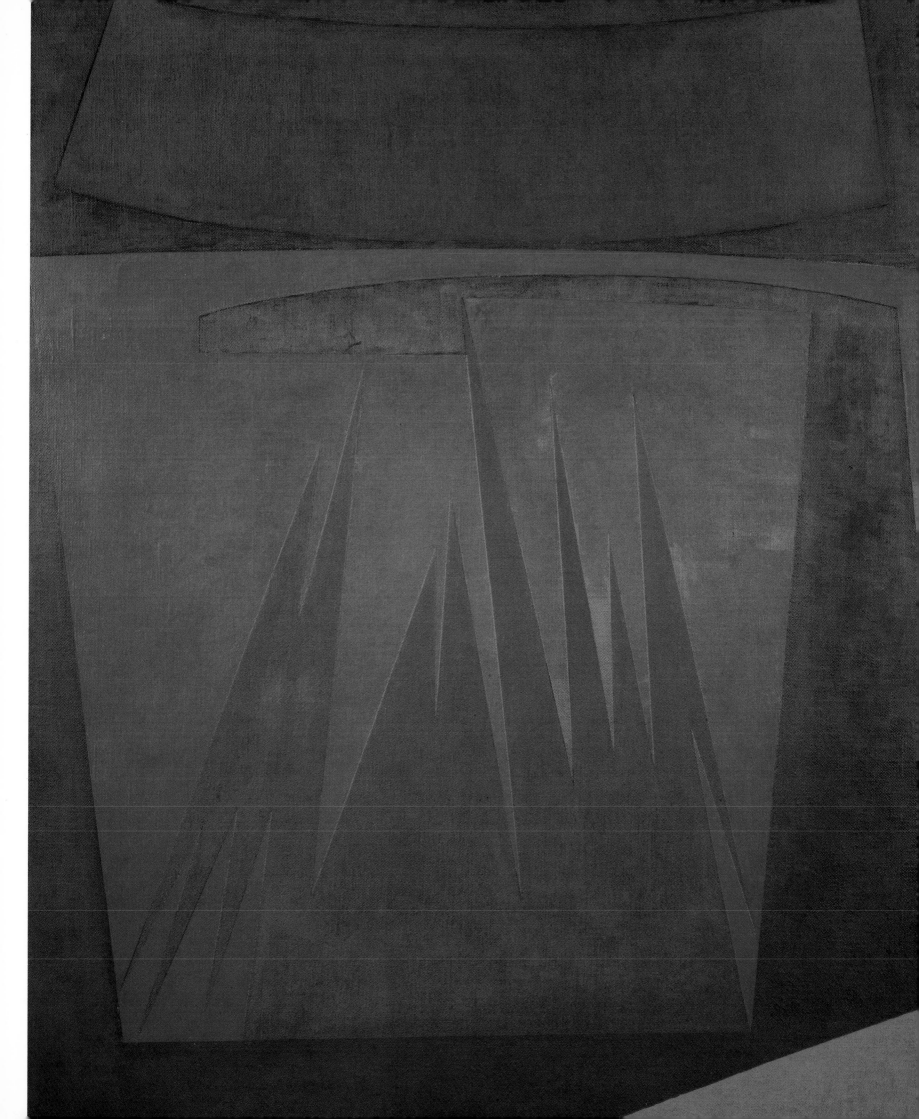

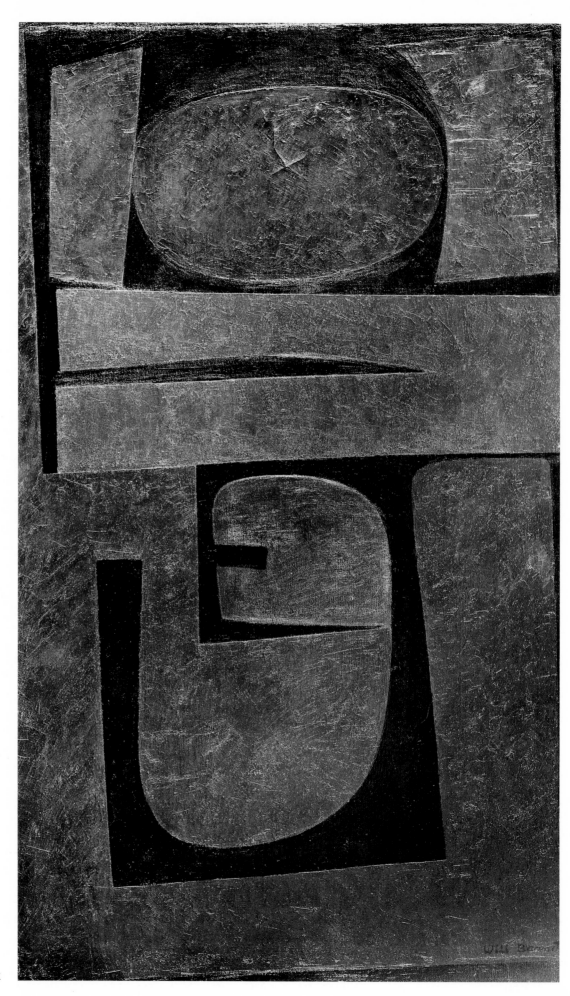

DARK IMAGE. 1960. Oil on canvas,
56½ × 34". Collection Mr. and
Mrs. Maurice S. Polkowitz, New York

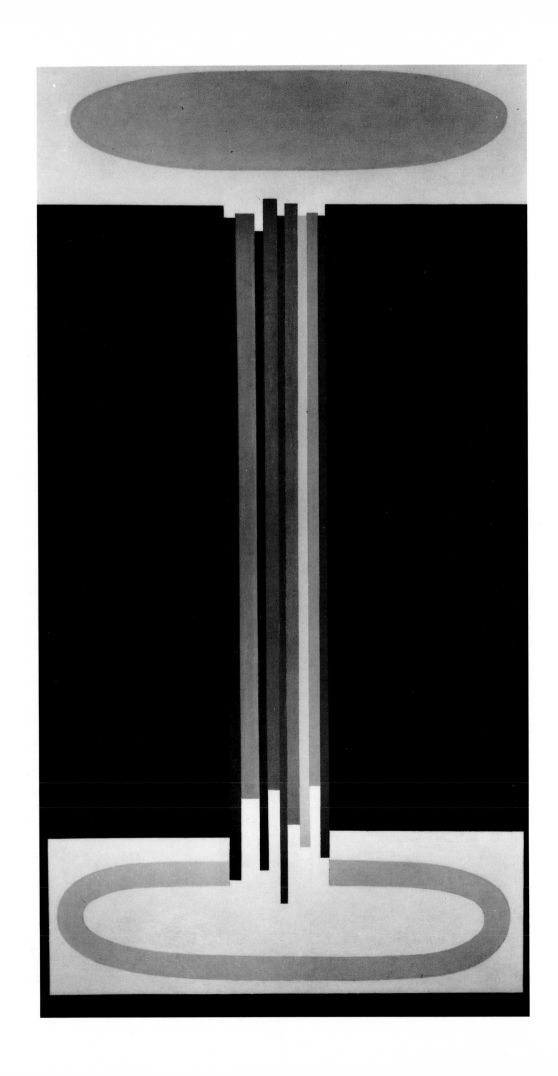

IMPULSE. 1964. Oil on canvas,
70 × 38″. Private collection

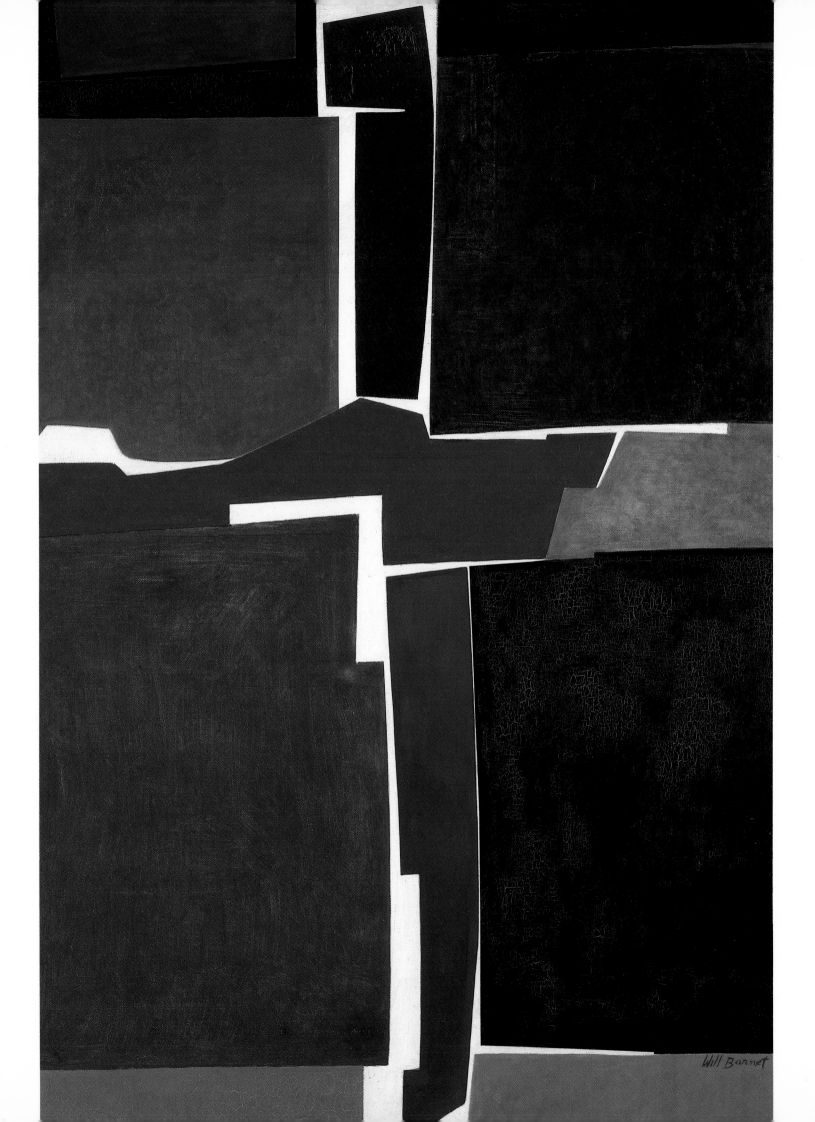

of being. Barnet was still searching for the meaning that lies hidden beneath things seen and felt, and was still determined to express his discoveries and revelations in terms of form and color.

His ventures in abstraction culminate in paintings and prints distinguished by precisely contoured forms that are reduced to their fundamental significance. The juxtaposition of the forms is crucial to the decisions governing their shape and size, and the placement is treated with the utmost delicacy and care. These are images resulting from emotions active over a long period of time, which were held in check and in balance until the decisive moment when every part came together as a whole. Painting was a slow, painstaking process. "If I paint something," Barnet wrote in 1962, "I want it to feel as if it had never been painted like that before. The evolution of what I think is a vital form may have elements that relate it to the past, but it is used in such a way that it becomes a new and fresh experience. . . . It stirs my imagination. . . . The fact that it takes on another physical reality, which is just a simple painting form on a flat surface, stimulates the whole possibility of a new world, of new things that I've never felt before or seen done this way." Barnet was now a master of the abstract statement, selecting subdued and exquisite colors, perfecting the positioning of unique forms, arranging the whole on the canvas, creating images of a personal vision which rank with the best of their time.

Much of the new work was shown at Bertha Schaefer's gallery early in 1960. The critics were laudatory. In *Art News*, Lawrence Campbell discussed the paintings done between 1958 and 1960:

> *Will Barnet, well-known teacher, painter and print-maker, continues to place his forms as though he were laying down cards on a table, adjusting them and arranging them to exact niceties. These contrasting shapes make unities of opposites: thick-thin, cool-warm, fat-lean, male-female, light-dark. In his most recent paintings he has moved into new regions. He simplifies his colors to a range of ochers and greys. His forms are now a few massive, textured ones, like slabs of granite. These contrast with playful, almost collage-like forms. The first in this new series is called* Night, *a most successful painting, and it is hard to suppose that the others could be any better, but they are.* Whiplash, Multiple Image, Singular Image *and* Big Grey *are exceptional. . . .*

In the *Christian Science Monitor*, Dorothy Adlow wrote: "Experience, practice, profound reflection characterize the paintings of recent vintage by an eminent American artist and teacher, Will Barnet (Bertha Schaefer Gallery). There is a typical core in these seemingly total abstractions that are developed in a painstaking manner. Edges are clean, virtually cut. Planes of color tilt, turn, overlap, separate slightly to allow flashing light to break through. There is a silent grandeur, a hidden magic in these depictions in which color modulations are realized with exceptional sensi-

Opposite: SINGULAR IMAGE. 1959.
Oil on canvas, 68½ × 46".
Private collection

65

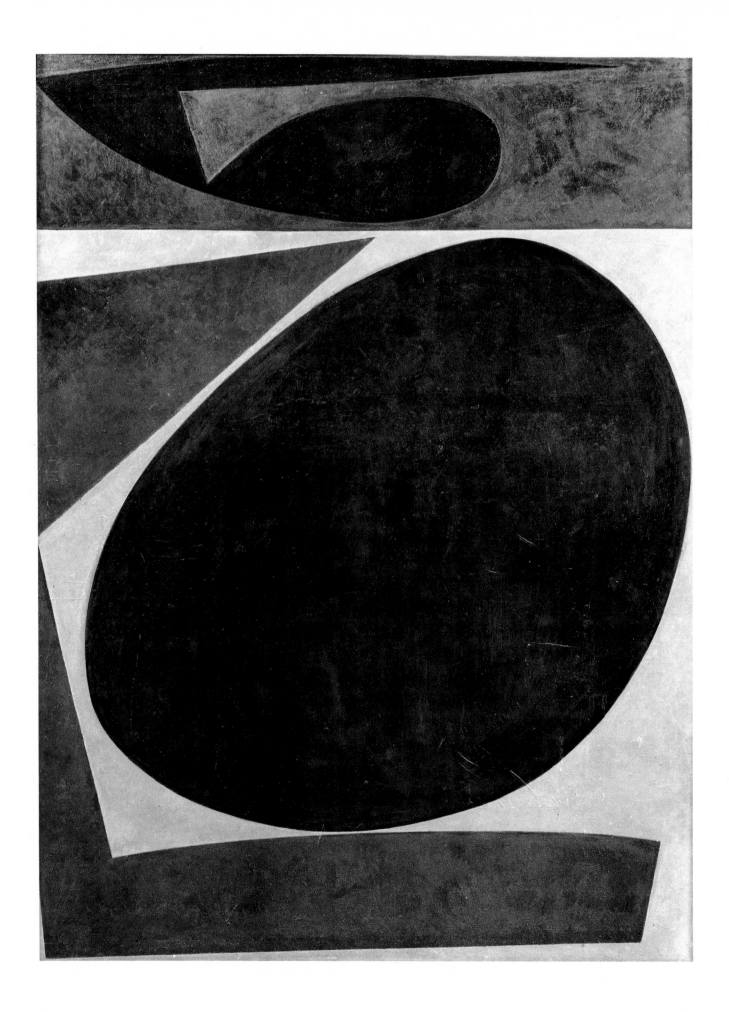

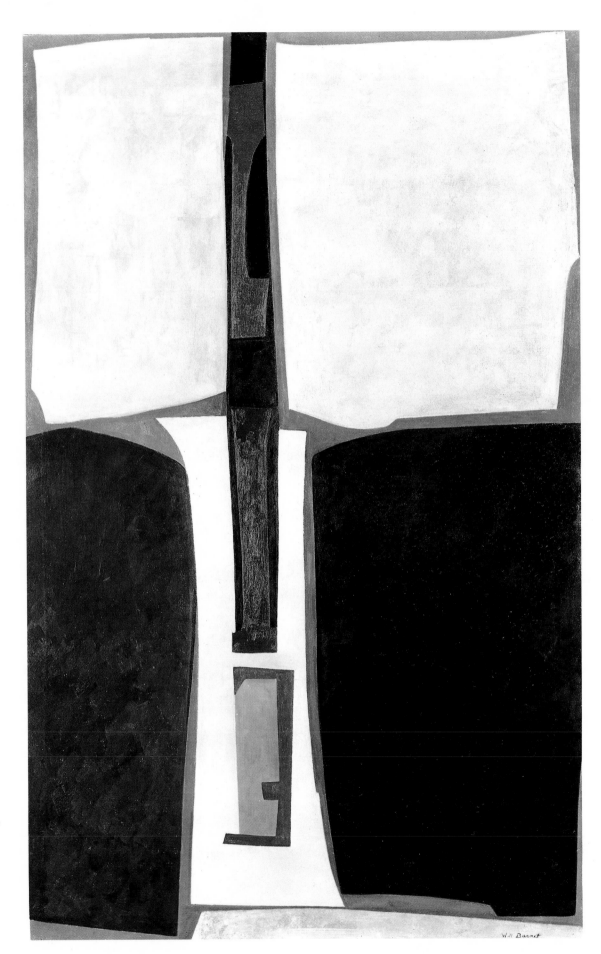

Opposite: POSITANO. 1960.
Oil on canvas, 57 × 42⅛″.
National Museum of
American Art, Smithsonian
Institution, Washington, D.C.
Gift of S. C. Johnson and Son,
Inc.

GOLDEN TENSION.
1959–60. Oil and gold leaf on
canvas, 64 × 39⅞″. The
Museum of Modern Art, New
York. Gift of Dr. Jack M.
Greenbaum

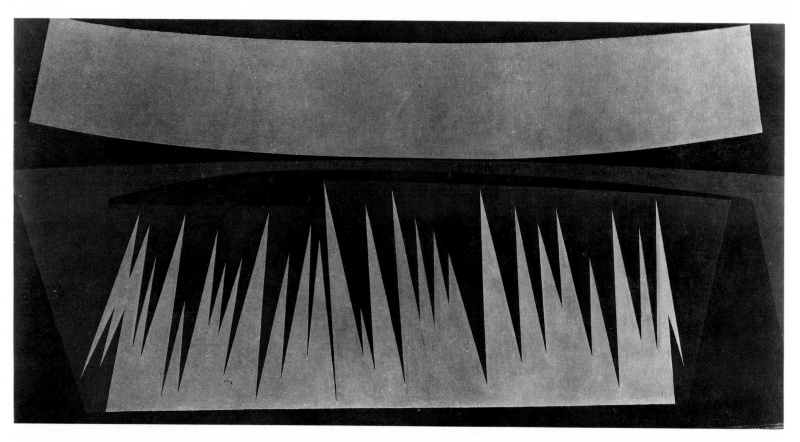

GREAT SPOKANE. 1965. Oil on canvas, 48 × 95″. University Art Museum, University of California, Berkeley

tiveness.'' Such praise was hard earned. The very deliberate, conscientious manner in which Barnet worked, the ever present self-criticism, the demands on his time from teaching, all served to limit his production. His pictures are monuments to his dedication and perseverance in the quest for values and meaning in what his eye perceived and his spirit conceived.

He was still dependent on the outside world for his subjects, but now they were summations of his personal and aesthetic experience, as though a life could be distilled into a day. Barnet's work always started with a particular personally important or moving experience, which was synthesized by his creative powers so that the particular was transformed into the universal. *Multiple Image I*, 1959, *Big Grey*, 1959, and *Singular Image*, 1959, all began as sketches and studies of the human figure. Over a period of several months, proportions and priorities changed. The forms and the structure continued to dominate the representational. Barnet realized that his attempts to make realistic images lacked freshness, newness, imagination, and directness. By relying on a certain austerity in the handling of form, he brought a firmness and a sharpness into the picture. Although it was not yet evident, Barnet was coming to a crossroads. He had solved many of the formal, stylistic problems in the path of the contemporary painter but he was unsatisfied. He wanted to make pictures about people, but without resorting to the traditional means. It was time for decisions about his art and directions for the future.

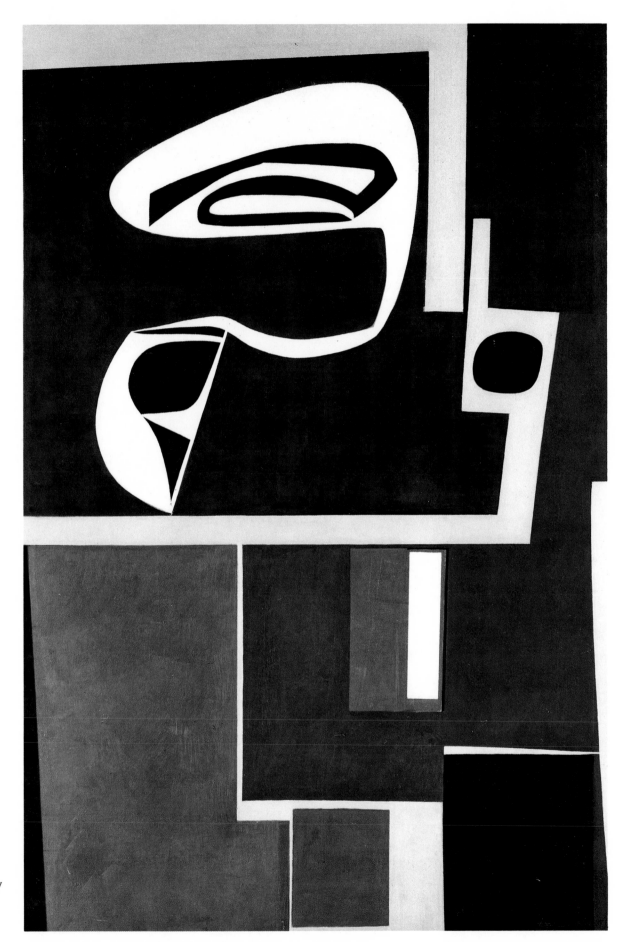

WHIPLASH. 1959. Oil on canvas, 62 × 41". Courtesy of the Pennsylvania Academy of the Fine Arts, Philadelphia

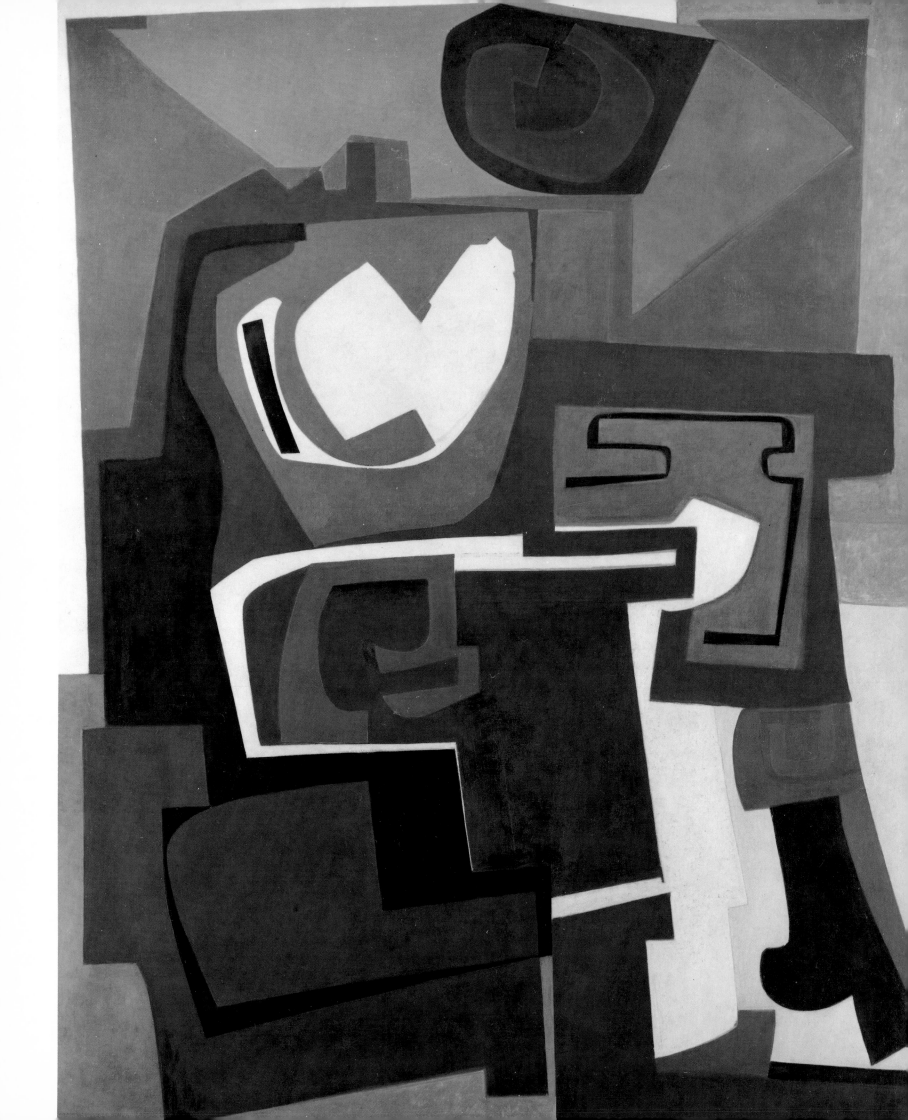

V NEW IMAGES
OF THE FIGURE

V NEW IMAGES OF THE FIGURE

For Barnet, from the beginning of his career to this day, the human figure has been a primary source of image content. A fascination with people, the family in particular, has consistently informed and inspired his art. His friend and biographer Una Johnson noted, "Barnet's personal life and his professional life are deeply entwined—one cannot exist without the other. Barnet has never found it feasible to maintain a studio outside the confines of his family quarters. He has always gained inspiration in the milieu of children growing up among the pleasant confusion and color of a succession of parrots, tropical fish, sedate cats and the exotic greenery of a variety of flourishing plants."

By 1960, Barnet could no longer think of the figure as a realistic object; the form held too many connotations of abstract symbols. Attempts to bridge the gap between realism and abstraction failed. Pictures that started as drawings of his wife, child, and cat ended as conceptions of form and structure. But the old desire to emulate Daumier and Rembrandt was still potent, the possibility of dismissing human beings altogether too disturbing. His quandary lasted for several years as he sought a combination of abstraction and figuration.

In 1962, Barnet exhibited a new series of paintings which achieved a balance between the formal characteristics of abstraction and the familiar representation of the human form. One of the early solutions to the problem was a painting entitled *Mother and Child*, 1961. First there had to be a resolution of the universal meaning in the picture. In a 1968 interview with Paul Cummings, Barnet explained what he had been seeking:

I wanted to present a modern version of a mother and child. It meant that I had to see the truth of our day which meant what was a child like? How do we look at children today? And how do children relate to their mother? I am not thinking of it in a literary sense, I am thinking of it as a plastic, image sense. So I created a woman on a couch—my daughter with my wife sitting on the couch, very abstract of course, you practically cannot see the

Preceding page: MULTIPLE IMAGE I.
1959. Oil on canvas, 62¼ × 48⅛".
The Corcoran Gallery of Art,
Washington, D.C. Museum Purchase,
Anna E. Clark Fund

71

couch. You just feel that it is there. And my daughter next to her but not connected in the sense of the old-fashioned picture with the mother holding the child and nestling it. Here were two distinct personalities. There was a certain attachment between the child and the mother by the way I juxtaposed her form on the right side and the mother on the left where the child is isolated in a sense. The mother is also isolated. It was a contemporary view—each individual has its own identity. . . .

The psychological implications are strengthened by the clarity of the forms, which were made by taking great liberties with the shapes of the figures. These become flat planes; the space they occupy is exceedingly compressed. There is no modeling or texture; colors are generally applied evenly and without modulation. Although the forms are flat, hard-edged, and carefully located on the surface plane of the canvas, the overall effect is one of fidelity to a common understanding of the shape and substance in the human form. Because of his background in the language of contemporary art, Barnet arrived at his own personal solution to the problem of presenting the human figure in modern terms.

Barnet has a singular ability to bestow order, stillness, and lucidity on scenes and things that are in continual flux by reconciling forms and emotional content and balancing the elements that are in themselves the structure of the picture. He saw the new paintings as figurative images abstractly conceived. *Singular Image,* 1959, and *Sleeping Child,* 1962, are both arrangements of perpendicular and horizontal forms. A solid background and the flat, planar nature of the forms suppress realistic dimensional space and allow the forms to act on a single frontal plane, with specific reference to the edges of the canvas. *Singular Image* is about strong forces held in check by their own presence and position. *Sleeping Child* pays homage to the dignity and beauty of the human figure. A passing moment becomes an eternity.

The new paintings of the figure were shown in Boston during 1963. The critic Robert Taylor wrote:

In their patterns, these pictures recall the designs of Japanese printmakers. Their sense of space and asymmetry, of unbroken contour and color groupings, eliminates, organizes and compresses. The closest American equivalent, perhaps, is Milton Avery but only in terms of approach. The artist employs a single color motif, usually: the gray, cool tones of "Maine Light," the tropical intensities of "The Red Robe," and the tans of "Double Portrait." Paint is applied thinly, the areas of dark and light unmodulated, the flat silhouette making a vivid contrast of form. Yet the surfaces have a warm vibrancy and the rhythms of the stylized figures create mysterious relationships of gesture, amiable movement of line. They are paintings that delight the eye even while the figurative subjects convey reverberant ambiguities of emotion.

Opposite: MOTHER AND CHILD.
1961. Oil on canvas, 46 × 39".
Private collection

72

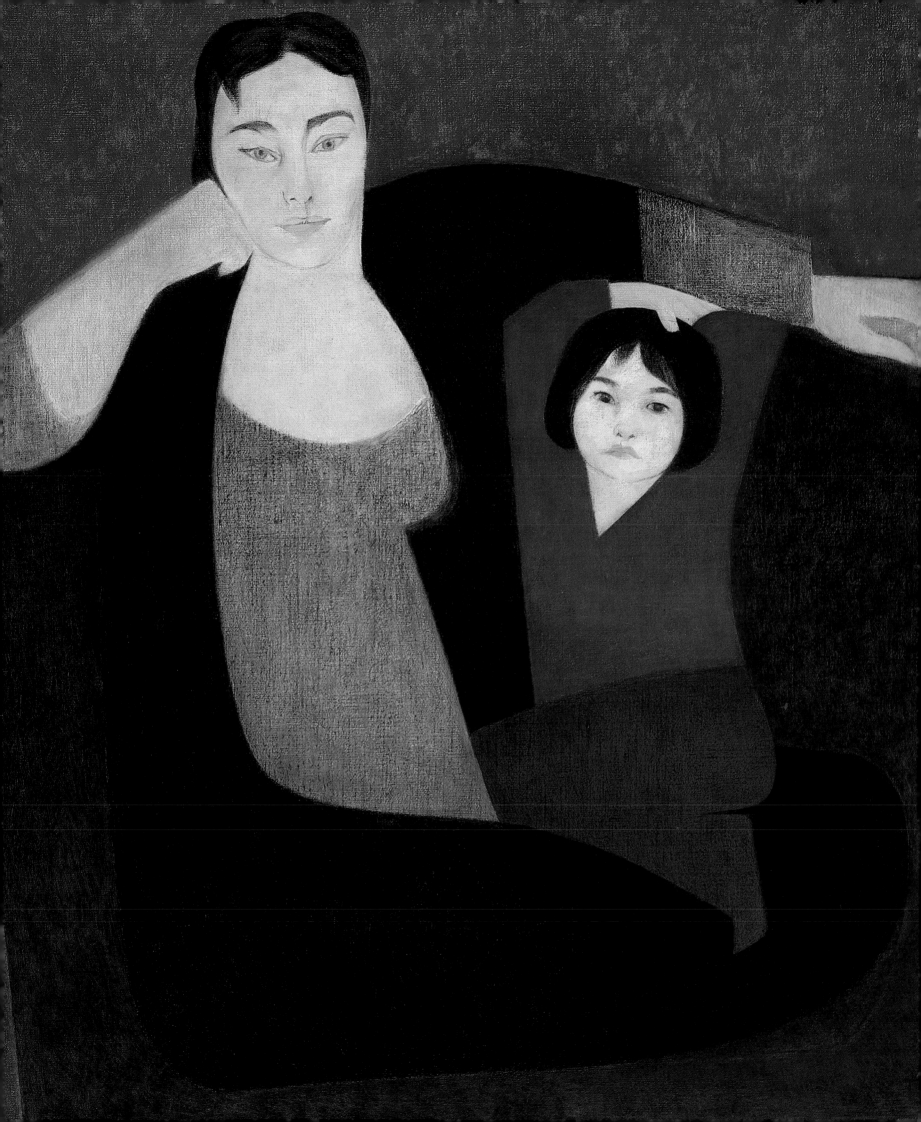

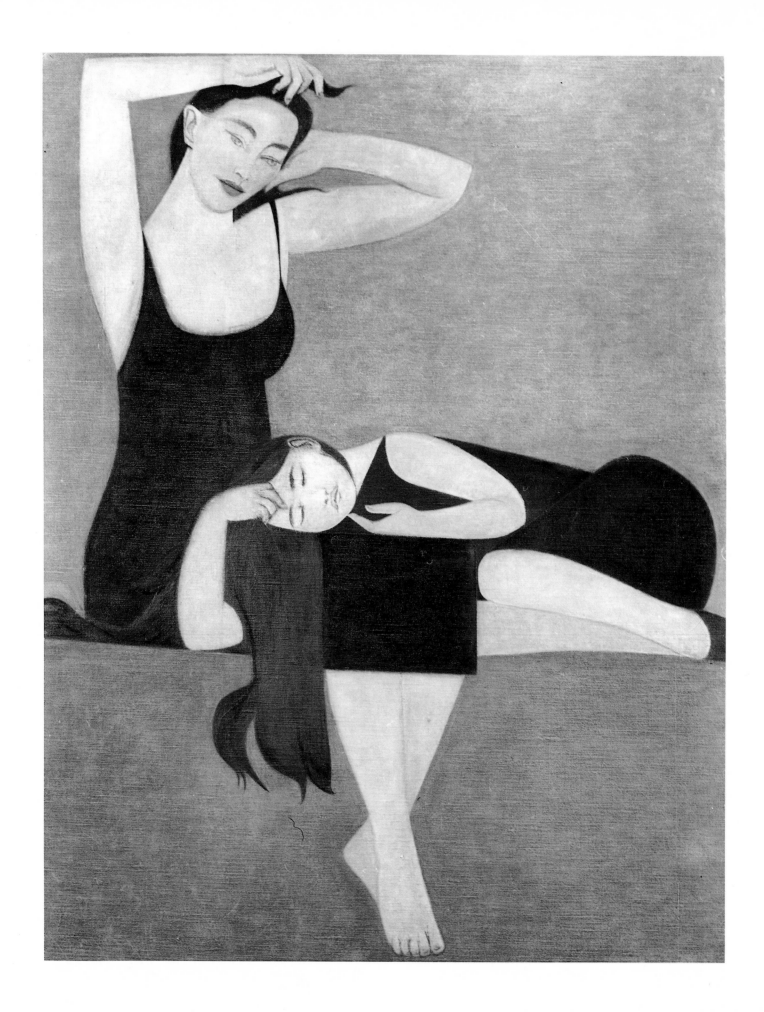

By again admitting the image of objective reality into his art, Barnet returned to the values of a common experience. It was a decision of great benefit to him and to American art.

Just as his abstractions were derived from specific experiences, Barnet's pictures of the figure are based on portrayals of real people. Although not intended as such, pictures such as *Mother and Child*, 1961, and the many individual images in which he used Elena and Ona as models stand as one of the most remarkable collective portraits in the history of art. Despite the reductive nature of abstraction, the figure paintings are highly descriptive of the people represented. Portraiture,

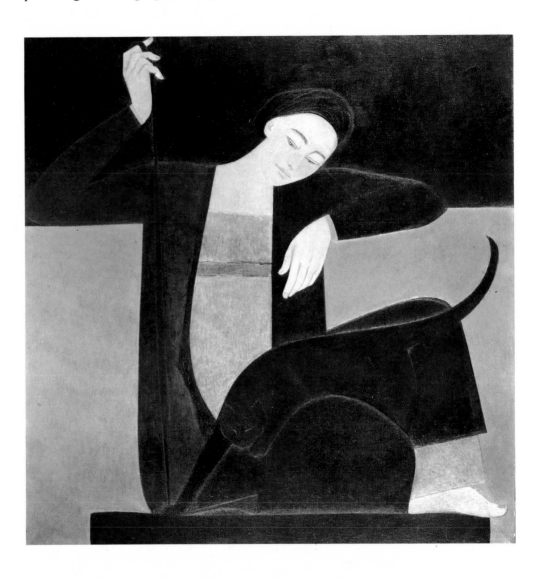

Opposite: SLEEPING CHILD. 1962. Oil on canvas, 64 × 50″. Sara Roby Foundation Collection

WOMAN, CAT AND STRING. 1962. Oil on canvas, 52½ × 51½″. Collection Mr. and Mrs. Maurice S. Polkowitz, New York

once a major concern of artists, had by midcentury lapsed into a formula practiced by fashionable specialists. The exceptions seem to be the works of painters whose broader accomplishments brought them the security or confidence to offer more than a mere flattering likeness of the sitter. Barnet was a penetrating observer who looked at family and friends with a regard that, while affectionate, was invariably direct and honest. He began to do portraits of friends and colleagues, vivid and of-

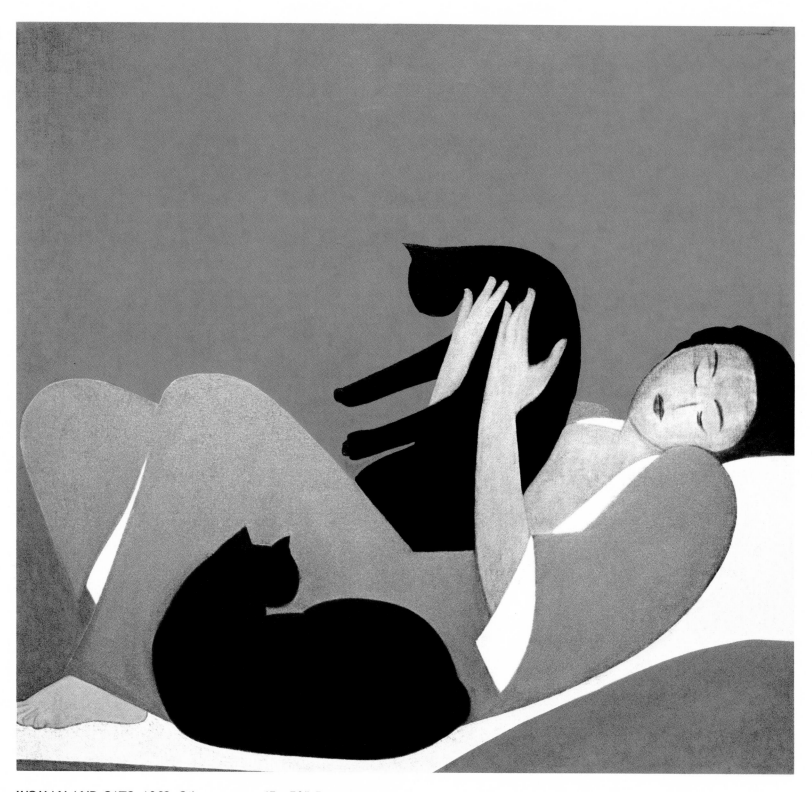

WOMAN AND CATS. 1962. Oil on canvas, 45 × 50″. Private collection

Opposite: THE BLUE ROBE. 1962. Oil on canvas, 50 × 54″.
Private collection

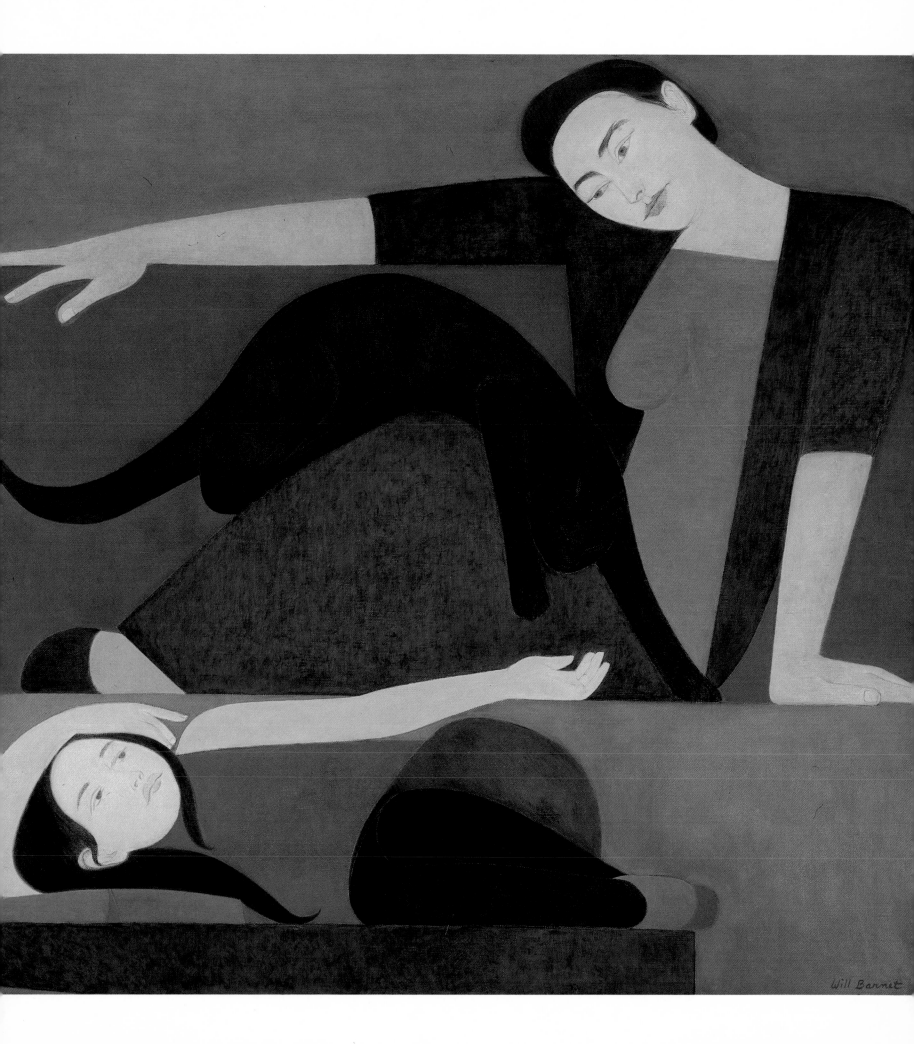

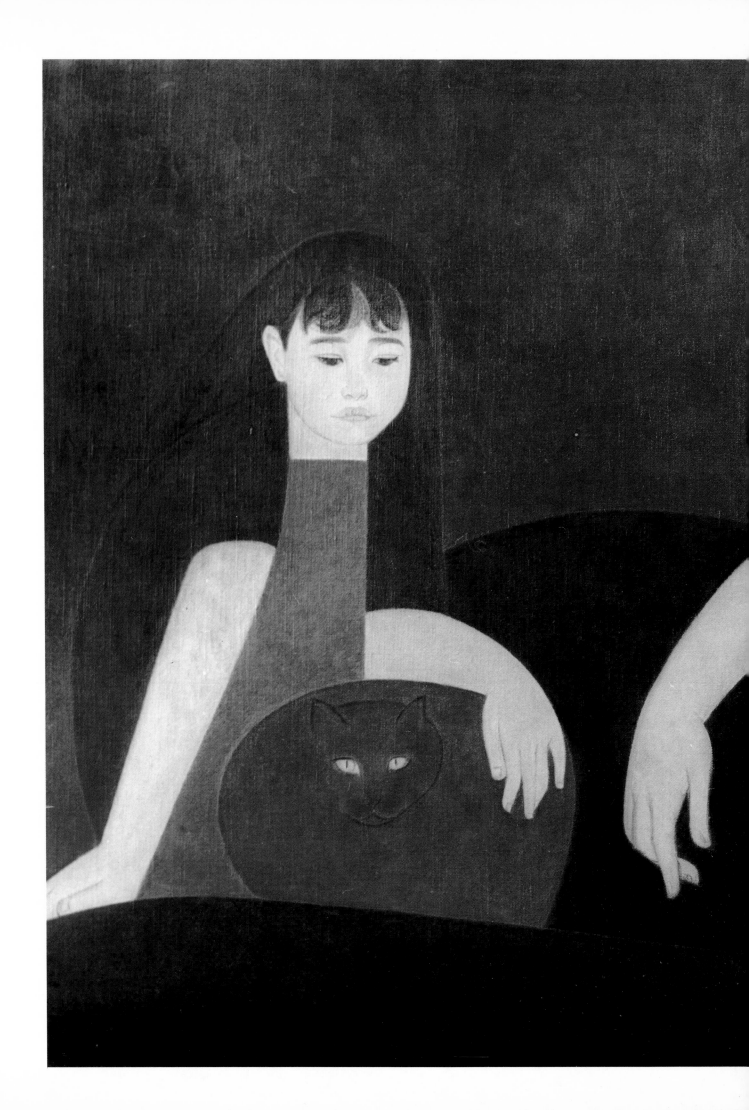

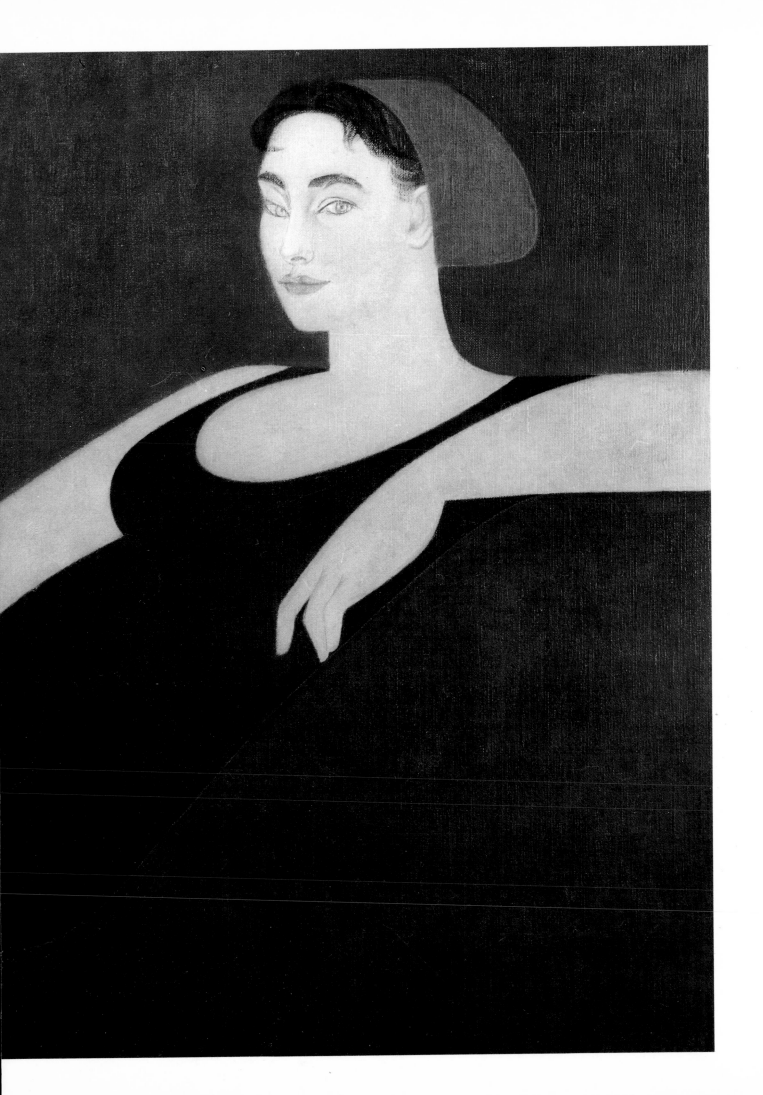

GRAY
HORIZONTAL.
1961. Oil on
canvas, 44 × 68″.
Private collection

ten intense penetrations of character made while working within the canons of his own particular style, which sprang from the methods of abstraction. For the catalogue of an exhibition at the Grippi and Waddell gallery, New York, in 1966, he wrote:

In this new group of paintings, those considerations which have impelled me to work abstractly for the past decade are present— though with a shift of focal reference. I see no ambivalence in the fact that the human figure has either been profoundly trans- formed, or transposed, with closer reference to its original struc- ture. There are no so-called "humanistic" rationalizations for the present change in my work. My interest has been in developing further the plastic convictions that have been evolving in my ab- stract paintings; so that a portrait, while remaining a portrait, be- comes in this sense an abstraction: the idea of a person in its most intense and essential aspect.

Barnet never made a picture with the intention of simply conveying infor- mation. Every image he created was the result of an act of the will, the assertion of very definite principles concerning a structure that evolves through the proper relation of size and form. But his portraits, which fol- low the same principles and do not attempt to emulate reality, are strik- ing characterizations of individual personalities. He posed Remi Messer seated in a chair, a white shawl around her shoulders and gathered in her lap. Her dress and the shawl become contrasting planes of light and dark; only the face and hands are drawn with reference to detail. It is a bold arrangement of line and form, but it is also an unmistakable portrait of an individual at a particular time.

It was impossible for Barnet not to respond to the subject as a per- son. His code as an artist was no greater than his affection and response to people as individuals. Henry Pearson is a close friend and fellow artist. Barnet shows him holding a painted sphere, which Pearson had made. The light face and hands, which are drawn with considerable attention to the long tapering fingers, contrast strikingly with the dark suit and back- ground. The face identifies Henry Pearson, while the prominence of the hands and the sphere denotes a person who creates unique objects. Barnet has captured the physical appearance of an individual and the dramatic spirit of his life as an artist. The allusion to the sitter's interests and the plain background are hallmarks of portraiture as it was practiced in America during the eighteenth century, a period and genre that Barnet as a youth had often encountered in the museums of New England. The austerity of the early painters suited Barnet's temperament and style, and he has spoken of his admiration for the portraits by John Green- wood, who worked in colonial America.

Thoughts about mortality and his own role in life prompted a self- portrait in 1966, which, Barnet said,

Opposite: PORTRAIT OF HENRY PEARSON. 1966–67. Oil on canvas, 40 x 32". The Metropolitan Museum of Art, New York

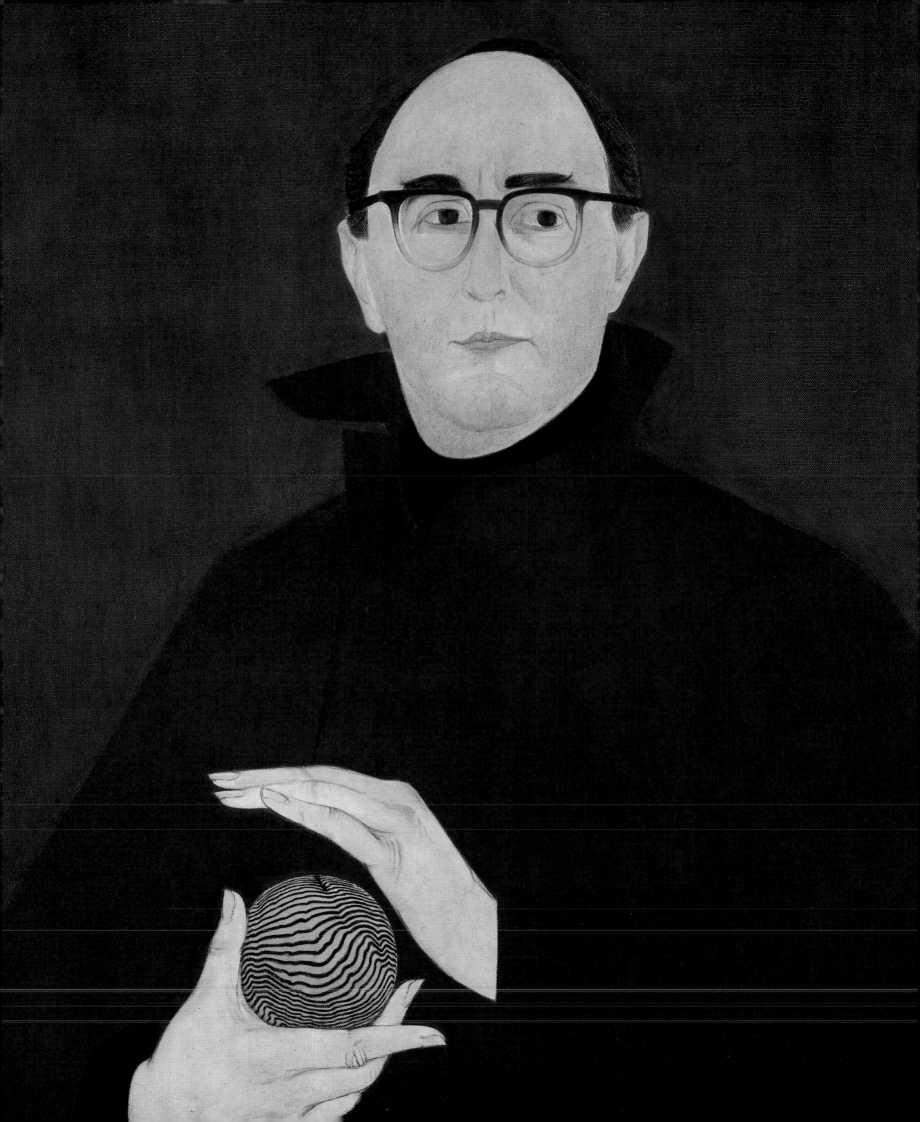

began as an emotional response to the death of my father-in-law in the early 1960s. My feelings for him and my sense of loss sparked the strong impulse to create a portrait responding to those feelings. Originally the painting was created in somber colors and with the same pose—my holding brushes and standing next to the canvas—as the present portrait. After completing the canvas I put it away for several months. When I saw it again I felt that it was incomplete and was dissatisfied with its structure and parts of the body, such as my arm coming down on the left side, which failed to explain itself. I then decided to begin a fresh canvas several inches longer but keeping the width the same as in the first painting. In lengthening the canvas I was able to add new imagery such as the cat which was not in the first sketch, the tabletop, the jar of turps, and, of course, lengthening the canvas within the canvas to its proper proportion in relationship to all other changes. The color mood changed from the somber earth colors to light grays, white, and pale tans, and there were also structural changes in the head and expression of the features from a piqued mood to a more robust one, so that the painting now assumed a more affirmative statement about life. It took me over two years to complete this painting in its present form as all the changes were developed slowly and with great consideration to the formal relationships that were needed in order to create an integral whole and to achieve my desire for a sense of monumentality.

The picture now hangs in the Museum of Fine Arts in Boston, in the company of the portrait by El Greco that Barnet had examined so closely and copied instructively as a young student.

Barnet's skill at visualizing emotional and psychological states is readily apparent in his portrait of *Kiesler and Wife*, 1965. As the scene is presented, the great visionary architect and sculptor is seated on a couch, which is also occupied by his wife, who is holding an apple. He is almost in profile, she is shown full face. He is small in stature, she is large in size. Barnet deftly shapes the play of opposites while remaining highly sensitive to the relationship between husband and wife.

The portraits grew richer, more complex as Barnet enhanced the "idea of the person" by placing the subject in his accustomed setting. He painted a portrait of the broker Roy Neuberger in his office. The architecture of the building satisfied Barnet's craving for structure and established the nature of the subject's working environment. Drawing on the portraits of Italian aristocracy in the Renaissance, Barnet painted the business executive "with a thrusting profile." Most of his subjects led active lives, but under Barnet's control they become part of a realm of serenity. If they have an interest that is a major factor in their lives, that too will be portrayed. The torso of an adolescent girl shares part of a canvas with the profile of Thomas Messer, art historian and director of the Solo-

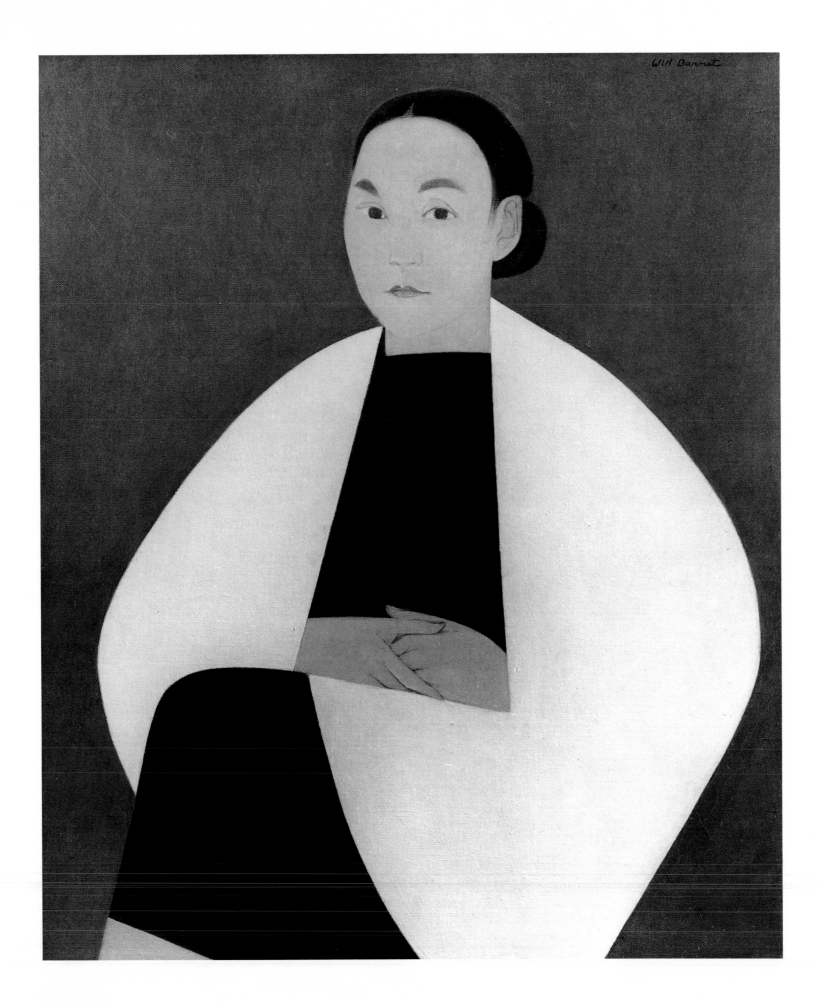

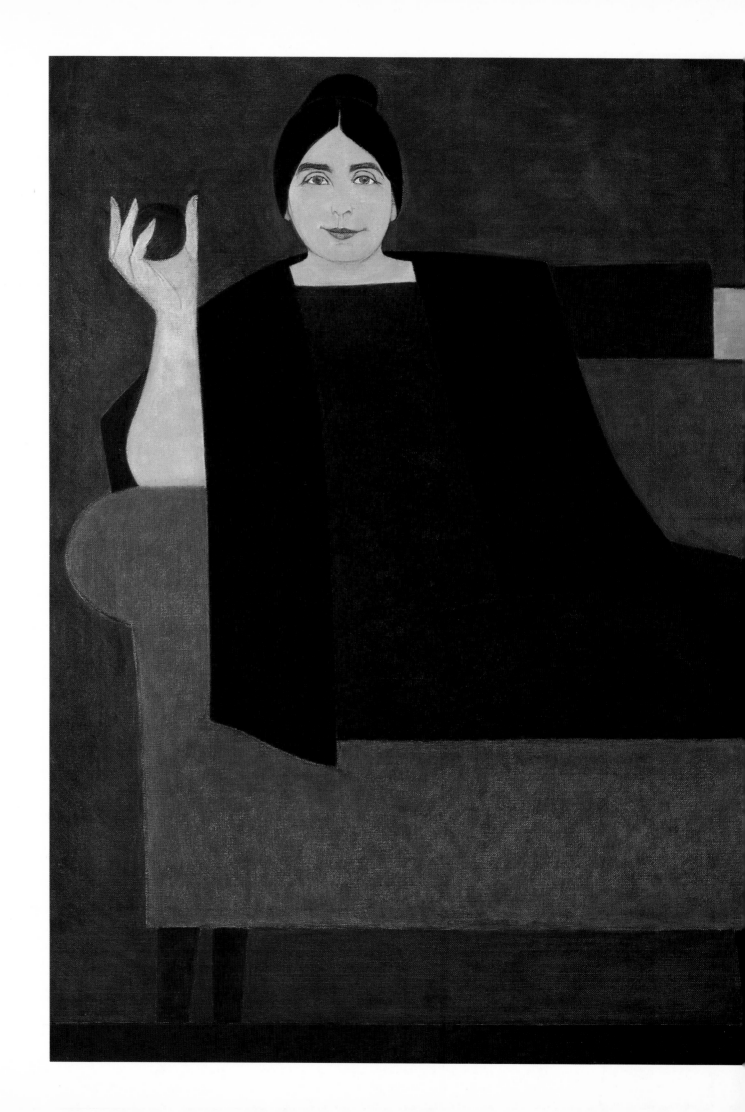

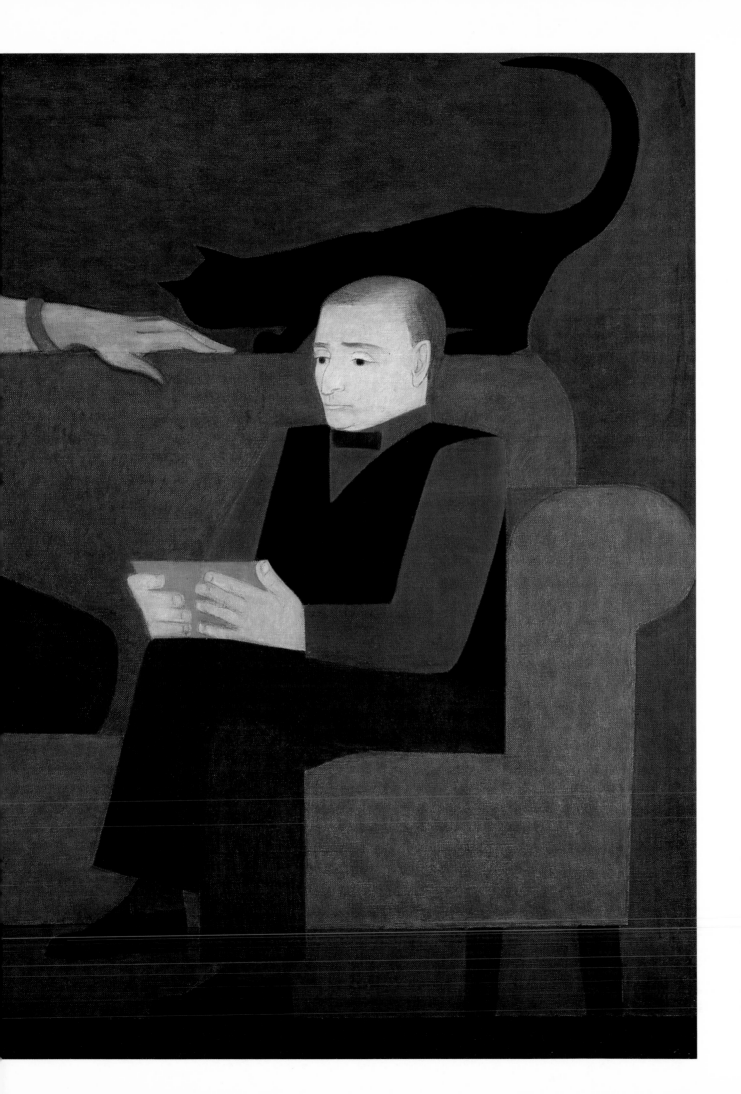

KIESLER AND
WIFE. 1965. Oil on
canvas, 48 × 71½″.
The Metropolitan
Museum of Art,
New York. Gift of
George A. Hearn
Fund and Roy R.
Neuberger

mon R. Guggenheim Museum. The girl is reproduced from a painting by Edvard Munch, an artist favored by Messer, who wrote a monograph on his work. The juxtaposition of the girl and the museum director is a triumph of composition and dramatic spirit. Almost two decades later, Barnet returned to the same motif for a portrait of the art critic Katherine Kuh. They shared an admiration of Fernand Léger's work, and so Barnet incorporated one of Léger's paintings into the backdrop for the features and an idiosyncratic gesture of Ms. Kuh. These incisive characterizations and associative symbols are visual biography at its very best. It is personal history that tells something of both the subject and the artist.

The appearance of a cat in Barnet's *Self-Portrait*, a camera that becomes an eye in the *Portrait of Djordje Milicevic*, 1967, a motorcycle in *The Three Brothers*, 1964, all herald a slow movement toward a new richness in Barnet's pictures. The rigorous dictums of structure and order are embellished with a new interest in architectonic forms and settings. The bannisters, mantels, and doorways of Barnet's residence in a turn-of-the-century building on the Upper West Side of New York become integral parts of the scenes that Barnet so carefully sets. Architecture constrains the space within the canvas and becomes part of the associative aspect of the whole. An atypical kind of color, lush and sensuous, pervades the work of the late 1960s and early 1970s. Space is compressed, unreal, and figures are generally placed so that they are viewed in profile, with contours defined by flowing line. Barnet painted numerous interiors populated by his wife, daughter, and cat, who seem to live a life of grace and domestic tranquillity, playing the piano or reading in an atmosphere of ambiguity and suspended time. They are representative of all wives and daughters, symbols of the human presence.

Barnet was steadily achieving an image that transcended the tangible world and opened the mind of the viewer to a communion with a poetic imagination. These pictures are fantasies rather than documentaries.

For an artist, there is a truth that has to do with re-creating the appearance of the real world and a truth that relates to making visual statements about the ideas and noble thoughts motivating human behavior in that world. In 1967, Barnet undertook a series of four related paintings that became an allegory of life in a changing world. The unchanging structure within the *Silent Seasons* is the architectural form of a window and a table. The window is a source of light from the world beyond, indicated by a tree glimpsed through the window. The personae of these pictures are a girl who leans on the table supported by her elbows and a parrot that maintains its station in a variety of positions at the upper right. The girl performs by smelling a flower, blowing bubbles from a pipe, contemplating a stack of books, and playing with the parrot. The variations in activity, objects, and color within each of the four pictures in the series denote the passage of time and the emotional impact of the seasonal shifts in light and atmosphere throughout the cycle of a year.

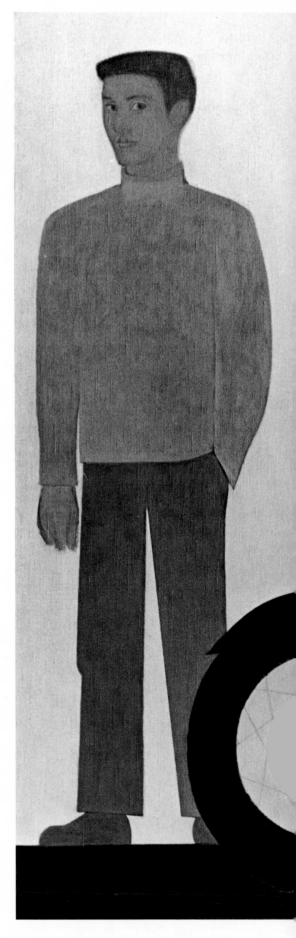

THE THREE BROTHERS. 1964. Oil on canvas, 58 x 72". Private collection

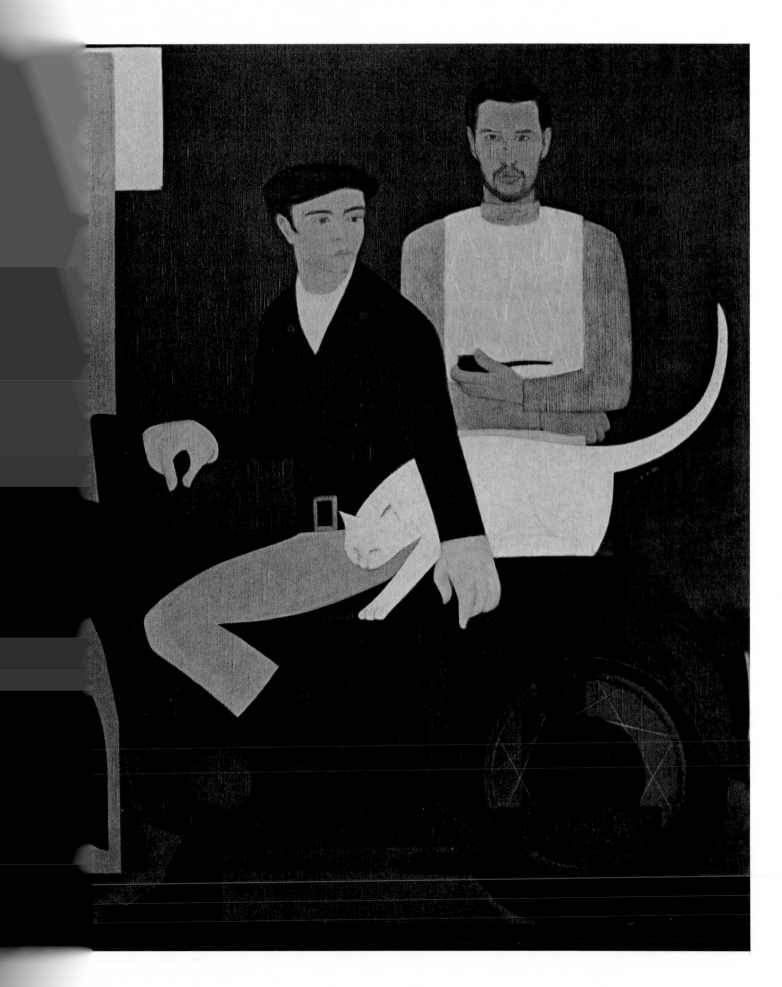

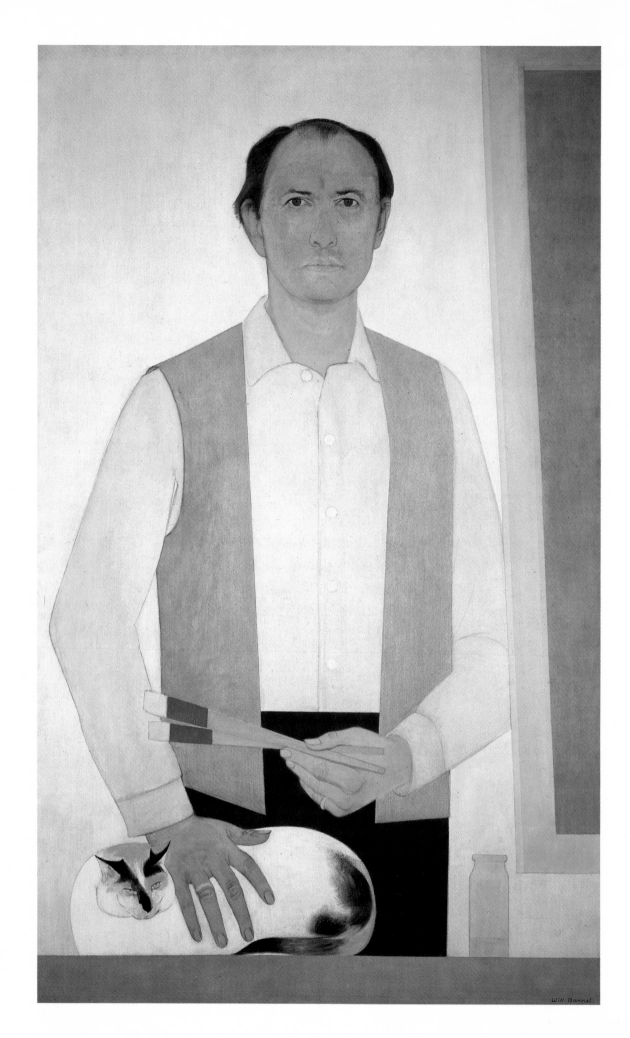

SELF-PORTRAIT. 1966. Oil
on canvas, 63 × 38".
Museum of Fine Arts,
Boston. Anonymous Gift

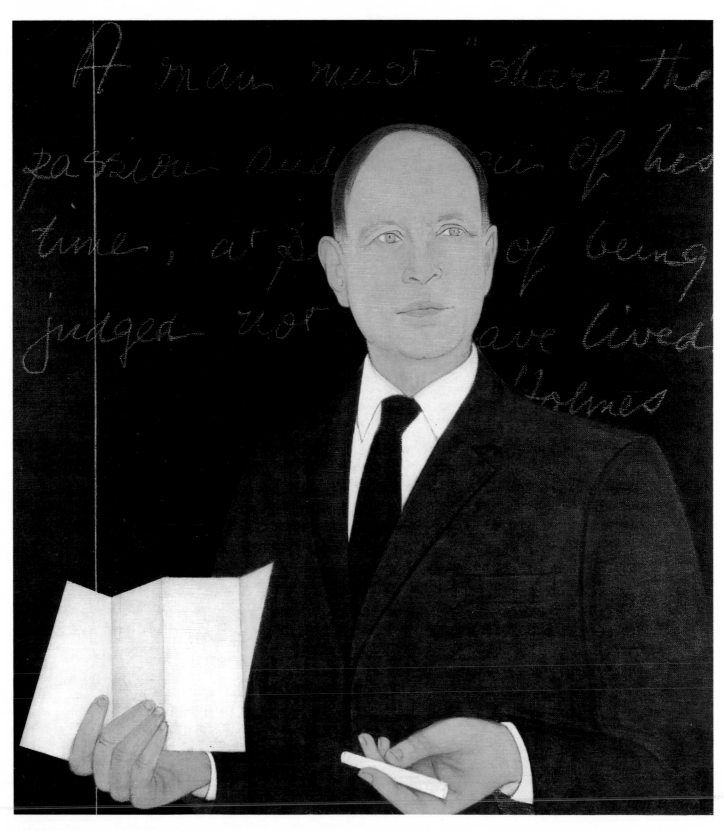

PORTRAIT OF PROFESSOR WALTER GELLHORN. 1970. Oil on canvas,
38 × 35". Columbia University Law School, New York

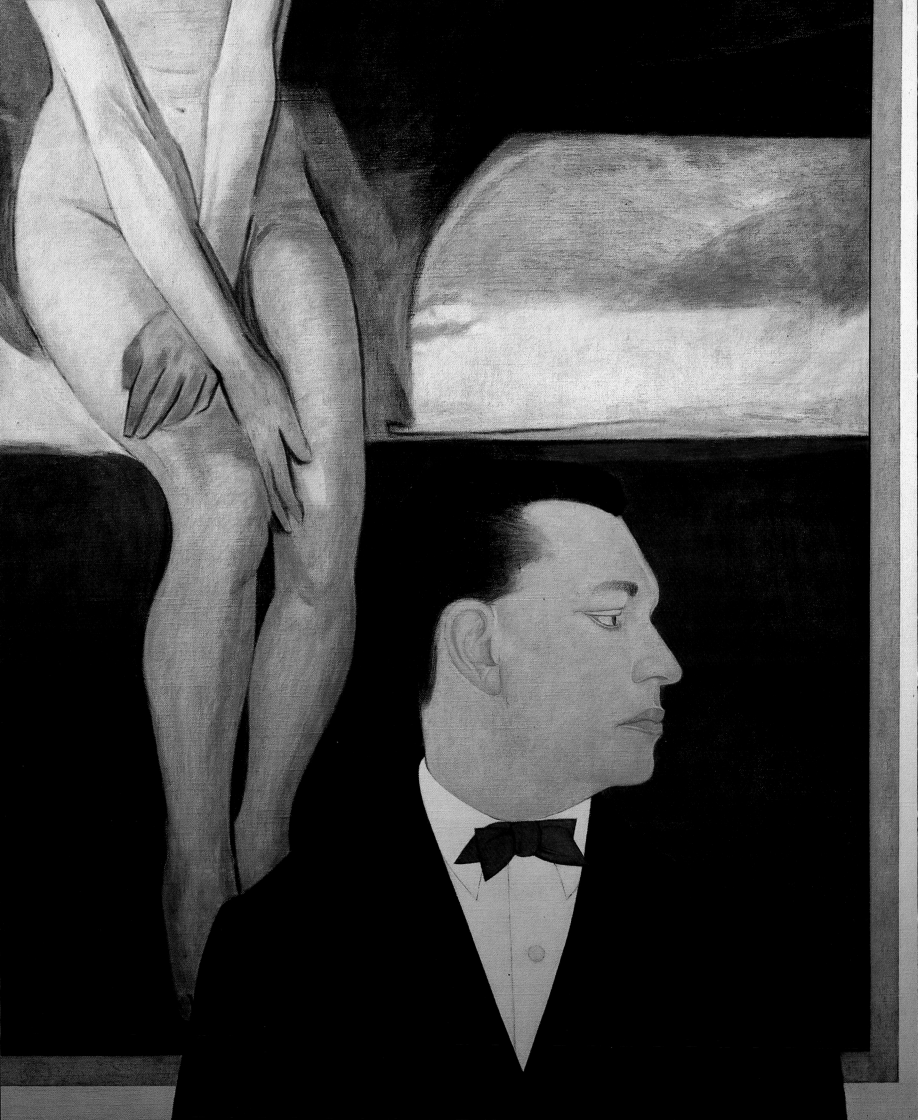

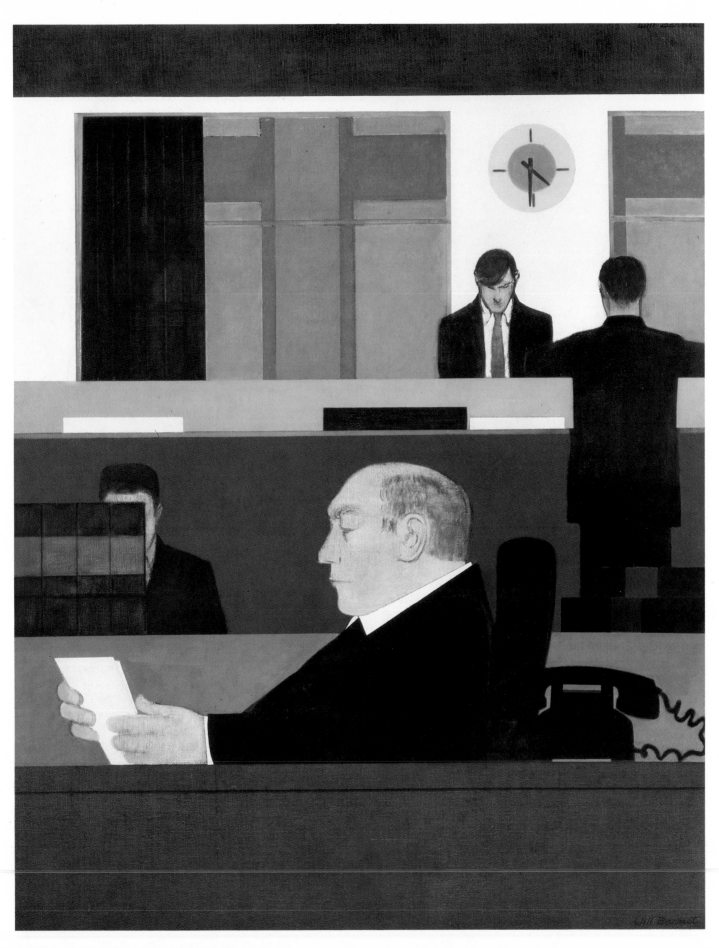

PORTRAIT OF ROY R. NEUBERGER. 1966–67. Oil on canvas, 53½ × 42½″. Neuberger Museum,
State University of New York, College at Purchase. Gift of Roy R. Neuberger

Opposite: PORTRAIT OF T. T. M. 1966. Oil on canvas, 64 × 33″. Collection Mr. and
Mrs. Thomas M. Messer, New York

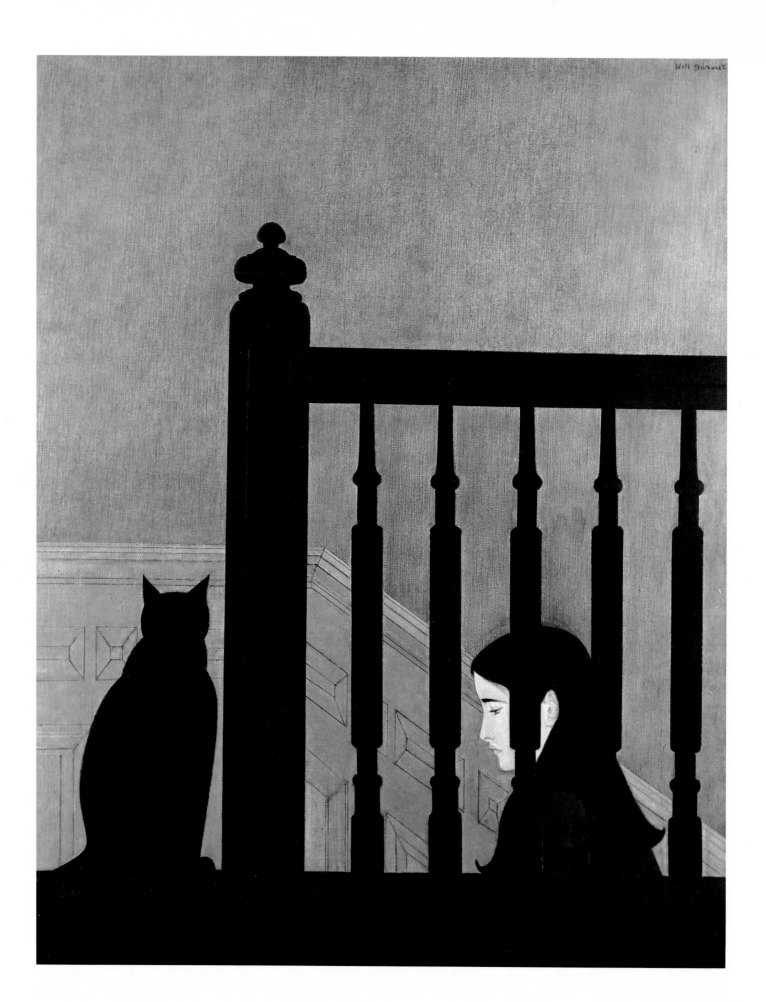

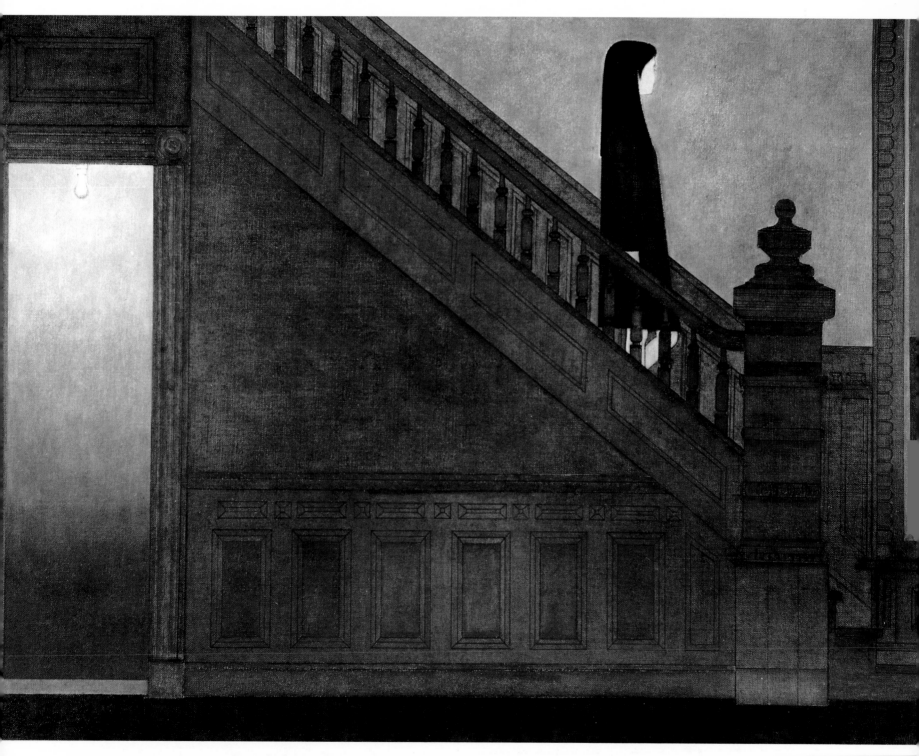

THE STAIRWAY. 1970. Oil on canvas, 47 ¼ × 66 ¼".
Private collection

Opposite: THE BANNISTER. 1970. Oil on canvas, 50 × 39 ¼".
Mead Art Museum, Amherst College, Amherst, Massachusetts

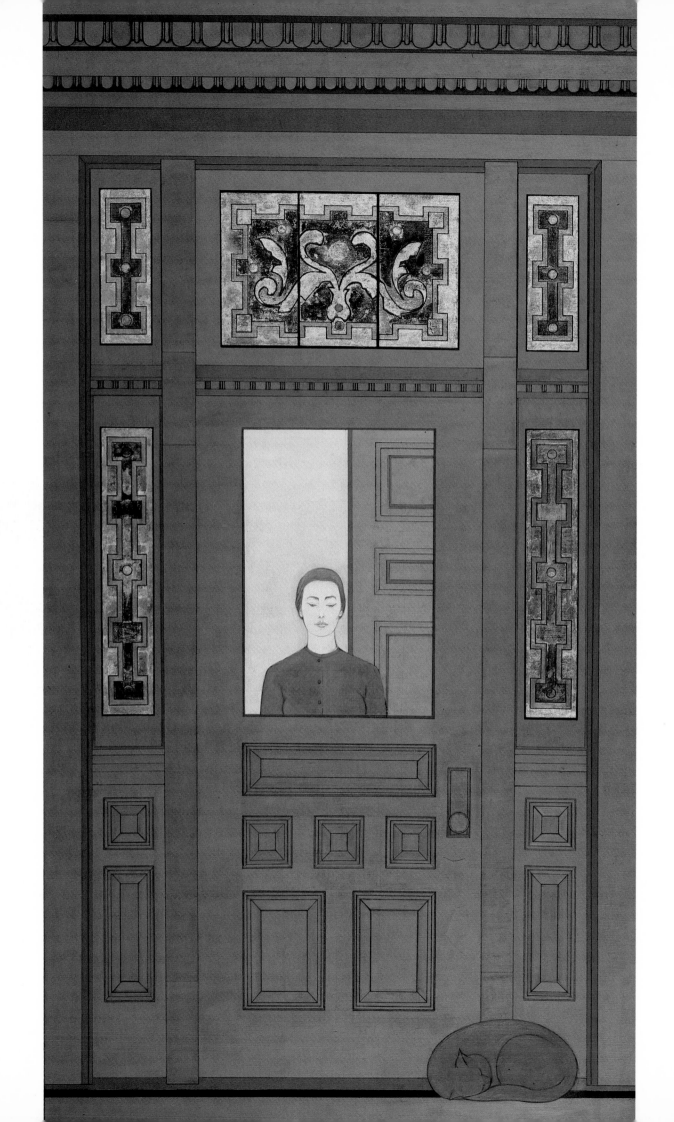

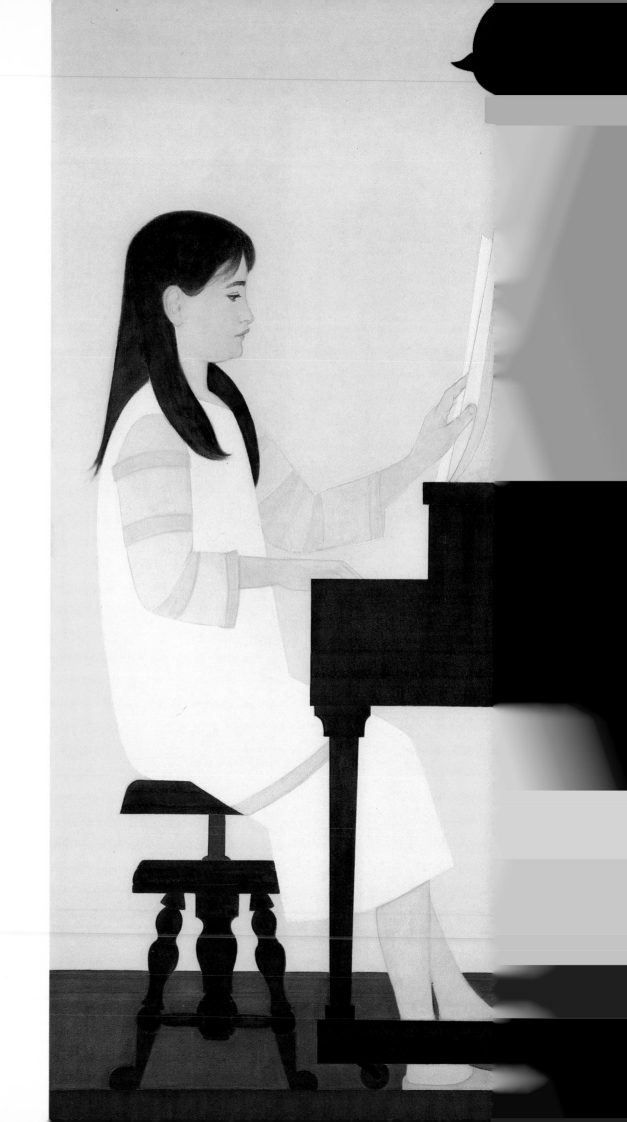

Opposite: THE DOORWAY. 1971. Oil on canvas, 95½ × 51″. Private collection

GIRL AT PIANO. 1966. Oil on canvas, 64 × 39″. Private collection

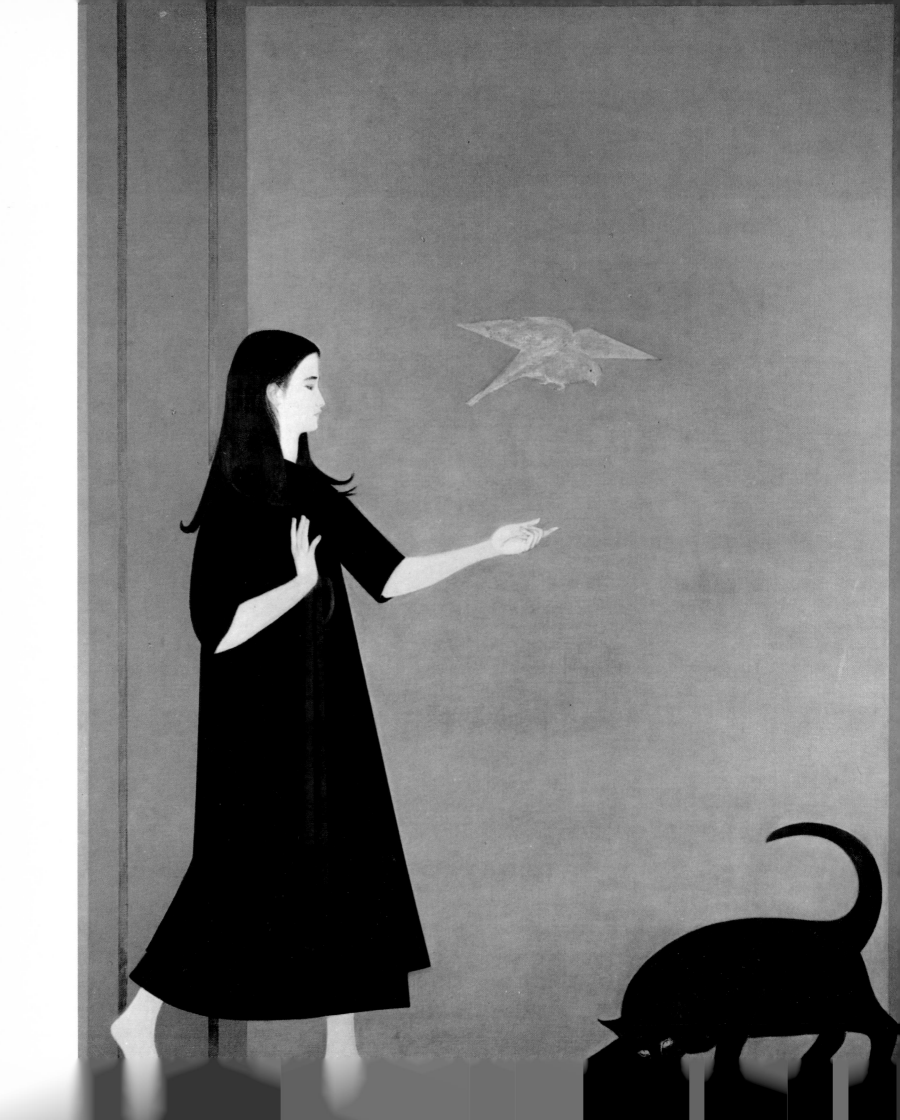

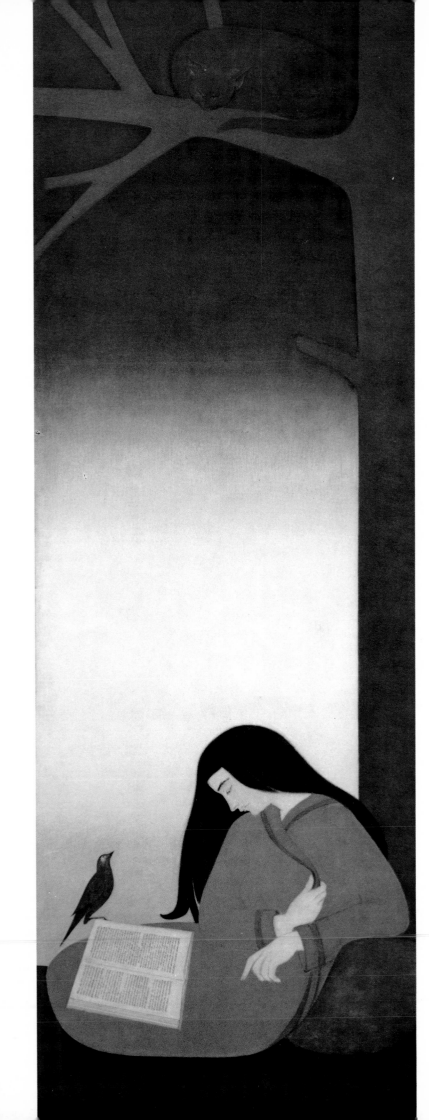

Opposite: YOUTH. 1970. Oil on canvas, 63¼ × 48¼". Private collection

THE CALLER. 1976. Oil on canvas, 95 × 30". Collection Mr. and Mrs. Jack Solomon, Jr., Chicago

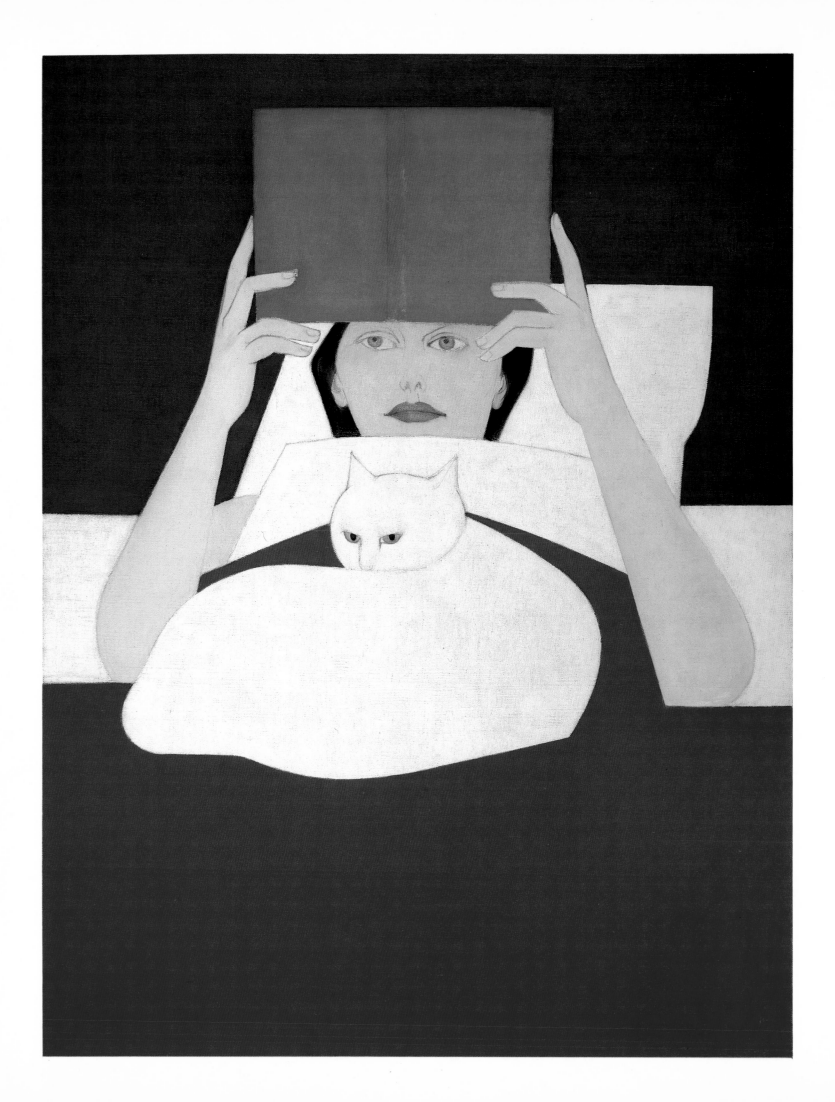

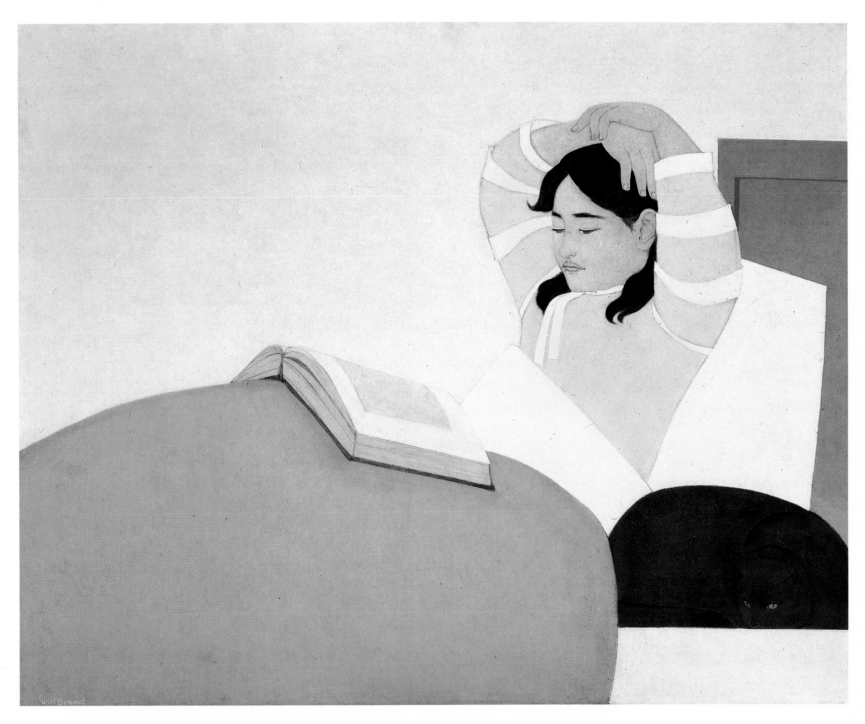

CHILD READING—PINK. 1966. Oil on canvas, 37 × 47".
The Cincinnati Art Museum. The Edwin and Virginia Irwin Memorial

Opposite: WOMAN READING. 1965. Oil on canvas, 45 × 35".
Collection Mrs. Walker O. Cain, New York

These paintings are concerned with dreams in a period dominated by realities, a triumph of imagination over reason.

As always, the work starts as a response to a familiar experience, in this case drawings of his daughter Ona seated by a window. In his introduction to *Will Barnet: Twenty Years of Painting and Drawing*, Burt Chernow describes what follows: "Barnet's attitude of communion with all things around him translates a hand, hair, scissors, a parrot into a visual language of structural simplicity. In examining the sense of sparseness in each of these four paintings, one finds a few carefully honed lines and forms knit together in a tightly articulated overall design. Subjects are reduced to their fundamental contours, and each variation on the theme, each small universe, is put into delicate balance. Barnet shows the pause, not the action, as changing fields of color in each work act as a backdrop for the quietly staged figures."

Areas of flat color become the architecture and setting for a black-robed female figure, golden bird, and black cat in the painting *Youth*, 1970. The girl reaches out toward the bird as though to follow its path of flight. Her gesture occurs against a field of reddish yellow, which pulsates with reflected light. The allusions are as strong as the color and composition—the search for spiritual enlightenment lives on in the youth of today. Barnet carried out the same image in a print, using the technique of printing with a silk screen, or serigraphy, which gave him the capability of reproducing the extraordinary hues and tonal ranges of his colors.

The allegorical pictures, which Barnet began to produce in the late 1960s, demonstrate that the modalities of imagination and spirit are still a viable part of the nature of humanity and the process of creative art in a century that was dominated by empirical thinking. Barnet arrived at a new relationship between content and pictorial means—color, line, and form—which was similar to that of another century, because he felt that such a method made possible spiritual perceptions neither apparent nor available in the art of the recent past or present. From his devotion to humanity came an art steeped in the traditions of the romantic visionary. He saw that art could be the embodiment of a pure life, the agent of noble experience. His tranquil and meditative pictures occupy a unique place in American art of the twentieth century.

Opposite: WOMAN AND WHITE CAT. 1966. Oil on canvas, 33½ × 28½". Collection Mr. and Mrs. Jaroslav Balaban, Flushing, New York

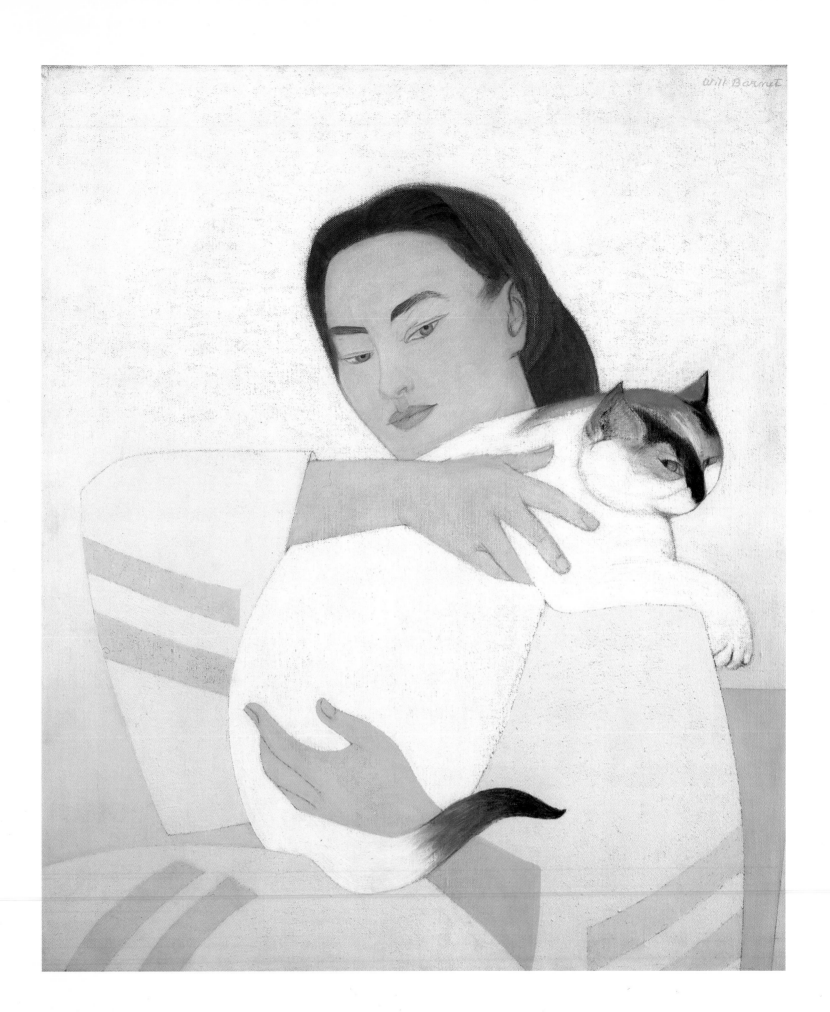

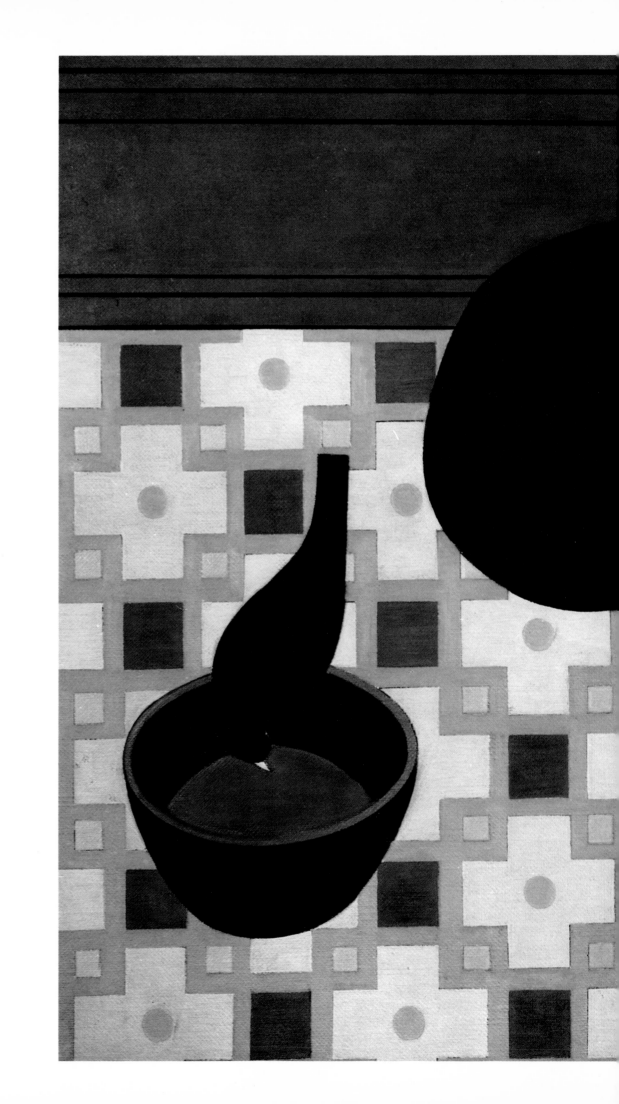

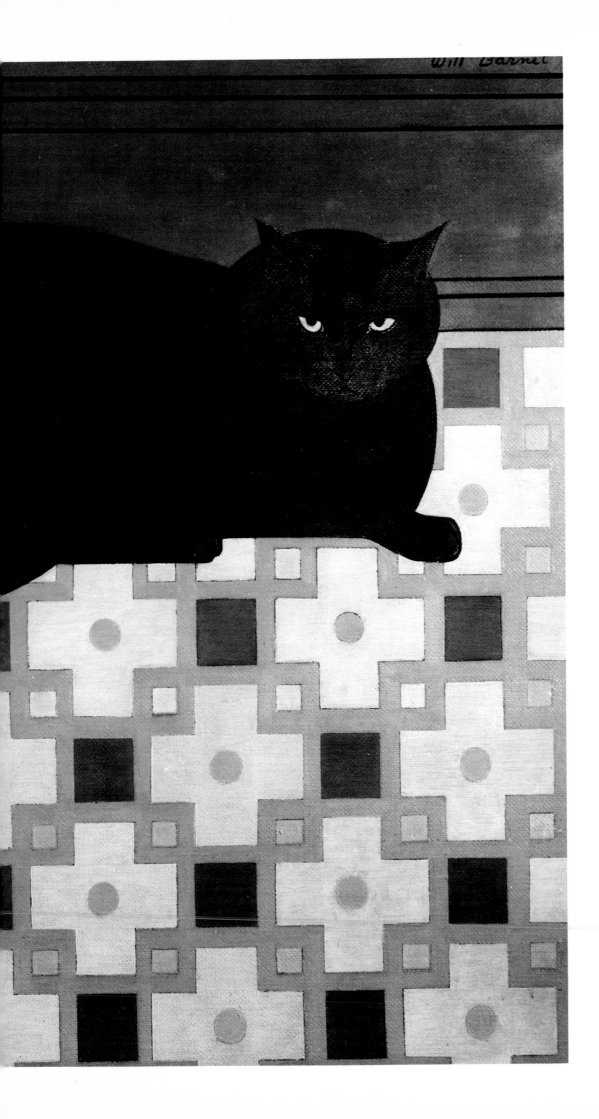

CAT AND BIRD. 1970. Oil on canvas, 28 × 34". Collection Warren and Anna Ajemian, White Plains, New York

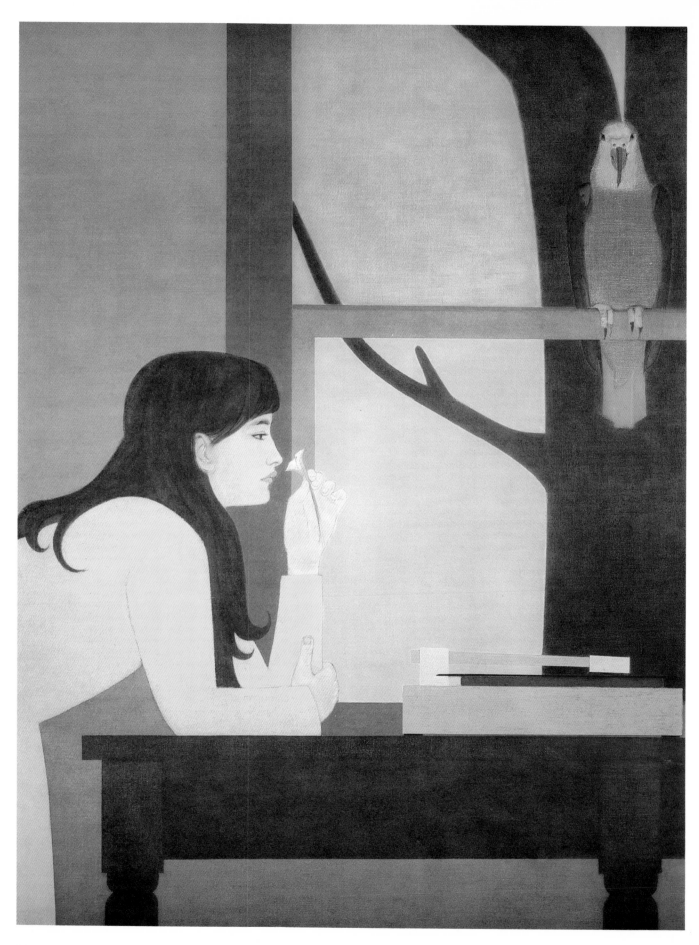

SILENT SEASONS—SPRING. 1967. Oil on canvas, 43½ × 33″. The Whitney Museum of American Art, New York. Gift of Mr. and Mrs. Daniel H. Silberberg

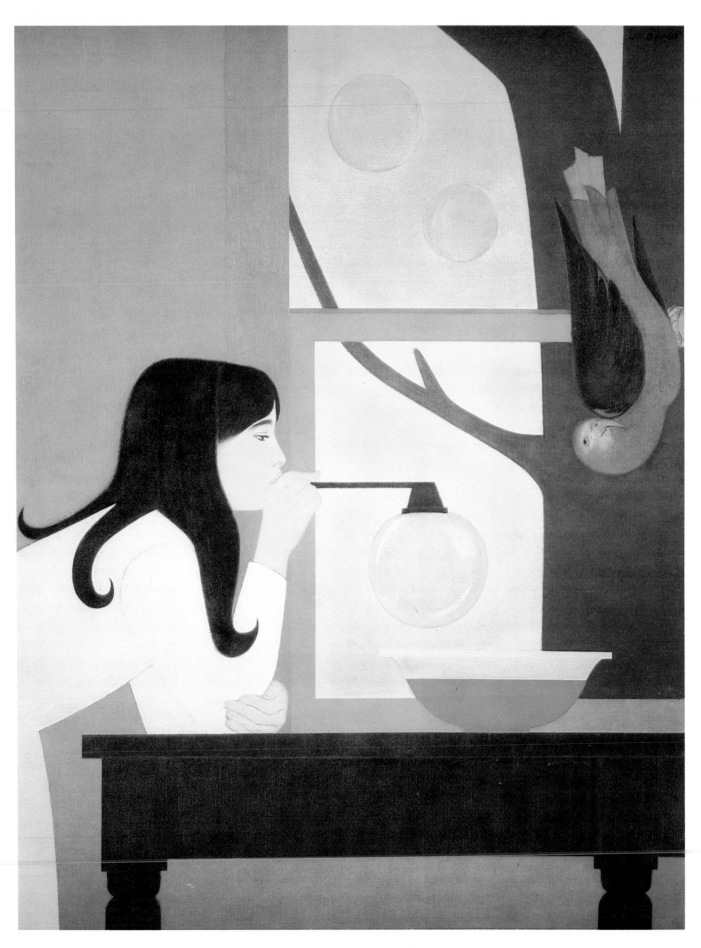

SILENT SEASONS—SUMMER. 1967. Oil on canvas, 43½ × 33″. The Whitney Museum of
American Art, New York. Gift of Mr. and Mrs. Daniel H. Silberberg

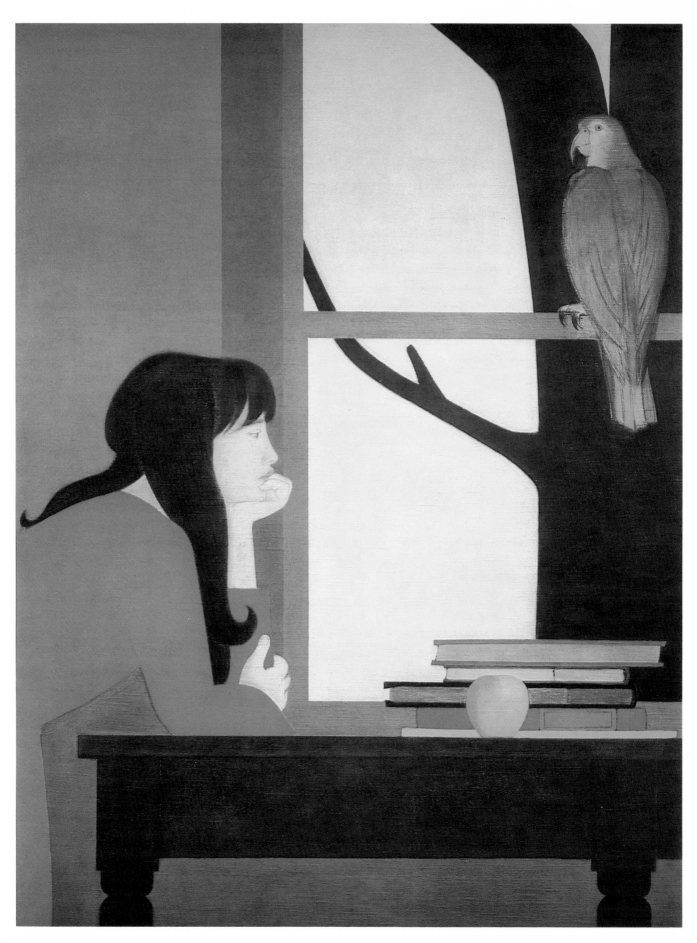

SILENT SEASONS—AUTUMN. 1967. Oil on canvas, 43½ × 33″. The Whitney Museum of American Art, New York. Gift of Mr. and Mrs. Daniel H. Silberberg

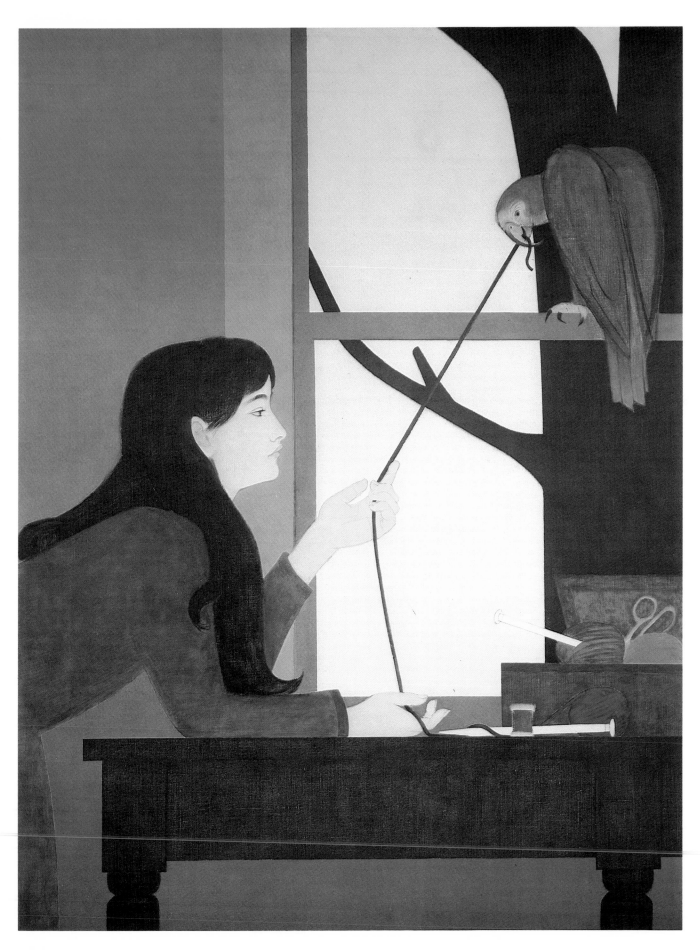

SILENT SEASONS—WINTER. 1967. Oil on canvas, 43½ × 33″. The Whitney Museum of American Art, New York. Gift of Mr. and Mrs. Daniel H. Silberberg

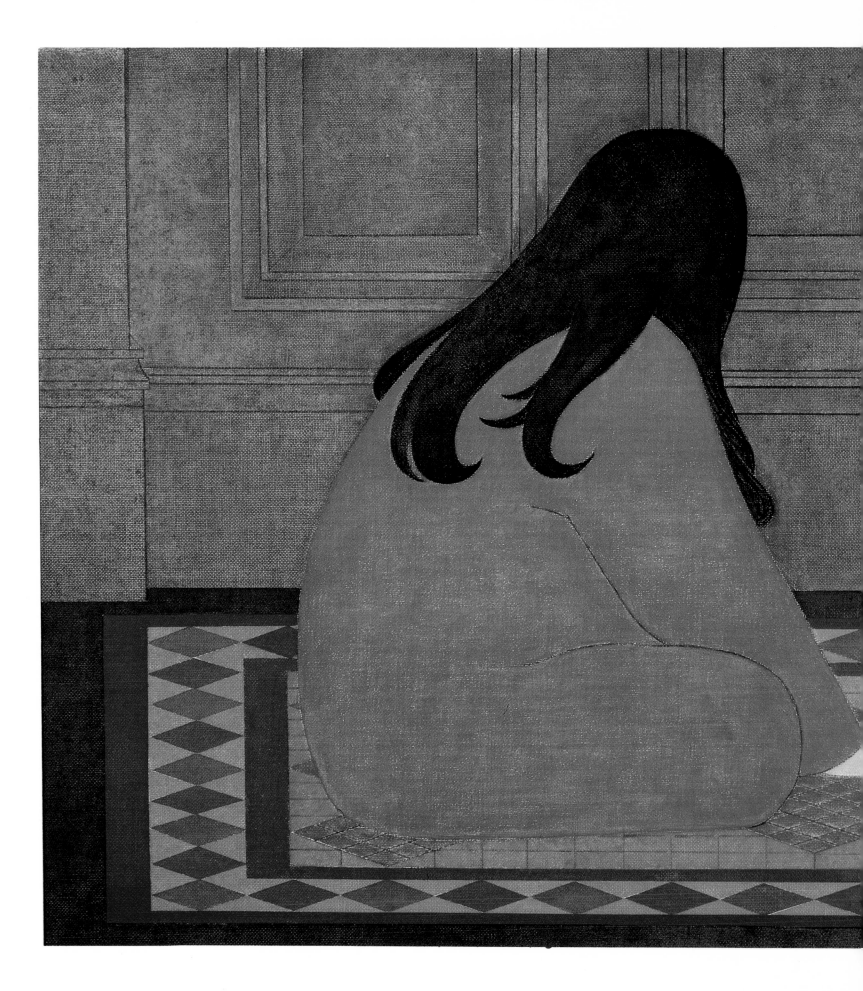

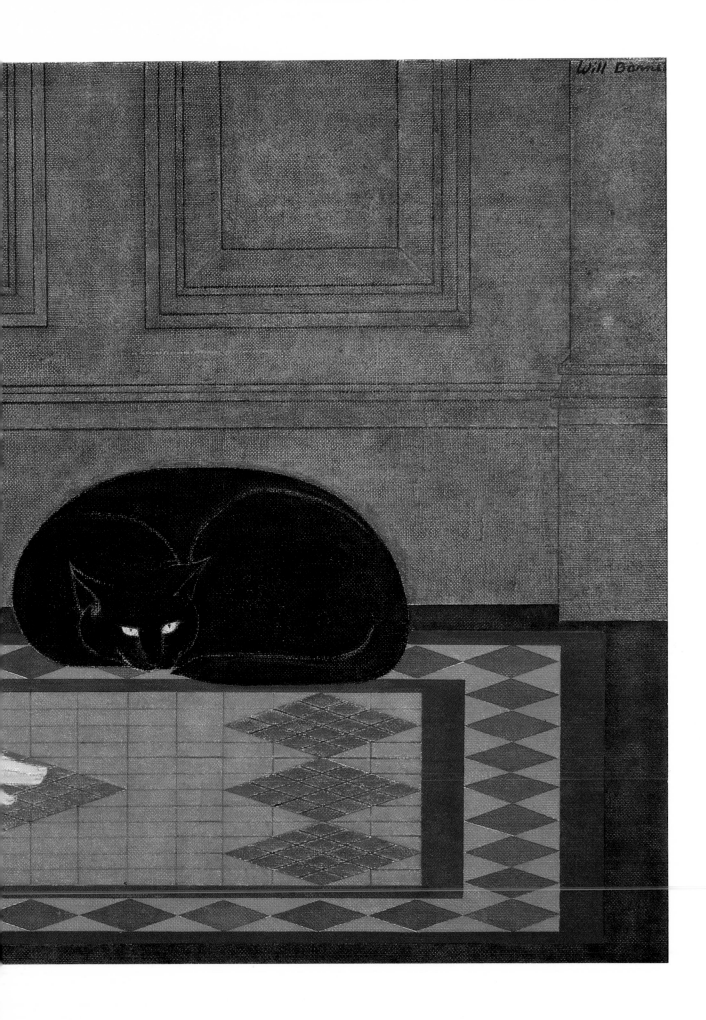

DIALOGUE IN GREEN.
1969. Oil on canvas,
32¼ × 56¾″. Collection
Mr. and Mrs. Arnold H.
Goodman, Fair Lawn,
New Jersey

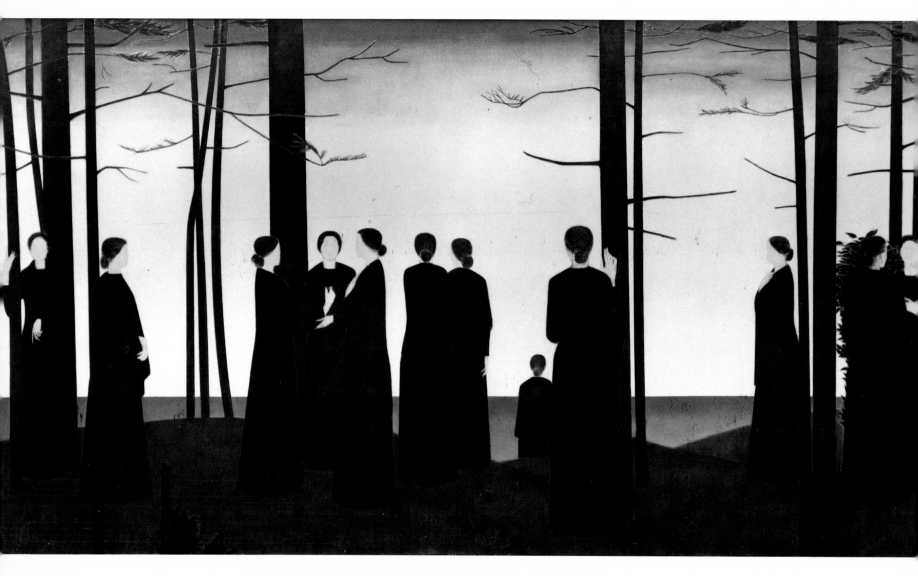

EARLY SPRING. 1976. Oil on canvas, 43 × 82″. Collection Mr. and Mrs. Ernest J. Schwartz, Bloomfield Hills, Michigan

VI THE IMAGINARY WORLD

VI THE IMAGINARY WORLD

Although Barnet spent all of his professional life in Manhattan, New England was never far from his thoughts. His childhood in Massachusetts remained a vivid memory. He returned often, to visit his family, to hold exhibitions of his work, and to teach. With the exception of the landscapes based on his summers in Provincetown, Barnet had never tried to capture the associations with this New England heritage in his art. In the mid-1940s, he had applied to the John Simon Guggenheim Memorial Foundation for a grant, citing his intention to do a series of etchings and paintings of New England that would "capture the suicidal dust of the North Shore" and the conflicting history of religious persecution and freedom. His application was unsuccessful, but the desire to work with New England as his subject lingered on. The breakthrough came in 1971, at a house in Maine that he had taken for the summer. One chilly evening at dusk he saw his wife, wrapped in a shawl, standing on the porch and silhouetted against the sea. It was a moment caught in the stillness of the last glow of light. The immediate beauty of the scene gradually became part of thoughts about a narrative of time past and the enduring values that made a future possible. From that moment came a new period in his work.

In 1972 he painted *Woman and the Sea* and *Early Morning*. In both, the figure of a woman standing on a platform looks out upon a vista of sea and sky. Barnet was not interested in documenting the coast of New England and its people; he wanted to analyze space, organize shapes, and use color to represent a particular time of day. His concern for the methods and materials of the painter remained as strong as ever, but there was now a different regard for why they should be used to unravel the mysteries of life.

"I was involved with the new problem of trying to deal with the sky, ocean and great distances," Barnet explains. "I felt the need to come to grips with the radiant light found in the atmosphere without being realistic or literary. I want to dissociate from normal human activity the rela-

111

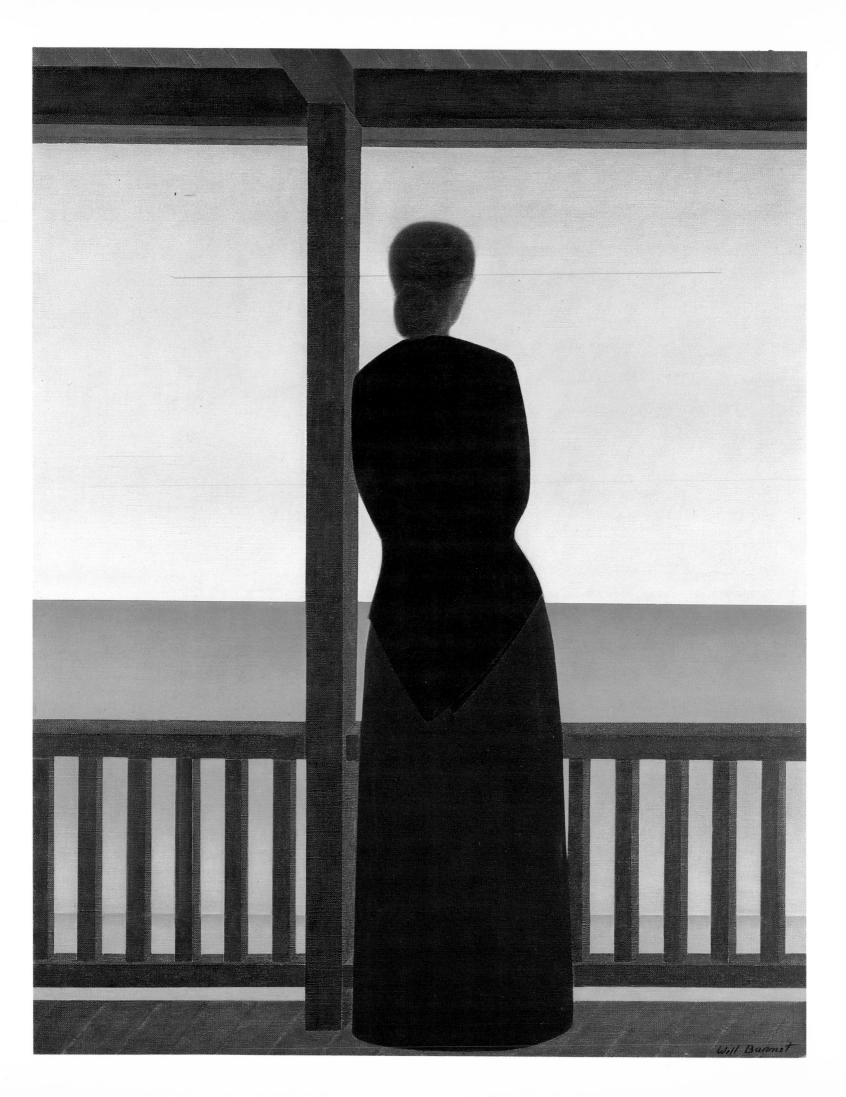

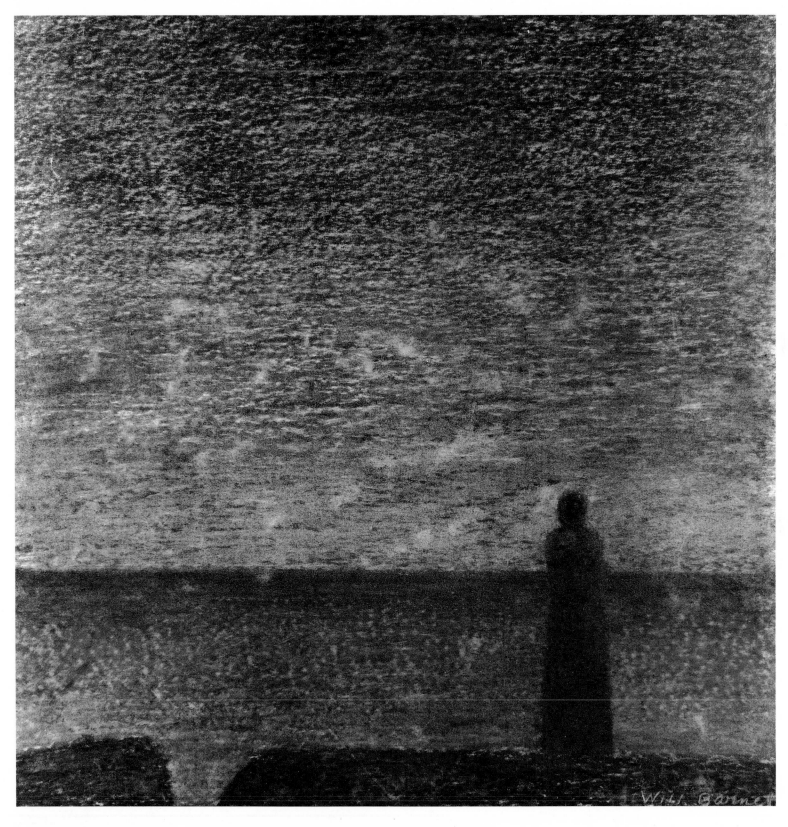

Study for EOS. 1973. Crayon, 58 × 58″. Collection Katherine Kuh, New York

Opposite: WOMAN AND THE SEA. 1972. Oil on canvas,
51¾ × 41″. Private collection

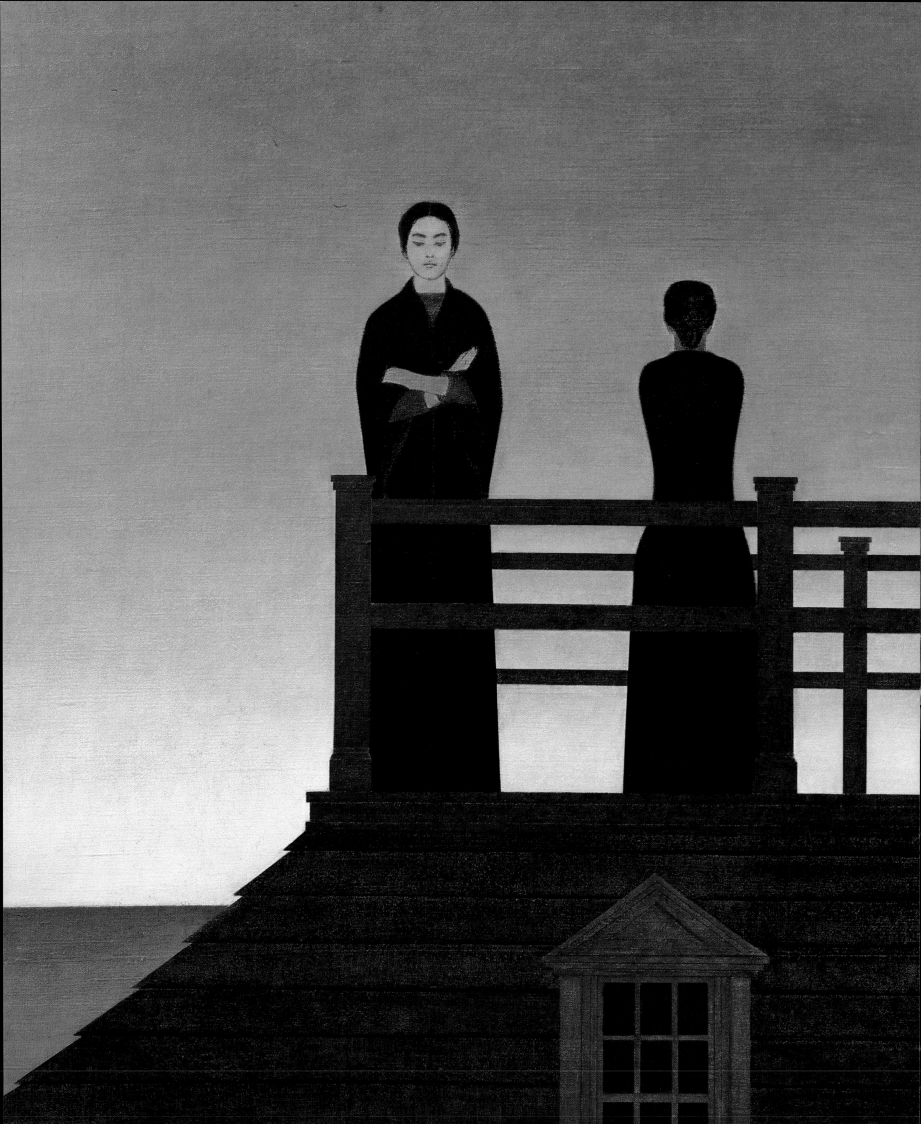

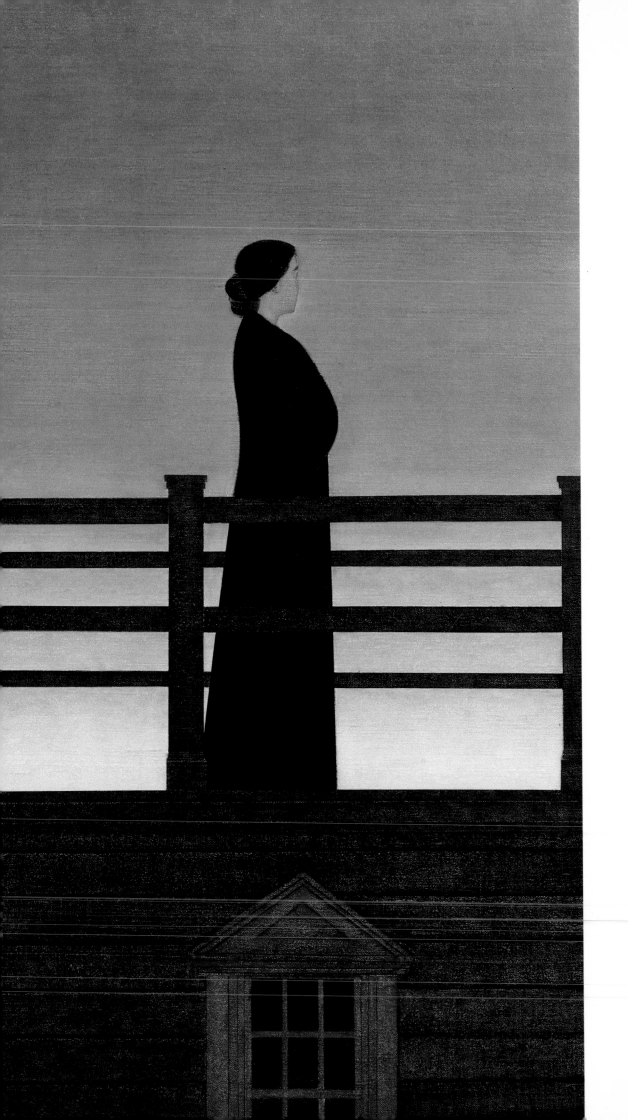

VIGIL. 1974–75. Oil on canvas, 48 × 67½ ".
Private collection

tionship between the figure and nature, and to deal instead with the mysterious poetry of the two. I want to give the sense of great distances yet keep the paintings two-dimensional." Barnet did not create the image of a specific woman. The personae of these pictures are effigies rather than actual human beings, functioning as part of the mood and remaining integral parts of the structure that determines all of Barnet's images. He kept striving for design rather than description, and mood rather than narrative. Sea and sky, figure and architecture work in harmony to establish a mood of prevailing calm and silent, eternal waiting. The accord between the figure and open space is clearly stated by the physical tenuity of the figure and the porch upon which it stands. The new pictures, like those leading up to them, were painted flat, and Barnet continued to eliminate, reduce, and simplify in order to achieve a classic unity.

The image of women and the seacoast was a major theme for Barnet during the 1970s. The columnar figures standing on the shore, a pier, or a widow's walk are the armatures around which the pictures are arranged. The proportions of the bodies are carefully calculated so that the space is viable without resorting to perspective, a factor that governs the three shapes in *Vigil*, 1974–75, an image of watching and waiting before an infinite horizon. *Stairs to the Sea*, 1973, reveals a woman seated on a stairway gazing out over the sea to a far horizon. In this and other pictures of the period, Barnet achieves a limitless expanse of space by respecting the flatness of the canvas and precision of line rather than replicating what the eye sees. Color was laid on in several applications, with rich, bright hues gradually giving way to darker tones. Dark greens, blue blacks over pale ocher, and violet set up a gentle resonance that corroborates the intimacy of emptiness, a vacuum in which the figures are evocatively positioned. Drawing plays a major part in the preparation and final execution of each work. In *Atlantis*, 1975–76, there is a compact gathering of women standing shoulder to shoulder on a pier that stretches out to a lustrous sea; the fastidiously drawn outline of each element is very pronounced. It is a linear painting in the manner of the French painter Ingres, whom Barnet admired tremendously. The rendition of the draped figure and the processional stance recall the work of Piero della Francesca, the Siennese painters, and the Pre-Raphaelites in England. They, too, saw the world with a fresh eye and rendered it with a very linear style and brilliant color, so that the intensity of their means overpowered the figures that were their subjects.

Barnet struggled to maintain a balance. The hauntingly beautiful effects that permeate his pictures of this period are the result of hundreds of drawings, hours of trying to find the right position, the right scale, so that figures occupy the space meant for them. In *Sanctum*, 1976, in an attempt to catch the essence of shapes and nature, Barnet took the figures into a landscape, putting trees, women, sky, earth, and water all together so that they become one powerful image. The final simplicity of the picture results from the breadth of composition, the tightly drawn

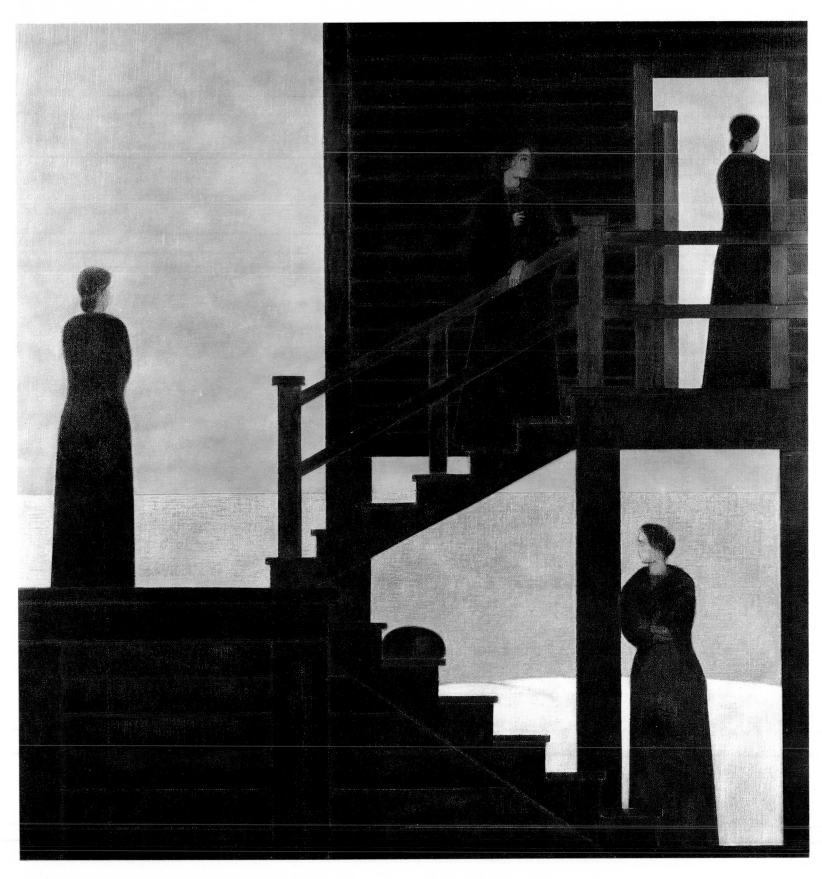

SUMMER NIGHT. 1974. Oil on canvas, 37¾ × 36¾".
Courtesy Kennedy Galleries, Inc., New York

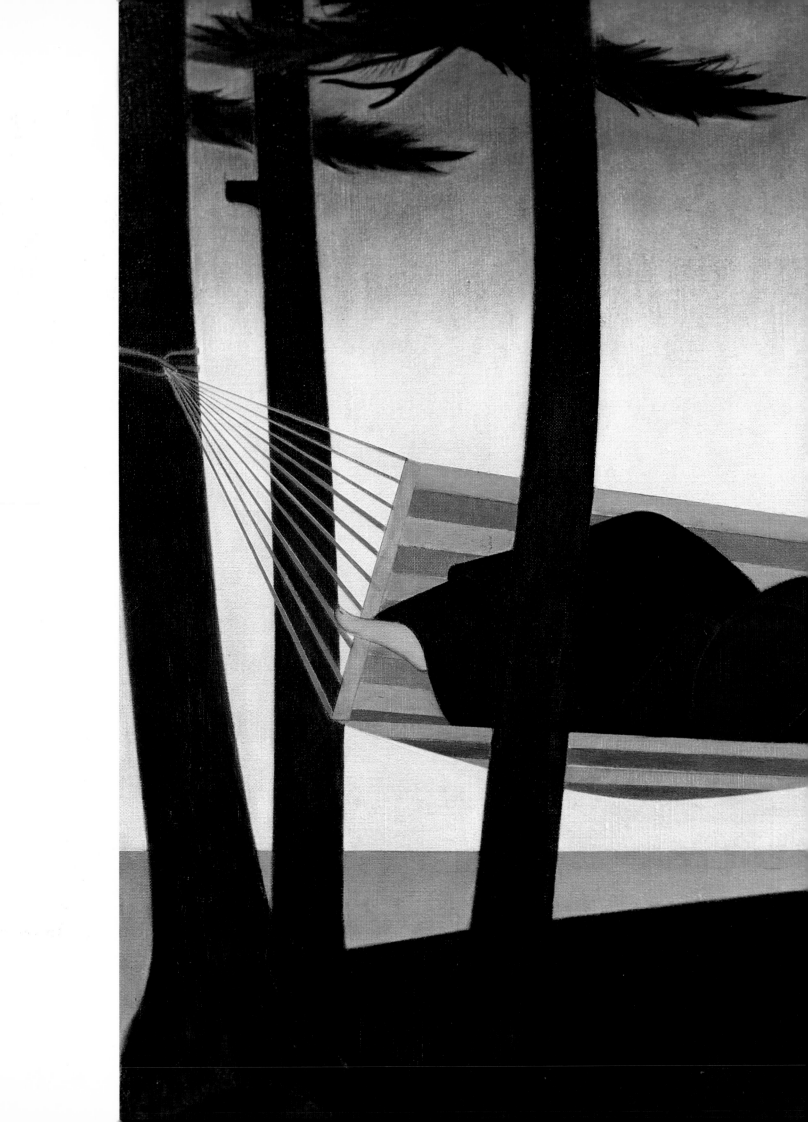

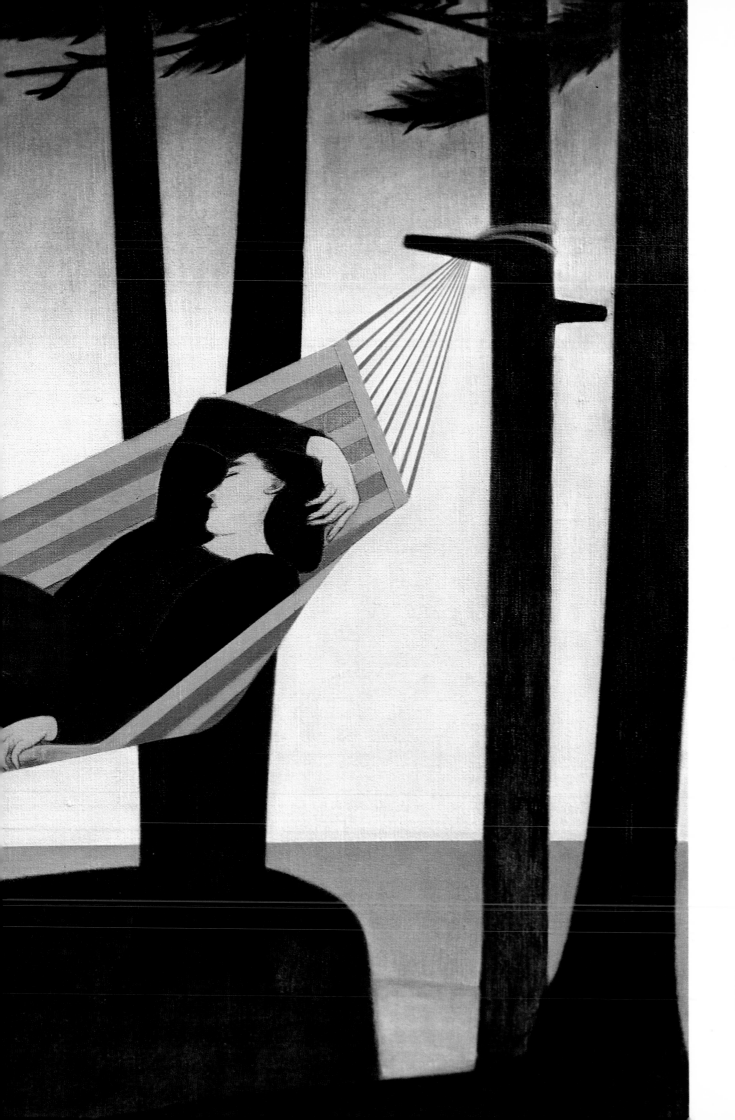

SUMMER IDYLL. 1975.
Oil on canvas, 41 × 53".
Private collection

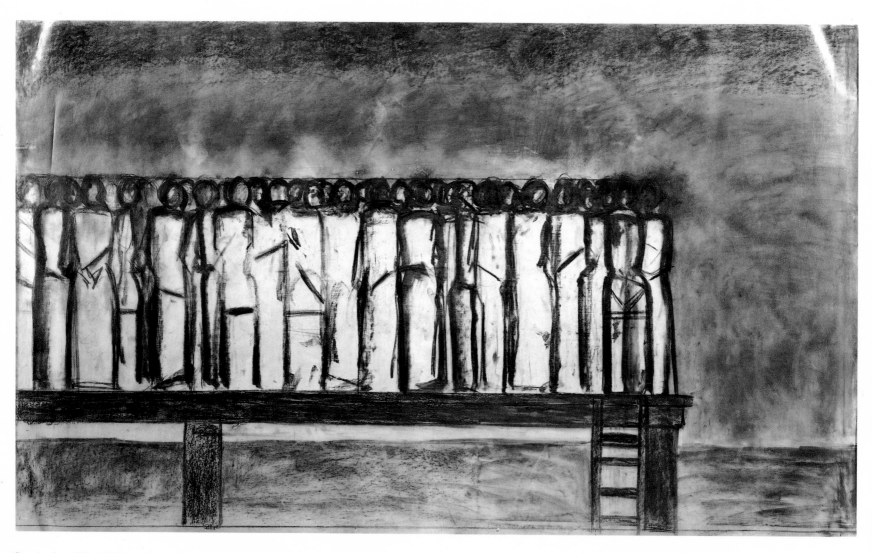

Study for ATLANTIS. 1975. Charcoal, 40¼ × 69½". Private collection

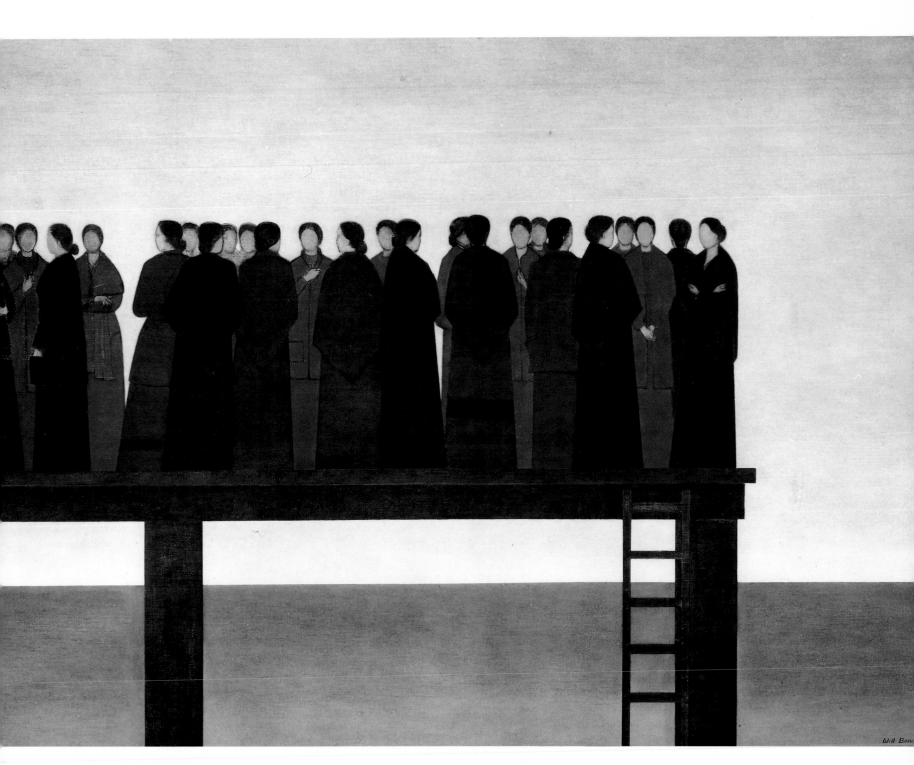

ATLANTIS. 1975–76. Oil on canvas, 49 × 69″. Courtesy Kennedy Galleries, Inc., New York

121

detail, and the fluidity of design that are interdependent elements. The picture is done with scrupulous care for descriptive exactness. Every part of every painting made in this period has a solidity suggesting sculpture, a characteristic of Barnet's painting throughout his lifetime. To be clear and to be strong in the form—those were his goals.

The importance of these paintings lies in the fact that, despite the artist's expertly disciplined style and the objective use of both the human figure and nature, these are images that generate strong personal associations and emotions. Upon viewing *Eos*, 1973, the Canadian critic James Purdie wrote:

> *The silence in the picture is such that you don't want to move about too much, creating noise in the room. There's an odd but not unpleasant sense of suspension, a simultaneous consciousness of earth and infinity. And it's here that you realize why it takes Barnet as long as a year to complete a single canvas. What he does with painting after painting is to pull infinity itself forward to the painting's surface—without distorting any of its dimensions. Then he holds it there on the surface by sheer tension. It's as if he had hung space along the horizon like washing on a line. His triumph is that it's all there, right on the surface and nothing falls away at the edges.*

Other critics have often remarked about a resemblance to the art of the Far Eastern cultures, and, indeed, Barnet has long admired the work of such Japanese printmakers as Utamaro and Hiroshige for their use of color and form. But, whereas their pictures are derived from legends and stories, Barnet was drawn to experiences with psychological states. Through their atmospheric effects, sensitivity to the nuances of light, and soft gradation of space, his pictures offer conjectures about solitude, patience, dignity, and awe. The stillness in the moods he creates opens the way for translucent suspensions of time, which include not only what is taking place but also hint at what is yet to come. It is an enchanted vision of serenity and loveliness, with menace held at bay. For Barnet, the woman is a symbol of strength and hope, and his paintings "are about endurance, not pain or anguish." The possibilities for interpretation are many and varied because the work is open-ended, lending itself to subjective connotations. Barnet had achieved an art that looked within itself for both its subject matter and its significance. It addresses a concern for spiritual values and treats them with veneration in a spirit of profound meditation.

Parallels can be drawn between the art of Will Barnet and the Luminist painters of mid-nineteenth-century America. He is heir to the regard for light that is central to the work of Martin Johnson Heade or Frederic Church. There are readily apparent similarities in the handling of space, objectivity toward means, and a sense of isolation on the part of artist and viewer. Comparisons can be extended to another group that

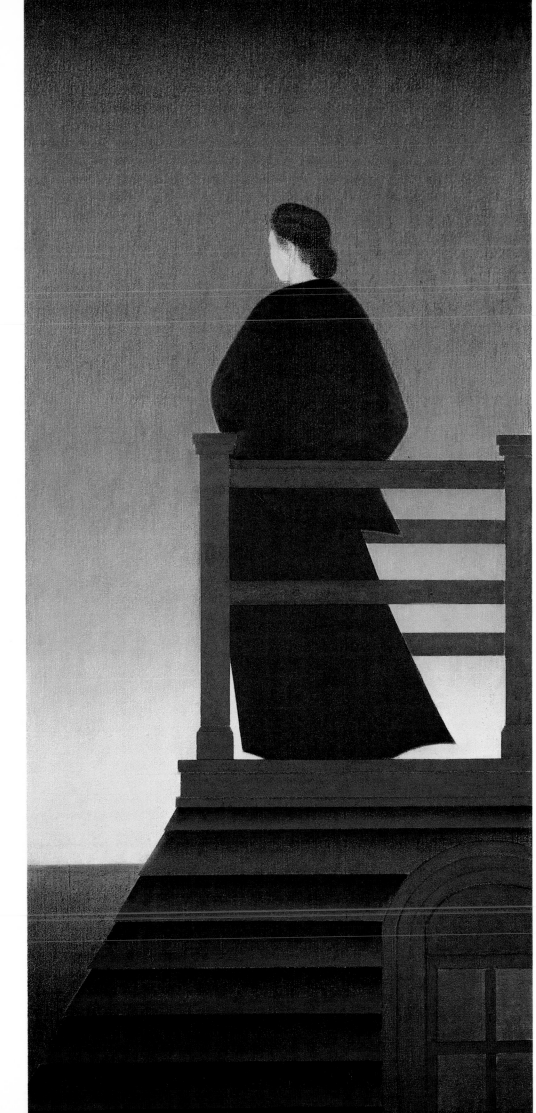

DAWN. 1976–83. Oil on canvas, 65 × 30".
Private collection

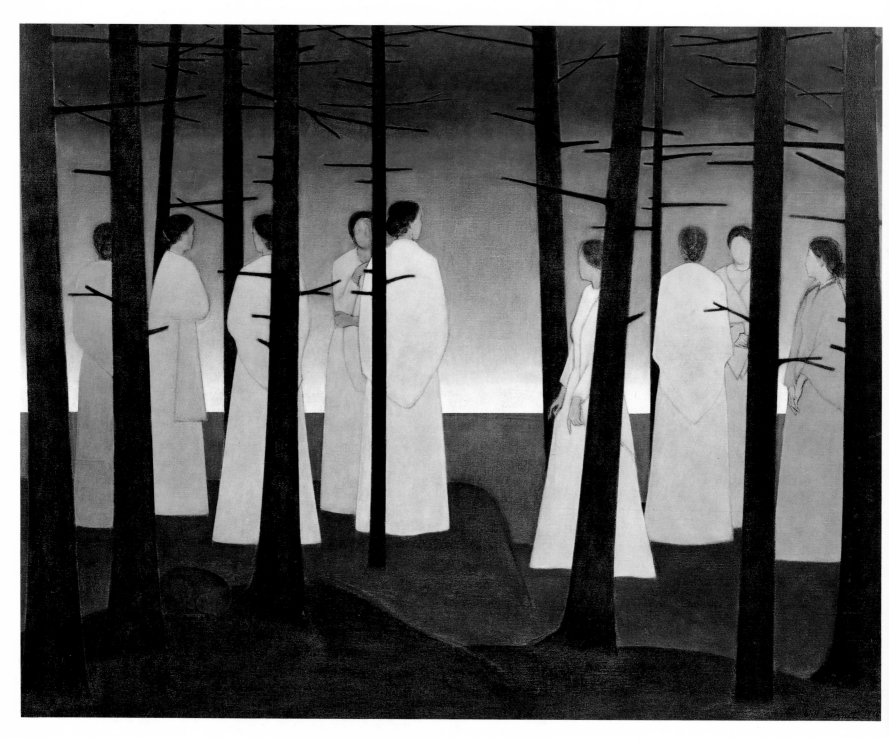

SANCTUM. 1976. Oil on canvas, 42¾ × 55″. Private collection

left its mark on the nineteenth century, the Transcendentalists of Barnet's native Massachusetts. One of their leaders and chief theoreticians, Ralph Waldo Emerson, preached a gospel of self-reliance and predestination in a world that was held to be primarily spiritual. Emersonian Transcendentalism stressed the moral character of natural facts—the body was regarded as a minor expression of spirit—and held that it was necessary to establish rapport between the material facts of the real world and the conjectural facts of any realm that lay beyond. Later, the Transcendental emphasis upon the unique ability of the individual to perceive and adapt to the world around him provided an effective antidote to the determinism promulgated by Charles Darwin and his followers.

A great number of artists in America and Europe chose to deal with values that could be imagined only by denying their own earthly nature, and in recent times artists such as Mark Rothko and Adolph Gottlieb recurrently referred to their paintings with such Transcendental terms as irony, fate, and ecstasy. Barnet wanted to epitomize the strength of the New England soul which had been so often tested by the tensions of renunciation and the subtle tragedies that often underlie human relationships. The images of women and the sea are steeped in the spiritual values that nurtured the intellect of New England. The women who wait, who stand in silent communion, are testimony to the ability of the human being to cope with whatever life might have in store. Those women whom Barnet portrays waiting for the approaching storm have known the worst that can touch their lives and are ready for any eventuality. Transcendentalism had made its impact upon New England and faded into obscurity before Barnet had begun to assimilate the beliefs and values of his own time, but, nonetheless, he was able to render on canvas the ideals and values that had made it a major part of American life a hundred years before.

The change and continuity that are the hallmark of everything that Barnet does had brought him to an art based upon the suggestion of ideas made through an appeal to basic emotions and attachments. Although the pictorial means were still those of the contemporary artist, a tendency toward subjectivity and introspection produced a delicate balance between austerity and a richness of imagination that sometimes bordered on the mystical. His work had become a fusion of intellect and emotion that led to reveries of a time past when the virtue of strength was the ability to deal with stress. Barnet saw nature as a setting in which people lived out their lives in "silent desperation," but, nonetheless, he selected moments in time—at the break of dawn, in the lowering dusk— when the light from the sea shone with colors that transformed the real world into an enchanted place. His precisely drawn figures, with their unbreakable relationship to a space that holds them in bondage, evoke a mood of deprivation and longing reinforced by their passiveness. To his already distinctive style, based on a rigorous regard for line and form, he added intimacy and expressiveness, which emerge from the constant use

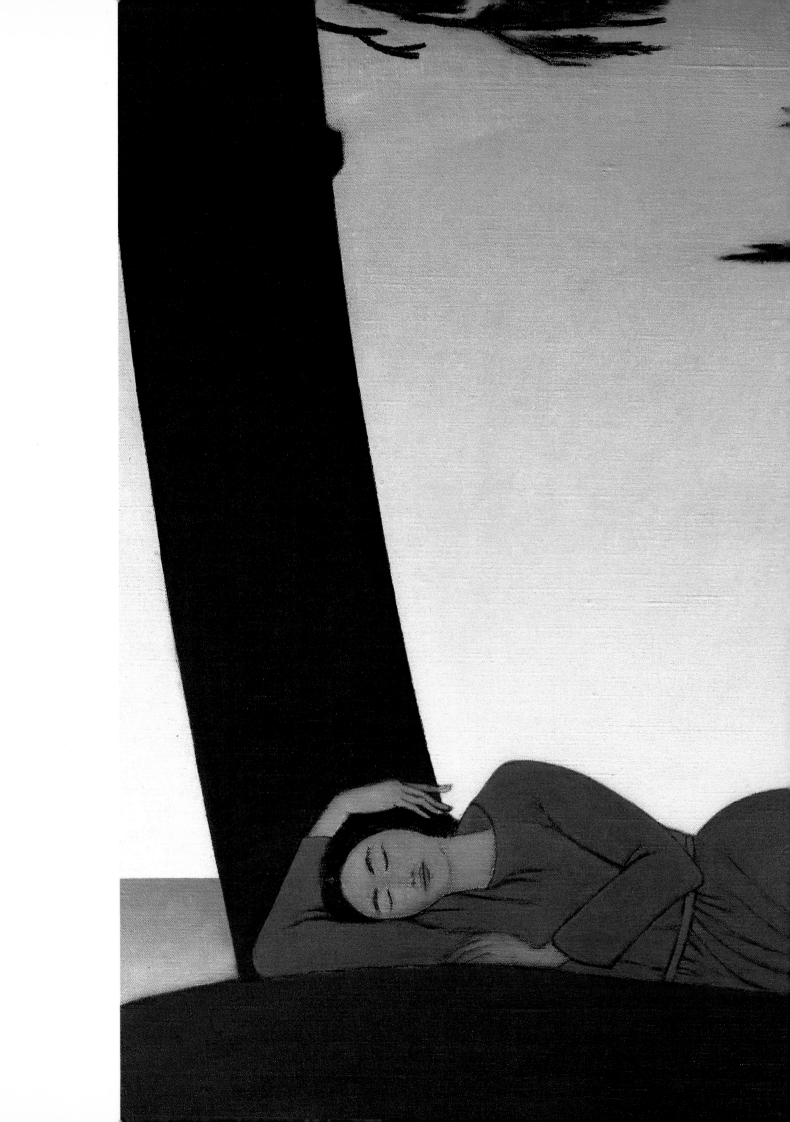

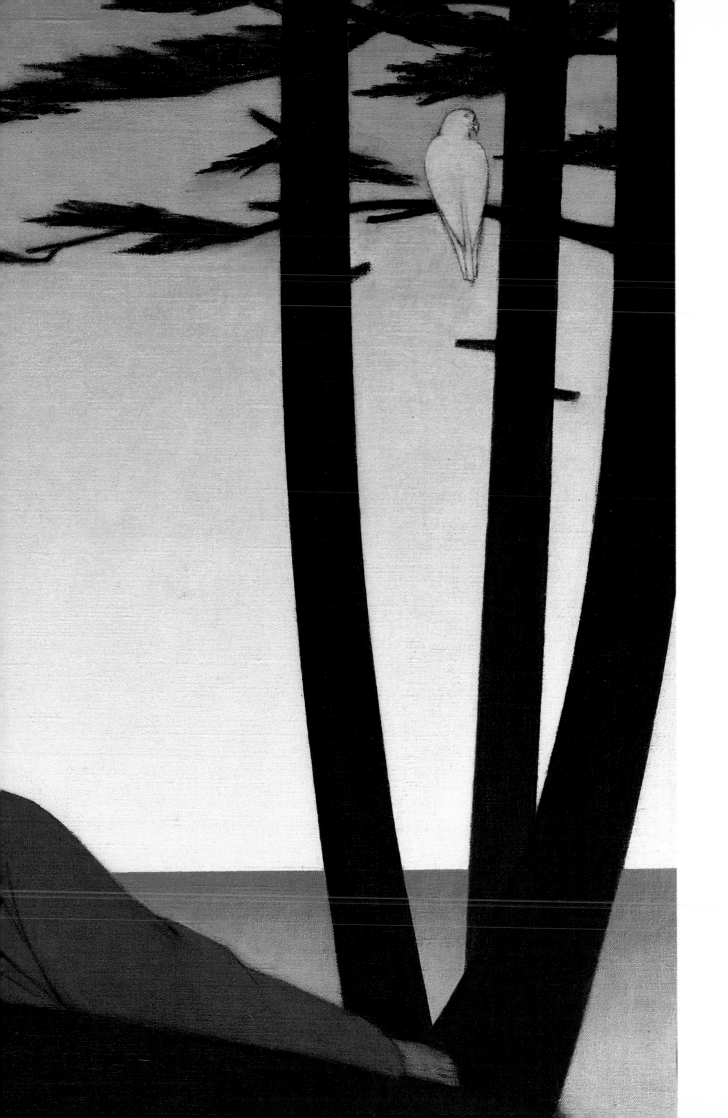

RECLINING WOMAN.
1978. Oil on canvas,
35½ × 45½". Courtesy
Kennedy Galleries, Inc.,
New York

of the female figure and his consummate treatments of light and color.

These pictures are a reflection of the artist's own experience, the pervasive loneliness of his childhood, his vast reservoir of knowledge about portraying the human figure, culminating in this effort to summarize his feelings about the beauty in life. His paintings of the 1970s are metaphors for his own moods and feelings. He could not change the real world, but he could create an environment that was quite different, a place where color was more spectacular, space more palpable, and nothing alien would ever intrude. He had become devoted to myth, legend, and dream in a time consecrated to the material, the process, and concreteness. But then so had other artists with a predilection for visionary contemplation.

Indeed, the desire to inhabit a place of quiet sanctuary is found often in the art of the twentieth century. Arthur B. Davies created landscapes fit only for idylls in the sun. Georgia O'Keeffe found such a place in the Southwest, whose intense color and light matched her own aspirations. Maxfield Parrish made the most commonplace setting a seat for the sublime by his incomparable mastery of light. Mark Rothko used expansive scale and the emotive potential of color to make paintings that engulf the viewer. Like these artists, Barnet shifted his orientation from outward to inward. Reality was a conduit for the enigmas of the mind, the proper means for finding symbols of primal experiences that were more psychological than veritable.

A painting much admired by Barnet is *The Yellow Christ* by Paul Gauguin. In his early years, he responded to its meaning about suffering and humanity, and he has continued to admire Gauguin's handling of light, color, and composition, especially the relationship of a group of women moving through the landscape. It is a picture that personifies life and death, time and judgment. Barnet knew that Gauguin had lifted a curtain that shrouded the fears and doubts of life, and he intended to do the same. In his reverence for Gauguin, he allied himself in spirit with a group of young French painters who worked at the end of the nineteenth century and called themselves the Nabis. They, too, created images of the idealized figure in living nature which were seen as arrangements of pure form and color. They expressed moods and emotion rather than naturalistic representation.

Similar concepts also made their way into the literature of the period. Poets and playwrights worked toward a deliberate freeing of poetry and prose from what they considered a restrictive role of conveying precise meaning; instead, they used language as the transmitter of an allusive and delicate beauty. American artists participated in this attempt to re-create the world of man and nature as a Symbolist image of exquisite refinement and near-abstract purity. Paintings of women in some leisurely pursuit were intended to be not only generalized symbols of feminine purity and virtue but also statements of higher moral and spiritual values. Such pictures offered an alternative to the real world and were, in

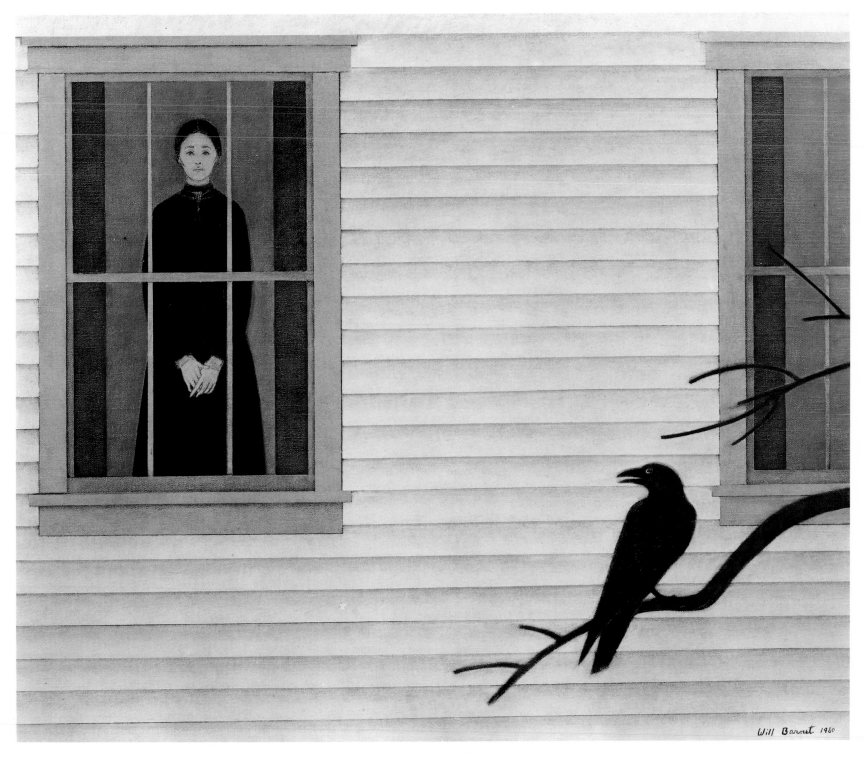

FEBRUARY. 1980. Oil on canvas, 34¾ × 41⅛″. Courtesy Kennedy Galleries, Inc., New York

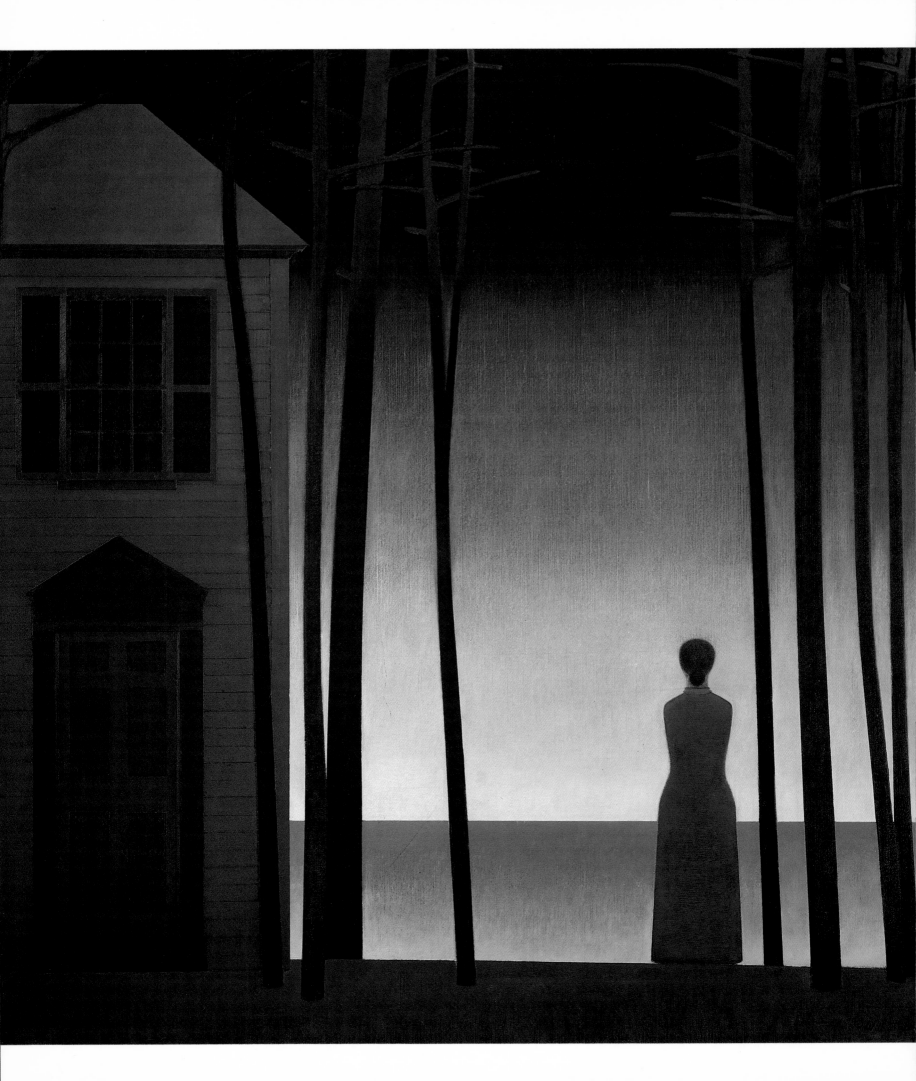

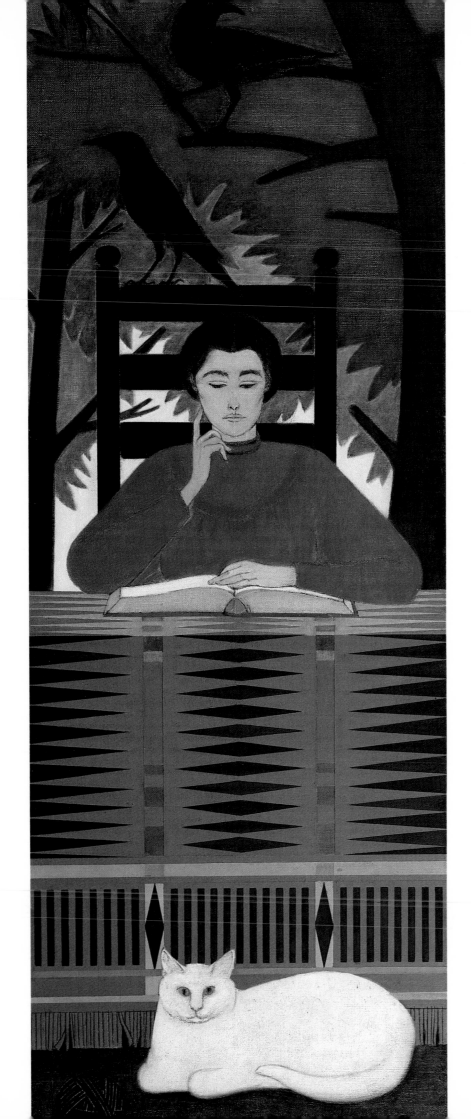

Opposite: EDGE OF THE
WORLD. 1979. Oil on
canvas, 58¼ × 58½".
Courtesy Kennedy
Galleries, Inc., New York

TOTEM. 1979. Oil on
canvas, 64¼ × 24".
Private collection

THE READER. 1980. Oil on canvas, 21 × 51½″. Private collection

Overleaf: NIGHTFALL. 1979. Oil on canvas, 40½ × 70½″. Private collection

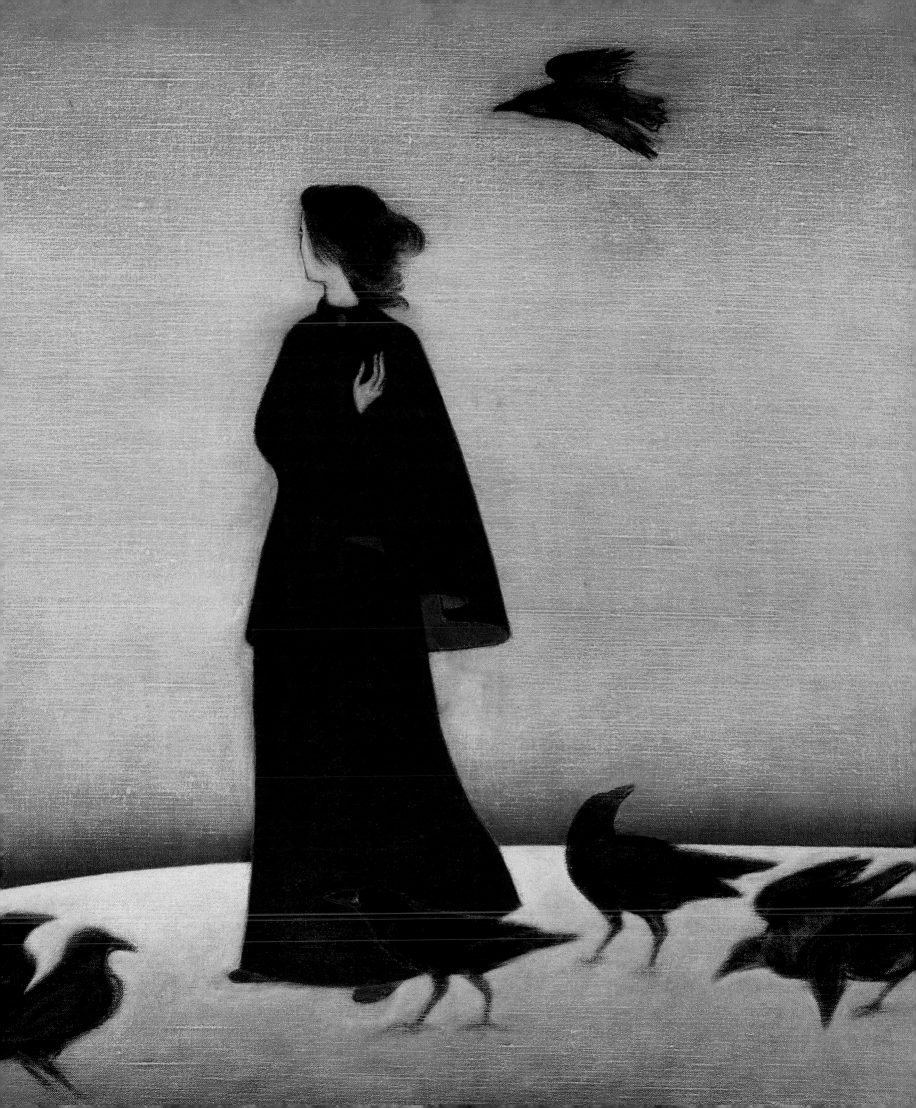

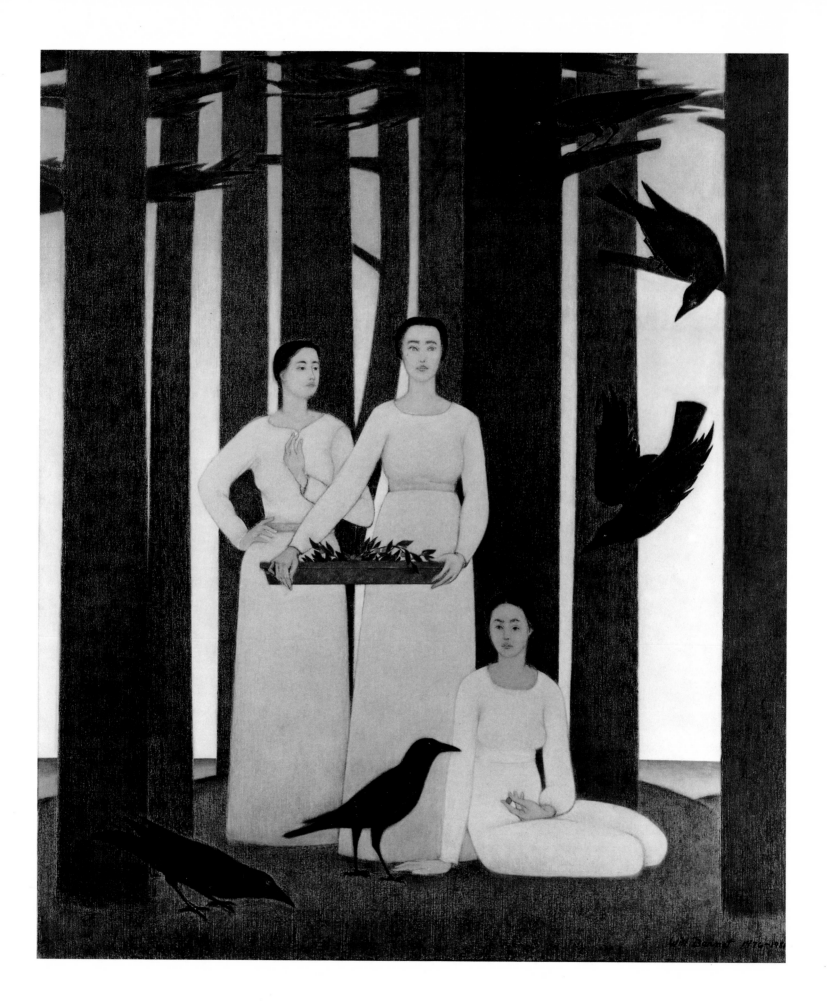

fact, a means of casting doubt upon the course of modern society. It was a time for change. According to Charles Eldredge, it was even a time for mild revolt. In *American Imagination and Symbolist Painting* (New York, 1979), he wrote: "The Symbolist poets and painters of the late nineteenth century were united in their common reaction against what they saw as the dominant materialist, naturalist and determinist ethos of the epoch. By focusing on the internal, symbolical world rather than the external, empirical one, by resorting to introspection rather than observation, they sought escape from the tyranny of Fact and the denunciation of Soul which threatened to extinguish the life of the Imagination."

The writings and the paintings of the Symbolists were characterized by several contradictions: the desirability of attaining eternal life contended with a pervasive fascination with death; absolutes of physical and spiritual beauty were often juxtaposed with images resulting from a preoccupation with degradation; the individuality of the artist was to be protected at all costs from the oppressive demands of society. The result was a broadening of the more vivid subjects for the imagination, looking inward to grasp the elusive and latent sensations and images just beyond the brink of the conscious mind, and outward toward a subjectivism rooted in material fact but governed by a refinement that directed all meaning through emphatic form and color.

A taste for the exquisite and luscious in color and line, a sensitivity to the vulnerability of the human condition, a passion for the transformations that awaken strong emotions unite the late work of Barnet and Symbolist painting in Europe and America. When Barnet chose to make statements about humanity, to portray the strength of the soul, he conveyed the meaning through the female figure situated in a strange, haunting openness, immersed in an unearthly light and atmosphere. Like Albert P. Ryder, Barnet was concerned with the outer limits of experience that are known to many but have rarely been described. Barnet has spent many years examining and expounding upon his reaction to the real world. The symbolism of his pictures is a bridge between his inner feelings and the need to communicate, a way to realize the manifestation of his spirit solaced, verified, and put to the service of everyone.

In 1975–76, Barnet made a print entitled *Atalanta*. The subject was familiar, his daughter Ona in the pose and setting that had appeared in *Silent Seasons*, but in this work she contemplates a golden apple. The direct observation of the figure was joined to thoughts about the Greek legend of Atalanta, whose fate turned on a golden apple, and an image was born linking contemporary life and the eternal values of the classical myths. He extended the symbolist nature of his work by acknowledging a deliberate debt to the culture of ancient Greece when he produced a series of works with titles such as *Circe*, 1979, *Hera*, 1980, *Persephone*, 1982, and *The Three Muses*, 1981. Each contains at least one robed female figure, who represents humanity. But she is no ordinary person, as were her counterparts in the women of the seacoast. She is quite obvi-

Opposite: THE THREE MUSES. 1976–81. Oil on canvas, 71 × 60½". Collection Frank Ribelin, Dallas

137

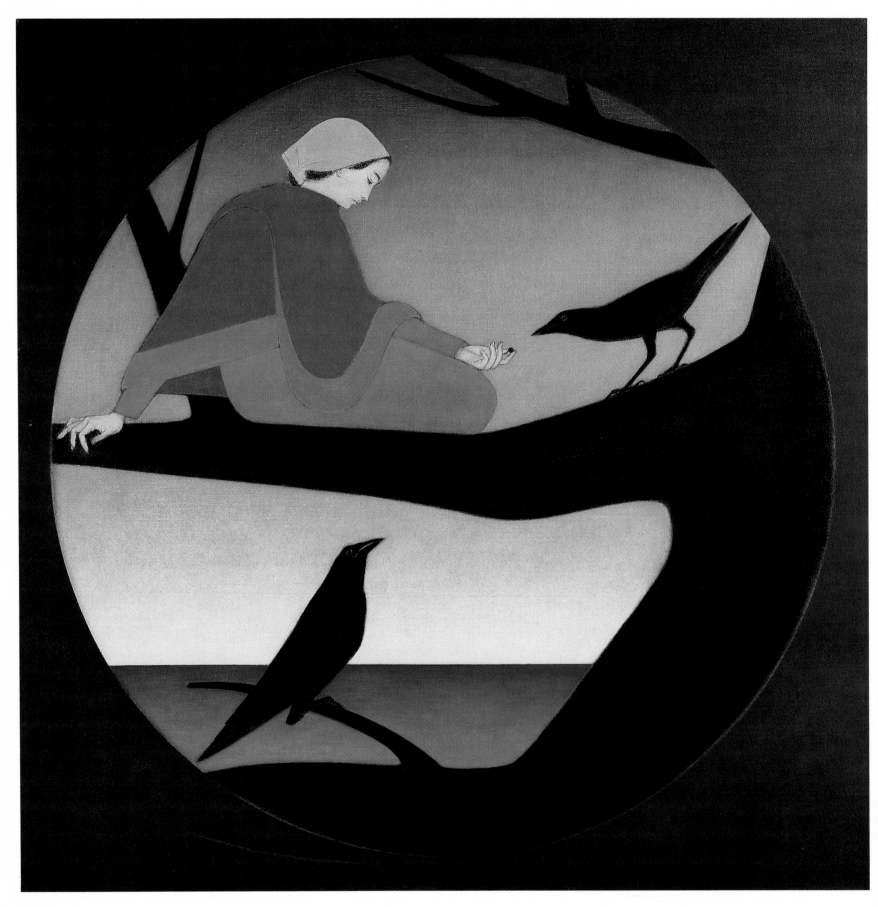

CIRCE. 1980. Oil on canvas, 39⅞ × 39⅞″. Collection Mr. and Mrs. Herbert Klapper, North Woodmere, New York

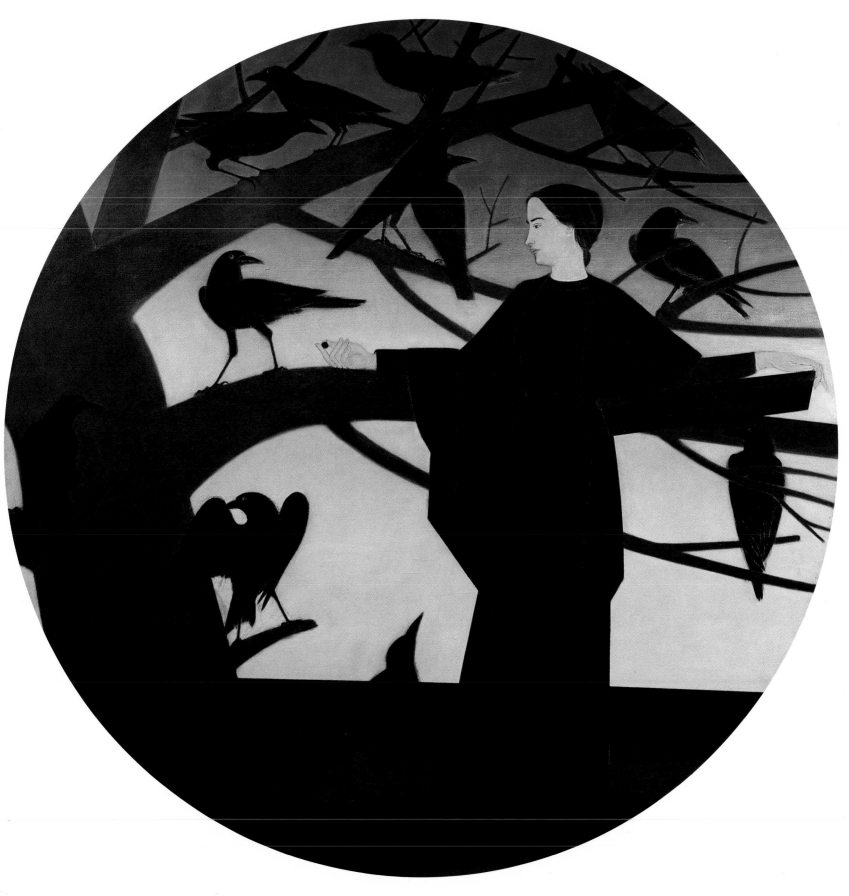

HERA. 1980. Oil on canvas, diameter 72".
Private collection

THE COLLECTORS. 1977. Carbon pencil and conté crayon on
Canson paper, 28½ × 41¼". Collection Dorothy and
Herbert Vogel, New York

Opposite: PORTRAIT OF RAPHAEL SOYER. 1981. Pencil on paper,
14 × 14". Private collection

140

Will Barnet Aug 19 81

MEMOIR. 1970–79. Oil on canvas,
38½ x 96". Courtesy Kennedy
Galleries, Inc., New York

ously someone who can move with ease through a foreboding land, fully in command of an archetypical wilderness. Her only companions are large black birds, which she feeds or relates to in some manner. The bird is symbolic of flight, of freedom, and of the supernatural. In a departure from his previous work, Barnet uses strong contrasts of color. The black bird, the dark purple of the robe, and the black shapes of trees and branches are sharply silhouetted against the luminous band of sky over the horizon. The specific references—figure, bird, landscape, space—are retained. Once again, Barnet has created a scene in which all is eternal and a spiritual unity reigns supreme.

The mythological background of the theme is appropriate for Barnet, who has perpetually questioned the popular and contemporary expectations of reality. Barnet is no longer content to report on appearances, but rather asserts his opinions and feelings about life and all its

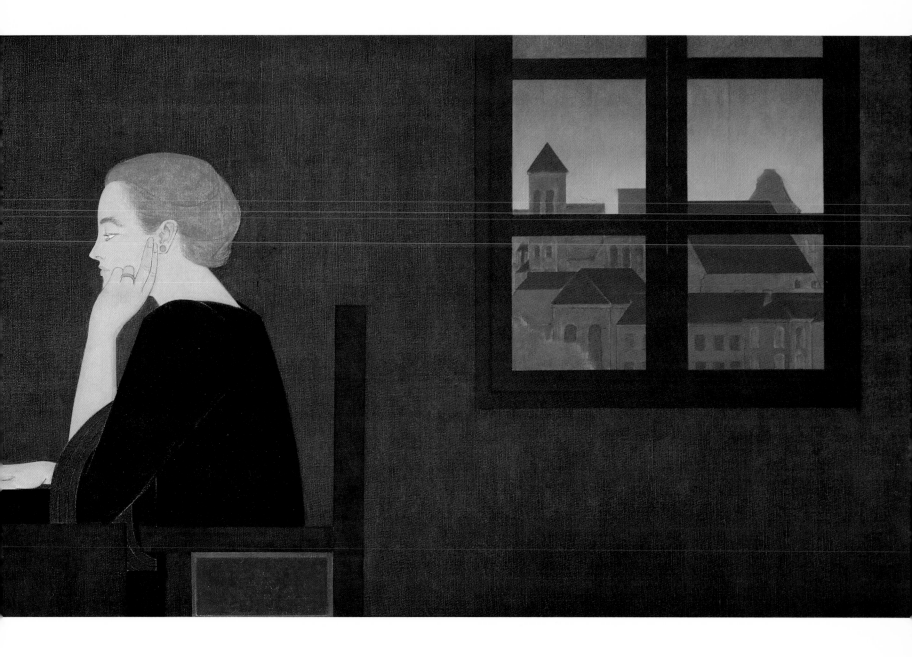

meanings. He has restructured the existing world, leading the way to an escape from the agony and simple dullness of reality. He poses questions that can only be answered with an understanding that comes from the power and the extent of individual imagination. He has explored the relationship between dreams and objective experience, imagination and reality, surface and substance. He has called upon associations, cues that unlock private emotions and recall events that shaped private destinies. He has created images of myths and symbols founded on the humanistic values that generated all great art through the ages. Barnet's art fulfills a major need for new pictures to raise a new consciousness of universal values, to speak to a common experience. Everything he does embodies the resolution, ardor, and devotion that have sustained him during a lifetime as a painter and printmaker.

BIOGRAPHICAL OUTLINE

1911 Born in Beverly, Massachusetts, May 25

1927 Begins to study at the School of the Museum of Fine Arts, Boston, where he stays until 1930

1930 Enters the Art Students League, New York

1934 Appointed official printer at the Art Students League

1935 Marries Mary Sinclair; children: Peter George, Richard Sinclair, Todd Williams

1936 Appointed Instructor of Graphic Arts and Composition, Art Students League

Joins the Works Progress Administration, Graphic Arts Project, New York Region, as Technical Advisor and Graphic Artist

1938 Appointed Instructor at the New School for Social Research, New York (through 1941)

Wins First Honorable Mention, Philadelphia Art Alliance

1942 Wins Mildred Boericke Prize, and three Honorable Mentions, the Print Club, Philadelphia

1943 Begins teaching at New Jersey State Teachers College, Newark (through 1945)

1944 Begins teaching at the Birch Wathen School, New York (through 1960)

Becomes Instructor in Graphic Arts, War Veterans Art Center, the Museum of Modern Art, New York (through 1946)

Given purchase prize, Seattle Art Museum

1945 Appointed Instructor of Graphic Arts, later Professor of Painting, Cooper Union for the Advancement of Science and Art, New York (through 1978)

Wins first prize for woodcut, the Print Club, Philadelphia

Appointed Instructor of Painting, Art Students League, New York (through 1980)

1947 Purchase Award, Brooklyn Museum

1951 Teaches in summer session, Montana State College, Bozeman

Receives Mary S. Collins Prize, the Print Club, Philadelphia

Instructor, People's Art Center, the Museum of Modern Art, New York

1952 Serves as Visiting Critic, School of Art and Architecture, Yale University, New Haven

Purchase Award, the Brooklyn Museum

Guest lecturer and critic, Memphis Academy of Arts

1953 Marries Elena Ona Ciurlys; child: Ona Willa

1954 Becomes a member of the faculty of Famous Artists School, Westport, Connecticut (through present day)

Visiting Artist, Munson-Williams-Proctor Institute, Utica, New York; gives lecture, "The Responsibility of the Amateur and Professional Painter in America"

1956 Serves as Visiting Lecturer, University of Wisconsin, Madison; gives lecture, "Painting Without Illusion"

1957 Teaches at Summer Artists Workshop, Regina College, Saskatchewan, Canada

1958 Teaches at Ohio University, Athens, and University of Minnesota, Duluth

1959 Instructor in Advanced Painting, summer session, University of Minnesota, Duluth

1960 Awarded Third W. A. Clark Prize, the Corcoran Gallery of Art, Washington, D.C.

1961 Albert List Purchase Award, New School for Social Research, New York

1963 Appointed Visiting Instructor in Advanced Painting, the Museum School, Museum of Fine Arts, Boston

Teaches in summer session, Washington State University, Spokane

1964 Receives Ford Foundation Grant, serves as Artist-in-Residence, Virginia Museum of Fine Arts, Richmond

Appointed Visitor to the Museum School, Museum of Fine Arts, Boston (renewed in 1965 and 1968)

1965 Serves as Visiting Artist, Des Moines Art Center

Appointed to the rank of full Professor, Cooper Union for the Advancement of Science and Art, New York

Chosen as Distinguished Visiting Professor of Art, Pennsylvania State University, University Park (renewed in 1966)

Visiting Professor, Virginia Polytechnic Institute, Blacksburg

1966 Teaches at Cornell University, Ithaca

1967 Appointed Instructor and critic at the Pennsylvania Academy of the Fine Arts, Philadelphia (through present day)

Lectures at University of Notre Dame, Indiana

1968 Receives the Walter Lippincott Prize for the best figure painting in oil by an American artist, Pennsylvania Academy of the Fine Arts, Philadelphia

1972 Commissioned by Vera List to do a print for the Jewish Museum, New York

1973 Elected to membership in the Century Association, New York

1974 Elected as an Associate Member of the National Academy of Design, New York

Receives Jefferson-Pilot Corporation Purchase Award

Lectures at the Solomon R. Guggenheim Museum, New York, on printmaking

1975 Commissioned to do an image for the *Kent Bicentennial Portfolio*

1976 Lectures at the Vatican Museum, Rome, "Personal Reflections on the Spiritual Values of American Art"

Elected to fellowship in the Royal Society of Arts, London

Commissioned by Kennedy Graphics to create an image for U.S. Olympic Editions 1976

1977 Awarded the Benjamin Altman Prize, National Academy of Design, New York

1979 Honored (with Julian Levi) at Art Students League Dinner, New York

Lectures at Ringling School of Art, Sarasota, Florida

1981 Awarded Childe Hassam Prize, American Academy and Institute of Arts and Letters, New York

Commissioned by the Dallas Opera to do a poster

Commissioned by WNET, New York, of the Public Broadcasting System, to do a poster

1982 Elected to membership in the American Academy and Institute of Arts and Letters, New York

Commissioned by Time Inc., to create a cover picture on arms control for *Time* magazine

1983 Gives commencement address at the School of the Museum of Fine Arts, Boston

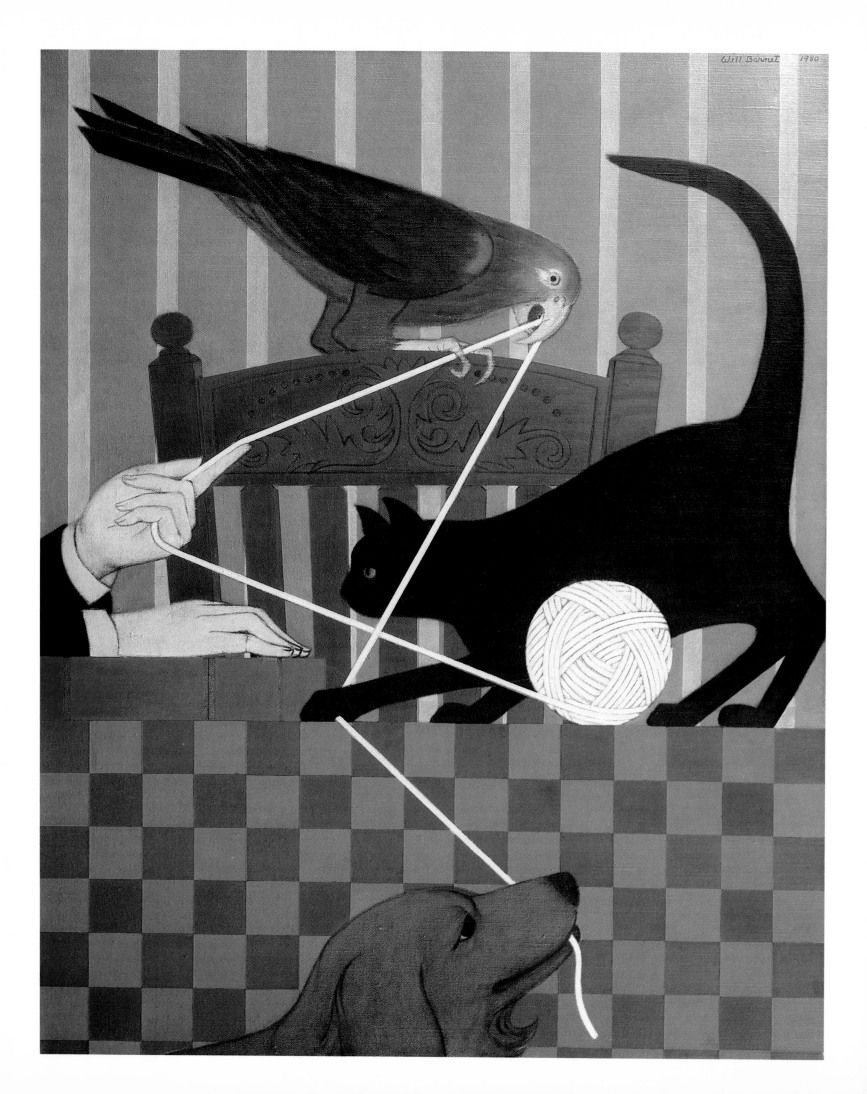

ONE-MAN EXHIBITIONS AND MAJOR CATALOGUES

1935 8th Street Playhouse, New York
1937 Hudson D. Walker Gallery, New York
 Philadelphia Art Alliance
1938 Hudson D. Walker Gallery, New York
1943 Galerie St. Etienne, New York
 The Neighborhood Club, Brooklyn, New York
 Virginia Museum of Fine Arts, Richmond
1945 Galerie St. Etienne, New York
 The Print Club, Philadelphia
1946 Arthur Harlow & Company, New York
 Bertha Schaefer, New York
1947 Bertha Schaefer, New York
1948 Bertha Schaefer, New York
1949 Bertha Schaefer, New York
1950 The Dallas Museum of Fine Arts
 Montana State College, Bozeman
 Stephens College, Columbia, Missouri
1951 "Will Barnet: New Color in Lithography," Bertha
 Schaefer, New York
 The Three Arts, Poughkeepsie, New York
1952 "Will Barnet Makes a Color Lithograph," the Ameri-
 can Federation of Arts, New York, and subse-
 quent tour
1953 Bertha Schaefer, New York
1954 Boris Mirski Art Gallery, Boston
 School of Art, Munson-Williams-Proctor Institute,
 Utica, New York
1955 Bertha Schaefer, New York
1956 New York University Art Gallery
1957 Esther Robles Gallery, Los Angeles
1958 "Will Barnet: A Retrospective Exhibition," Tweed
 Gallery, University of Minnesota, Duluth. Cata-
 logue introduction by Orazio Fumagalli
 "Selected Works of Will Barnet: 15 Years," Oscar
 Krasner Gallery, New York. Catalogue introduc-
 tion by John Knowlton

Opposite: THE GOLDEN THREAD.
1980. Oil on canvas, 46 × 37".
Courtesy Kennedy Galleries, Inc., New
York

147

1960 Peter H. Deitsch Gallery, New York
Bertha Schaefer, New York
Galleria Trastevere, Rome

1961 "Will Barnet," Institute of Contemporary Art, Boston. Catalogue introduction by Thomas M. Messer
Bertha Schaefer, New York

1962 Albany Institute of History and Art
Bertha Schaefer, New York

1963 Peter H. Deitsch Gallery, New York
Mary Harriman Gallery, Boston
Edward John Noble University Center, St. Lawrence University, Canton, New York

1964 Virginia Museum of Fine Arts, Richmond

1965 Des Moines Art Center
Grippi and Waddell, New York
The Wooster School, Danbury, Connecticut

1966 Grippi and Waddell, New York

1968 "Will Barnet Paintings 1966–1968," Waddell Gallery, New York. Catalogue introduction by Richard J. Boyle

1969 "Will Barnet in the Sixties," Peale House Galleries, Pennsylvania Academy of the Fine Arts, Philadelphia. Catalogue introduction by Richard J. Boyle

1970 Waddell Gallery, New York

1971 Fairweather-Hardin Gallery, Chicago

1972 David David Gallery, Philadelphia
"Will Barnet: Etchings, Lithographs, Woodcuts, Serigraphs, 1932–1972," Associated American Artists Gallery, New York. Catalogue introduction by Robert Doty

1973 "Recent Paintings by Will Barnet," Hirschl & Adler Galleries, Inc., New York. Catalogue introduction by Richard J. Boyle
Department of Art, Madison College, Harrisonburg, Virginia

1974 Graphics Gallery, Toronto
Harmon Gallery, Naples, Florida
"Will Barnet: 4 Decades of Graphic Works," Jorgensen Auditorium Gallery, University of Connecticut, Storrs
Meredith Long Gallery, Houston
"A One Man Show by Centurion Will Barnet," the Century Association, New York

1975 "Will Barnet: New Paintings," Hirschl & Adler Galleries, Inc., New York. Catalogue introduction by Daniel Catton Rich
Bear Gallery, Fairbanks, Alaska
Sordoni Art Gallery, Wilkes College, Wilkes-Barre, Pennsylvania

1977 Prince Arthur Galleries, Toronto
Louise Himelfarb, Water Mill, New York
The Print Club, Philadelphia
Swearingen Haynie Gallery, Louisville, Kentucky
"Will Barnet: Five Decades in Printmaking," Jane Haslem Gallery, Washington, D.C.

1978 Allentown Art Museum, Pennsylvania
Gallery Gemini, Paim Beach, Florida
Alice Simsar Gallery, Ann Arbor, Michigan
Posters Plus–Hamilton Street Gallery, Albany, New York
Tahir Gallery, New Orleans

1979 Associated American Artists Gallery, New York
"Will Barnet: Twenty Years of Painting and Drawing," Neuberger Museum, State University of New York, College at Purchase, and John and Mable Ringling Museum of Art, Sarasota, Florida. Catalogue essays: "Will Barnet: An Introduction" by Burt Chernow, "Will Barnet: Artist/Teacher" by Richard J. Boyle, "Will Barnet: An Appreciation" by Katherine Kuh
Mint Museum, Charlotte, North Carolina
Newport Gallery, Newport Beach, California

1980 Foster Harmon Galleries, Sarasota, Florida
Graduate School of Business and Public Administration, Cornell University, Ithaca, New York
Jeri Galleries, Marlboro, New Jersey
Documents, Paris
"Will Barnet Retrospective," the Essex Institute, Salem, Massachusetts

1981 Benjaman's Galerie, Buffalo, New York
"Will Barnet: New Paintings," Hirschl & Adler Galleries, Inc., New York. Catalogue introduction by Prescott Schulz
Southwest II Gallery, Dallas

1982 Associated American Artists Gallery, Philadelphia and New York
"Sittings: Portraits by Will Barnet," Terry Dintenfass Gallery, New York. Catalogue introduction by Katherine Kuh
Old Town Circle Gallery, San Diego, California

1983 "Will Barnet: Paintings and Prints 1932–1982," Wichita Art Museum, Kansas. Catalogue introduction by Howard E. Wooden

1984 "Will Barnet," the Currier Gallery of Art, Manchester, New Hampshire, and subsequent tour. Catalogue introduction by Robert Doty
Kennedy Galleries, New York

ARTIST AND SCHOLAR. 1982. Oil on Swiss vellum, 30 × 27½″.
Collection Mr. Dionigi Cossu and Dr. Rebecca Cort, New York

INTERLUDE. 1980. Oil on canvas, 30½ × 57⅞″. Private collection

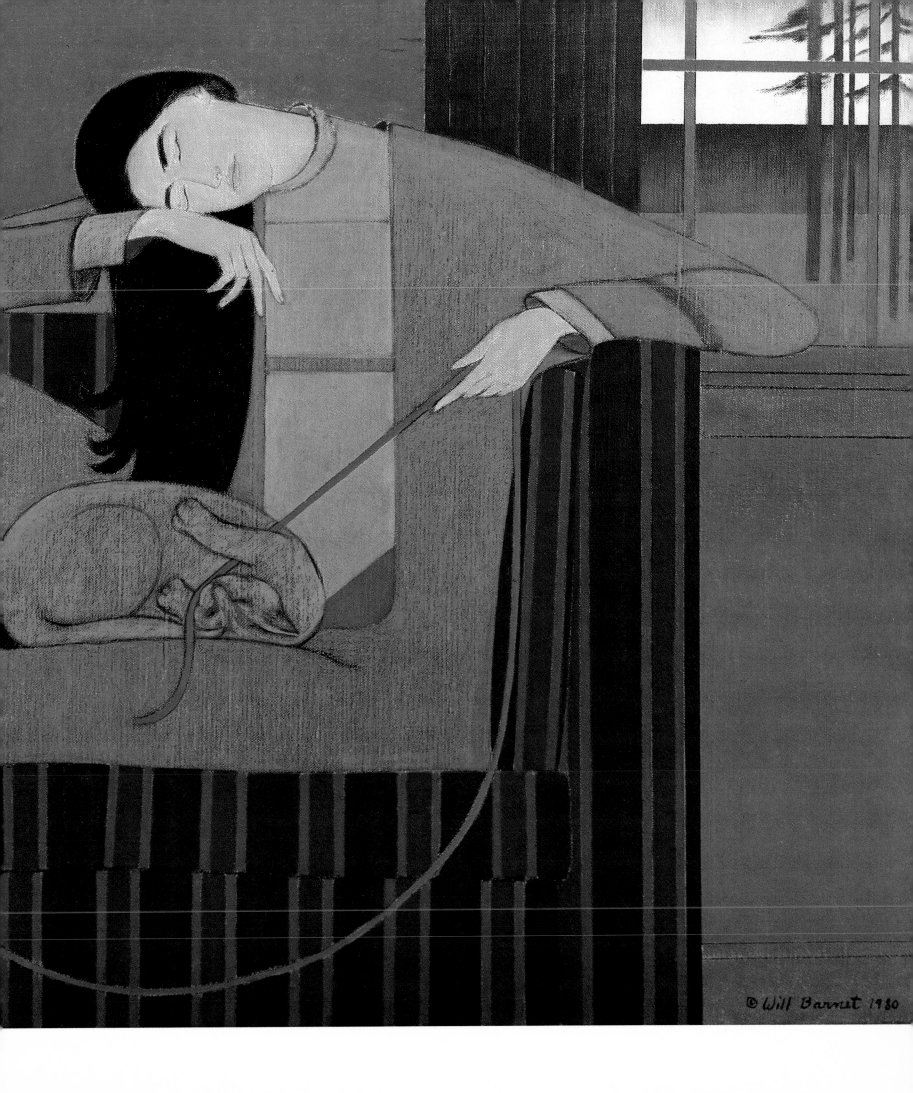

© Will Barnet 1980

GROUP EXHIBITIONS AND CATALOGUES

1934 "American Print Makers: Eighth Annual Exhibition," the Downtown Gallery, New York

 "Fifty American Prints," Architectural League, New York

1935 "Group Show," ACA Gallery, New York

1936 "Exhibition of Recent Fine Prints," Federal Art Gallery, New York

 "The Social Scene," American Artists School, New York

1937 "American Print Makers: Tenth Annual Exhibition," Midtown Galleries, New York

 "15th Annual of American Prints," Philadelphia Art Alliance

 "National Lithograph and Woodcut Exhibition," National Arts Club, New York

 "Will Barnet, Adolf Dehn, Frank Van Sloun," Hudson D. Walker Gallery, New York

1938 "Group Show," Hudson D. Walker Gallery, New York

 "Group Show," Municipal Art Galleries, New York

 "16th Annual Exhibition of American Prints," Philadelphia Art Alliance

 "Eighth Exhibition of Prints," American Institute of Graphic Arts, New York

1939 "America at Play," Wanamaker Gallery, New York

 "American Art Today," World's Fair, Flushing, New York

 "American Print Makers: Eleventh Annual Exhibition," Associated American Artists Gallery, New York

 "Fifth International Exhibition: Etching and Engraving," Art Institute of Chicago

 "First Annual Membership Exhibition: American Artists Congress," Rockefeller Center, New York

1941 "The Vanguard," Harlow, Keppel & Company, New York

1942 "Third Annual Exhibition of The American Color Print Society," the Print Club, Philadelphia

"The 14th Annual Exhibition of American Lithography," the Print Club, Philadelphia

"The 16th Annual Exhibition of American Block Prints and Wood Engravings," the Print Club, Philadelphia

"The 19th Annual Exhibition of American Etching," the Print Club, Philadelphia

"The Vanguard," Harlow, Keppel & Company, New York

1943 "Adventures in Perspective," Norlyst Gallery, New York

"America in the War," exhibited simultaneously in twenty-six museums

"The Vanguard," Harlow, Keppel & Company, New York

1944 "An American Group, Inc.: Thirteenth Annual Exhibition," American-British Art Center, New York

"Fifty American Prints," American Institute of Graphic Arts, Society of Illustrators, New York

"Painting in the United States, 1944," Department of Fine Arts, Carnegie Institute, Pittsburgh

"Recent Accessions," Whitney Museum of American Art, New York

"Selected Intimate Paintings by American Artists," Babcock Galleries, New York

1945 "Painting in the United States, 1945," Department of Fine Arts, Carnegie Institute, Pittsburgh

"The Nineteenth Biennial Exhibition of Contemporary American Oil Painting," the Corcoran Gallery of Art, Washington, D.C.

"Cameron Booth and Will Barnet," Bertha Schaefer, New York

"12 American Painters," Bertha Schaefer, New York

1947 "Fact and Fantasy 1947," Bertha Schaefer, New York

"First National Print Exhibition," the Brooklyn Museum

"The Twentieth Biennial Exhibition of Contemporary American Oil Paintings," the Corcoran Gallery of Art, Washington, D.C.

1948 "Fact and Fantasy 1948," Bertha Schaefer, New York

"In Gouache and Crayon," Bertha Schaefer, New York

"Thirty-Third Annual Exhibition: The Society of American Etchers, Gravers, Lithographers and Woodcutters, Inc.," New York

1949 "The Child in Modern Paintings," Emmerick Gallery, New York

"Graphics/Ceramics," Bertha Schaefer, New York

"Technical Processes in Contemporary Printmaking," University Gallery, University of Minnesota, Minneapolis

1950 "American Painting Today," the Metropolitan Museum of Art, New York

"First International Biennial of Contemporary Color Lithography," Cincinnati Art Museum and subsequent tour

"7 Painter-Printmakers," Jacques Seligmann Galleries, New York

"6 Modern American Painters," Bertha Schaefer, New York

1951 "American Printmakers," the Contemporaries, New York

"Annual Exhibition of Lithography," the Print Club, Philadelphia

"Fact and Fantasy 1951," Bertha Schaefer, New York

1952 "Color Prints by 10 Well-known Painters," the Contemporaries, New York

"9 American Artists," Tweed Gallery, University of Minnesota, Duluth

"Sixth National Print Exhibition," the Brooklyn Museum, New York

1953 "1953 Annual Exhibition: Contemporary American Painting," Whitney Museum of American Art, New York

"Contemporary American Watercolors," John Herron Art Museum, Indianapolis

"International Water Color Exhibition: Seventeenth Biennial," the Brooklyn Museum, New York

"Nebraska Art Association Sixty-third Annual Exhibition," University Galleries, University of Nebraska, Lincoln

"Prints—1942–1952," Brooks Memorial Art Gallery, Memphis, Tennessee

"14 Painter-Printmakers," the Stable Gallery, New York

1954 "Eighteenth Annual American Abstract Artists 1954," Riverside Museum, New York

"Fact and Fantasy 54," Bertha Schaefer, New York

"14 Painter-Printmakers," Kraushaar Galleries, New York

1955 Art Students League, New York

"14 Painter-Printmakers," the Brooklyn Museum. Catalogue introduction by John Gordon and Una Johnson

"Exhibition of the Works of Visiting Critics, Department of Design, Yale University, 1951–1955," Street Hall, Yale University, New Haven

"Fact and Fantasy 55," Bertha Schaefer, New York

"44th Annual Exhibition of Contemporary American Painting," Randolph-Macon Woman's College, Lynchburg, Virginia

"Will Barnet, Cameron Booth, Balcomb Greene," Bertha Schaefer, New York

1956 "40th Annual Exhibition of The Society of American Graphic Artists," Architectural League, New York

"Circulating Gallery," Dayton Art Institute, Ohio

"Fact and Fantasy 56," Bertha Schaefer, New York

"Ten Years of American Prints, 1947–56," the Brooklyn Museum

"Tribute to Modern Art, USA," Bertha Schaefer, New York

1957 "41st Annual Exhibition of The Society of American Graphic Artists," Architectural League, New York

"American Paintings 1945–1957," the Minneapolis Institute of Arts. Catalogue introduction by Stanton L. Catlin

"American Abstract Artists: 21st Annual Exhibition," the Contemporaries, New York

"American Abstract Painting Today," the Norman McKenzie Art Gallery, University of Saskatchewan, Regina, and subsequent tour

"Coast Meets Coast," Esther Robles Gallery, Los Angeles

"Columbia Painting Biennial," the Columbia Museum of Art, South Carolina

"Major Artists," Esther Robles Gallery, Los Angeles

"1957 Annual Exhibition: Sculpture, Paintings, Watercolors," Whitney Museum of American Art, New York

"Fact and Fancy," Bertha Schaefer, New York

"Painter-Printmaker," Kraushaar Galleries, New York

"Twenty Fifth Biennial Exhibition of Contemporary American Oil Paintings," the Corcoran Gallery of Art, Washington, D.C.

1958 "First Provincetown Art Festival," Provincetown, Massachusetts

"Group 256," Riverside Museum, New York

"An Invitational Exhibition of New York State Artists," New York State Fair, Syracuse

1959 "42nd Annual Exhibition of The Society of American Graphic Artists," Riverside Museum, New York

"23rd Annual Exhibition of the American Abstract Artists," Betty Parsons Gallery, New York

"Twenty Sixth Biennial Exhibition of Contemporary American Oil Paintings," the Corcoran Gallery of Art, Washington, D.C.

1960 "43rd Annual Exhibition of The Society of American Graphic Artists," IBM Gallery, New York

"American Art Today and Yesterday," Memorial Union, Iowa State University, Iowa City

"Barnet, Sugai, Leyden," the Arts Club of Chicago

"Contemporary Drawings—American and European," Bertha Schaefer, New York

"Humanists of the 60's," the New School Art Center, New York

"International Biennial Exhibition of Prints," Tokyo

"Recent Acquisitions," the Museum of Modern Art, New York

1961 "Annual Exhibition 1961: Contemporary American Painting," Whitney Museum of American Art, New York

"Second Annual Invitational Print Show," Brooks Memorial Art Gallery, Memphis, Tennessee

"Sixth International Art Exhibition," Metropolitan Art Gallery, Tokyo

"Twenty Seventh Biennial Exhibition of Contemporary American Oil Paintings," the Corcoran Gallery of Art, Washington, D.C.

"WPA Prints," Ira Smolin Gallery, New York

1962 "44th Annual Exhibition of The Society of American Graphic Artists," Associated American Artists Gallery, New York

"Geometric Abstraction in America," Whitney Museum of American Art, New York. Catalogue introduction by John Gordon

"S.C. Johnson & Son Collection of American Art," Milwaukee Art Center and subsequent tour

"Paintings by Five Americans," Bertha Schaefer, New York

"The One Hundred and Fifty-Ninth Annual Exhibition: American Painting and Sculpture," Pennsylvania Academy of the Fine Arts, Philadelphia

1963 "45th Annual Exhibition of The Society of American Graphic Artists," Associated American Artists Gallery, New York

"22nd Annual Exhibition of the Federation of Modern Painters and Sculptors," Lever House, New York

"Twenty Eighth Biennial Exhibition of Contemporary American Oil Paintings," the Corcoran Gallery of Art, Washington, D.C.

"Mother and Child in Modern Art," the American Federation of Arts, New York, and subsequent tour

"Museum Collection," the Solomon R. Guggenheim Museum, New York

"Print Blocks and Plates," Joseph Grippi Gallery, New York

"Science, Technology and Art," IBM Gallery, New York

1964 "Contemporary American Woodcut and Its Variations," United States Information Agency. Catalogue introduction by Una Johnson

"14th National Print Biennial," the Brooklyn Museum and subsequent tour

"Golden Anniversary Exhibition," Provincetown Art Association, Massachusetts

"National Invitational Print Exhibition," Art Galleries, California State College at Long Beach

"Recent Accessions," University of Massachusetts, Amherst

"The Red Show," Greenross Gallery, New York

"25th Anniversary Show," Galerie St. Etienne, New York

1965 "46th Annual Exhibition of The Society of American Graphic Artists," Associated American Artists Gallery, New York

"1965 Annual Exhibition: Contemporary American Painting," Whitney Museum of American Art, New York

"Unique Images," Joseph Grippi Gallery, New York

"New England Art Faculty Invitational Exhibition," Silvermine Guild of Artists, New Canaan, Connecticut

1966 "47th Annual Exhibition of The Society of American Graphic Artists," the Pepsi Cola Gallery, New York

"First American Masters Exhibition," Collectors Gallery, Inc., Miami

"The First Flint Invitational," Flint Institute of Arts, Michigan. Catalogue introduction by G. Stuart Hodge

"Will Barnet, George Mueller—Realism/Abstraction," Waddell Gallery, New York

"The Collection of the Sara Roby Foundation," the American Federation of Arts, New York, and subsequent tour

"Recent Graduates of the Museum School," the Copley Society, Boston

"A Salute to the Artists of the West Side," Gallery 72 West, New York

1967 "48th Annual Exhibition of The Society of American Graphic Artists," Associated American Artists Gallery, New York

"American Masters—Art Students League," the American Federation of Arts, New York, and subsequent tour

1968 "The One Hundred and Sixty-Third Annual Exhibition: American Painting and Sculpture," Pennsylvania Academy of the Fine Arts, Philadelphia

"Giant Prints," the Art Gallery, State University of New York at Albany, and subsequent tour

1969 "The One Hundred and Sixty-Fourth Annual Exhibition: American Painting and Sculpture," Pennsylvania Academy of the Fine Arts, Philadelphia

"Contemporary American Painting and Sculpture 1969," Krannert Art Museum, University of Illinois, Champaign. Catalogue introduction by James R. Shipley and Allen S. Weller

"2nd Flint Invitational," Flint Institute of Arts, Michigan. Catalogue introduction by G. Stuart Hodge

1970 "Twentieth Anniversary Exhibition," Tweed Gallery, University of Minnesota, Duluth

1971 "Accessions 1970–1971," the University of Iowa Museum of Art, Iowa City. Catalogue introduction by Ulfert Wilke

"The Indignant Eye," the American Federation of Arts, New York, and subsequent tour

1972 "American Abstract Artists," Fairleigh Dickinson University, Madison, New Jersey

"Americans: Individuals at Work, From the Sara Roby Foundation Collection," the American Federation of Arts, New York, and subsequent tour

"36th Annual Midyear Show," the Butler Institute of American Art, Youngstown, Ohio

1973 "23rd National Exhibition of Prints," Library of Congress, Washington, D.C.

1974 "38th Annual Midyear Show," the Butler Institute of American Art, Youngstown, Ohio

"Davidson National Print and Drawing Competition," Davidson College, North Carolina

World's Fair, Spokane, Washington

1975 "Drawing America," Albrecht Art Museum, St. Joseph, Missouri. Catalogue introduction by Jim Ray

"Drawings USA 75," Minnesota Museum of Art, Saint Paul. Catalogue introduction by Malcolm E. Lein

"The Kennedy Galleries Are Host to the Hundredth Anniversary Exhibition of Painting and Sculptures by 100 Artists Associated with The Art Students League of New York," the Kennedy Galleries, New York. Catalogue text by Lawrence Campbell

"New York by Artists of The Art Students League of New York: In Celebration of the Centennial Year of The Art Students League of New York," the Museum of the City of New York. Catalogue introduction by Joseph V. Noble

"One Hundred Prints by 100 Artists of The Art Students League of New York, 1875–1975," Associated American Artists Gallery, New York. Catalogue text by Judith Goldman

"Kent Bicentennial Portfolio: Spirit of Independence," Lorillard, New York. Catalogue introduction by John I. H. Baur

"150th Annual Exhibition," National Academy of Design, New York

"39th Annual Midyear Show," the Butler Institute of American Art, Youngstown, Ohio

1976 "Aspects of American Realism, Selections from the Sara Roby Foundation Collection," the Grey Art Gallery and Study Center, New York University, New York

"A Museum Menagerie," the Museum of Modern Art, New York

"Spiritual Inspiration in American Art," the Vatican Museum, Rome

1977 "Art in Transition: A Century of the Museum School," Museum of Fine Arts, Boston. Catalogue text by Bartlett Hayes

"Barnet the Elder & Barnet the Younger," Discovery Art Galleries, Clifton, New Jersey

"Contemporary Aubusson Tapestries," World Trade Center, New York

"Invitational American Drawing Exhibition," Fine Arts Gallery of San Diego, California

"New York City WPA Art," Parsons School of Design, New York. Catalogue introduction by Emily Genauer

"Perceptions of the Spirit in Twentieth Century American Art," Indianapolis Museum of Art and subsequent tour. Catalogue text by John and Jane Dillenberger

"Provincetown Painters: 1890s–1970s," Everson Museum of Art, Syracuse, New York. Catalogue foreword by Ronald A. Kuchta, text by Dorothy Seckler

"30 Years of American Printmaking," the Brooklyn Museum. Catalogue text by Gene Baro

1978 "Grabadores Norteamericanos / Barnet, Colescott, Kipniss, Nanao," Museo de Arte Moderne La Tertulia, Cali, Colombia

"42nd Annual Midyear Show," the Butler Institute of American Art, Youngstown, Ohio

"The Sara Roby Foundation Collection," University Art Gallery, State University of New York at Binghamton. Catalogue foreword by Jill Elyse Grossvogel

"Works from the Collection of Dorothy and Herbert Vogel," the University of Michigan Museum of Art, Ann Arbor. Catalogue introduction by Bret Waller

1979 "Born in Boston," De Cordova Museum, Lincoln, Massachusetts. Catalogue introduction by Jeffrey Deitch

Discovery Art Galleries, Clifton, New Jersey (exhibited with his son Peter)

"West '79 / The Law," Minnesota Museum of Art, Saint Paul

1980 "Portraits Real and Imagined," Guild Hall Museum, East Hampton, New York. Catalogue introduction by Eloise Spaeth

"West '80: Art and the Law," Minnesota Museum of Art, Saint Paul

1981 "Recent Acquisitions 1979–1981: Gifts from Academicians and Associates of the National Academy of Design," National Academy of Design, New York. Catalogue introduction by Mario Amaya

"Masters of American Realism, Selections from the Sara Roby Foundation Collection 1920–1980," Fort Wayne Museum of Art, Indiana

1982 "Americans and the Sea," Pensacola Museum of Art, Florida

"Masterworks by Artists of New England," the Currier Gallery of Art, Manchester, New Hampshire

1983 "The Sailor 1930–1945," the Chrysler Museum, Norfolk, Virginia. Catalogue introduction by Thomas W. Sokolowski

BIBLIOGRAPHY

WRITINGS BY THE ARTIST

"Technical Supplement" (with Harry Sternberg). In *Concerning the Education of a Print Collector* by André Smith. New York: Harlow, Keppel & Co., 1941.

"Chardin." *The League* 14 (November 1942), cover, pp. 4–5.

"The Resurrection of Block Print Making." *The League*, April 1944, p. 7.

Statement in *Technical Processes in Contemporary Printmaking*. Minneapolis: University Gallery, University of Minnesota, 1949.

"Painting Without Illusion." *The League Quarterly* 22 (Spring 1950), pp. 8–9.

"Aspects of American Abstract Painting." In *The World of Abstract Art*, edited by the American Abstract Artists. New York: George Wittenborn Inc., 1957.

"A Letter to an English Critic." *Castalia* 1 (Fall 1961), pp. 66–69. Also published in *The Pioneer* 44 (November 20, 1964), p. 4.

"Unique Images." *Art in America* 51 (December 1963), pp. 70–71.

Statement in *Will Barnet: New Paintings*. New York: Grippi and Waddell, 1966, p. 2.

"Adventures in Limestone." In *The Lithographs of Ture Bengtz*. Duxbury, Massachusetts: The Art Complex Museum, 1978, p. 45.

"Artist in the Library." *The Quarterly Journal of the Library of Congress* 40 (Summer 1983), pp. 180–87.

WRITINGS ABOUT THE ARTIST

Books

Alexenberg, M. *Aesthetic Experience in Creative Process.* Ramat Gan, Israel: Bar-Ilan University Press, 1981.

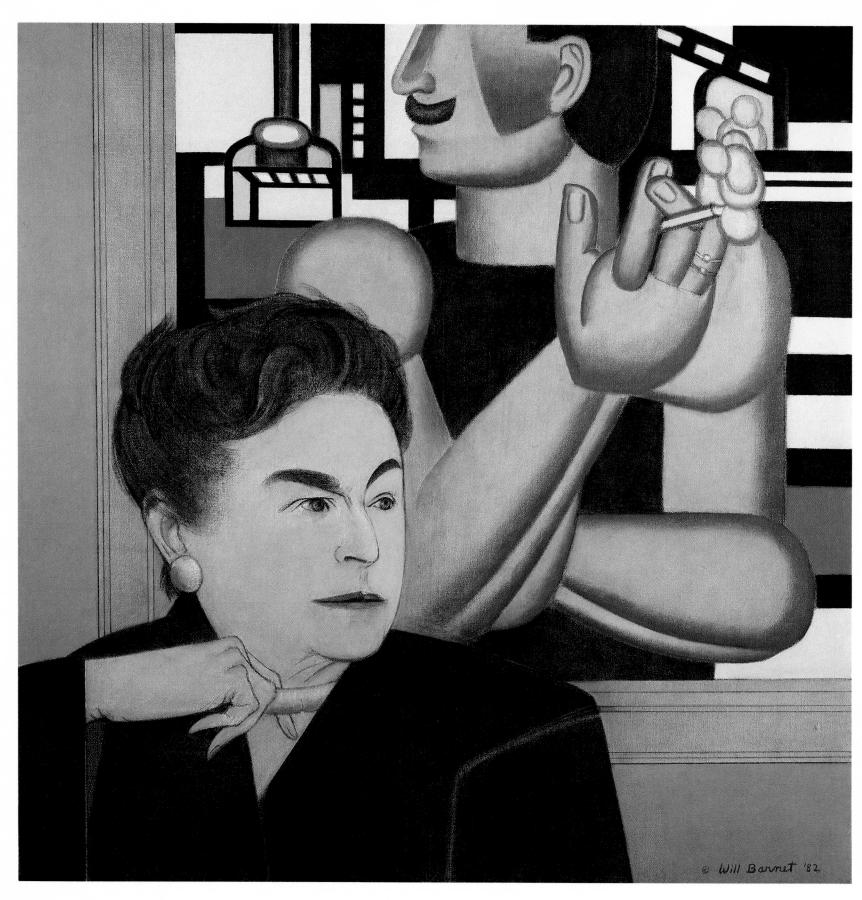

HOMAGE TO LEGER, WITH K. K. 1982. Oil on canvas, 39½ × 39½".
Private collection

American Artists' Congress, ed. *America Today: A Book of 100 Prints*. New York: Equinox Cooperative Press, 1936.

Barnet, Peter. "Will Barnet: Artist and Teacher." Dissertation, School of Education, New York University, 1974.

Cole, Sylvan, Jr., ed. *Will Barnet (1932–1972)*. New York: Associated American Artists Gallery, 1972.

Cummings, Paul. *A Dictionary of Contemporary American Artists*. New York: St. Martins Press, 1971.

Farland, Evelyn and Leo. *Posters By Painters*. New York: Harry N. Abrams, Inc., 1978.

Farrell, James T. *The Paintings of Will Barnet*. New York: Press Eight, 1950.

Guitar, Mary Anne. *22 Famous Painters and Illustrators Tell How They Work*. New York: David McKay Company, Inc., 1964.

Hale, Robert Beverly. *Will Barnet: Twenty-Seven Paintings Completed During the Period 1960–1968*. New York: Waddell Gallery, 1968.

Hayter, S. W. *About Prints*. London: Oxford University Press, 1962.

Heller, Jules. *Printmaking Today: A Studio Handbook*. New York: Holt, Rinehart and Winston, Inc., 1972.

Janis, Harriet, and Blesh, Rudi. *Collage: Personalities, Concepts, Techniques*. New York: Chilton Book Company, 1961.

Johnson, Una E. *Will Barnet: Prints 1932–1964*. Brooklyn, New York: The Brooklyn Museum, 1965.

———. *American Prints and Printmakers*. Garden City, New York: Doubleday & Company, Inc., 1980.

Meyer, Susan E. *Will Barnet: 27 Master Prints*. New York: Harry N. Abrams, Inc., 1979.

Nordness, Lee, ed. *Art: USA: Now*. New York: The Viking Press, 1963.

O'Neill, John P. *Metropolitan Cats*. New York: The Metropolitan Museum of Art and Harry N. Abrams, Inc., 1981.

Reese, Albert. *American Prize Prints of the 20th Century*. New York: American Artists Group, Inc., 1949.

Saff, Donald, and Sacilotto, Deli. *Printmaking: History and Process*. New York: Holt, Rinehart and Winston, 1977.

Zigrosser, Carl. *Prints and Their Creators: A World History*. New York: Crown Publishers, Inc., 1974.

Periodicals

Adlow, Dorothy. "Paintings from Many Places, Including the Fiftieth State." *The Christian Science Monitor*, February 13, 1960, p. 4.

———. "Whiplash: An Oil Painting by Will Barnet." *The Christian Science Monitor*, March 5, 1960, p. 18.

———. "Paintings by Will Barnet." *The Christian Science Monitor*, August 21, 1961, p. 11.

"An Amateur Draws the Model." *Art News* 51 (November 1952), p. 8.

Arb, Renee. "Barnet Turns Children into Vital Design." *Art News* 44 (February 1946), pp. 100–101.

Arms, Dorothy Noyes. "Annual Print Exhibition." *The Print Collectors Quarterly* 29 (February 1949), p. 16.

Arms, John Taylor. "Printmakers' Processes and a Militant Show." *Art News* 42 (October 1943), pp. 9–14, 32.

Ashton, Dore. "Fifty-Seventh Street in Review: Will Barnet." *The Art Digest* 26 (November 1951), p. 56.

———. "Will Barnet, Humanist." *The Art Digest* 26 (January 1952), p. 22.

———. "Art: Paintings by Barnet." *New York Times*, October 2, 1958, p. 43.

Barnitz, Jacqueline. "In the Galleries: Will Barnet." *Arts Magazine* 39 (May 1965), p. 61.

———. "Will Barnet's Abstract Portraits." *Arts Magazine* 40 (April 1966), pp. 48–49.

Beals, Kathie. "Art is Heaven to Talented Will Barnet." *Gannett Westchester Newspapers*, November 5, 1979, p. B-1.

Benbow, Charles. "Barnet's Vision Creates an Oasis of Tranquility." *St. Petersburg Times*, April 20, 1980, p. E-1.

Berg, Helene. "Prints Haunting and Enigmatic." *Staten Island Sunday Advance*, December 19, 1976, p. E-6.

Betz, Margaret. "New York Reviews: Will Barnet." *Art News* 75 (December 1976), p. 114.

Bornstein, Karen. "The Unique Tranquil Artistry of Will Barnet." *The Michigan Daily* (Ann Arbor), April 4, 1978, p. 18.

Boyle, Richard J. "Paintings of the Later 20th Century." *The Cincinnati Art Museum Bulletin* 8 (October 1968), p. 16.

———. "The World of Will Barnet." *Famous Artists Magazine* 19 (March 1971), pp. 12–17.

———. "Will Barnet—The Survival of an Individualist." *Art News* 72 (October 1973), pp. 81–83.

Breuning, Margaret. "Will Barnet Gains." *The Art Digest* 19 (February 1946), p. 19.

———. "Fifty-Seventh Street in Review: Barnet More Abstract." *The Art Digest* 22 (March 1948), p. 23.

———. "Fifty-Seventh Street in Review: Will Barnet." *The Art Digest* 27 (March 1953), p. 20.

———. "Retrospective of Will Barnet." *Arts* 33 (October 1958), pp. 50–51.

Brown, Gordon. "In the Galleries: Will Barnet." *Arts Magazine* 42 (March 1968), p. 64.

———. "Will Barnet at Waddell." *Arts Magazine* 44 (April 1970), p. 57.

Browne, Rosalind. "Reviews and Previews: Will Barnet." *Art News* 64 (May 1965), p. 15.

————. "Reviews and Previews: Will Barnet." *Art News* 67 (March 1968), p. 11.

————. "Reviews and Previews: Will Barnet." *Art News* 69 (May 1970), p. 20.

Bryant, Kathy. "A Decade of Prints." *Newport Ensign* (Newport Beach, California), April 20, 1979, p. 20.

Campbell, Lawrence. "Reviews and Previews: Will Barnet." *Art News* 54 (April 1955), p. 47.

————. "Will Barnet." *Pen and Brush* 3 (July–August 1955), pp. 12–14.

————. "Reviews and Previews: Contemporaries." *Art News* 55 (April 1956), p. 85.

————. "Reviews and Previews: Will Barnet." *Art News* 58 (February 1960), p. 13.

————. "Reviews and Previews: Paintings by Five Americans." *Art News* 61 (March 1962), p. 52.

Carlson, Helen. "Many Approaches Liven New Shows." *New York Sun*, January 31, 1947, p. 26.

Chernow, Burt. "Utamaro and Barnet Struggle for Simplicity." *Fair Press* (Fairfield, Connecticut), August 23, 1978, p. 16.

————. "The Tranquil World of Will Barnet." *Fairfield's Feature Magazine* 1 (November 1979), pp. 26–28, 46.

Colker, Ed. "Independent Art Schools: Traditions and Departures." *Art Journal* 42 (Spring 1982), pp. 24–27.

Courtney, Marian. "Barnets Show Art." *The Herald News* (Northern New Jersey), February 17, 1977, p. B-4.

Day, Worden. "Will Barnet." *Art News* 61 (February 1963), p. 10.

Dean, Kevin. "Later Tonight: A Conversation with Will Barnet." *The Longboat Observer* (Florida), April 18, 1980, p. 6, and April 25, 1980, p. 6.

Dennison, George. "In the Galleries: Will Barnet." *Arts Magazine* 34 (March 1960), p. 60.

Devree, Howard. "A Reviewer's Notebook." *New York Times*, October 3, 1943, p. X11.

————. "Provincetown Festival Opens in Tents." *New York Times*, July 20, 1958, p. 6X.

Donohoe, Victoria. "Barnet's Prints Are Opulent." *Philadelphia Inquirer*, April 1, 1977, p. 3-C.

————. "Art." *Philadelphia Inquirer*, April 11, 1982, p. 8-R.

Dunn, Rita Jean. "Will Barnet Exhibit at Contemporary Art Institute." *Beverly Evening Times* (Massachusetts), August 15, 1961, p. 21.

Eichenberg, Fritz, ed. "Printmaking: A Family Affair." *Artists' Proof* 3 (Spring–Summer 1963), pp. 19–31.

Florescu, Michael. "The Portraiture of Will Barnet." *Arts Magazine* 57 (April 1983), pp. 120–21.

Forman, Nessa. "Crumple It Won't." *Philadelphia Sunday Bulletin*, April 3, 1977, p. 23.

Fosberg, S. Joslyn. "Will Barnet-Oriental Delicacies." *The Courier* (New Orleans), March 23, 1978, p. 8.

Gallati, Barbara. "Reviews: Will Barnet." *Arts Magazine* 55 (June 1981), p. 31.

Genauer, Emily. "Art in Village." *New York World-Telegram*, August 31, 1935, p. 24.

Gibbs, Josephine. "Booth and Barnet." *The Art Digest* 19 (January 1945), p. 23.

Gibson, Ann. "Painting Outside the Paradigm: Indian Space." *Arts* 57 (February 1983), pp. 98–104.

Glueck, Grace. "Who's Minding the Easel?" *Art in America* 56 (January 1968), p. 111.

Goldfarb, Myra Y. "Modern Artists." *Morning Call* (Allentown, Pennsylvania), March 2, 1978, p. B-5.

Goldstein, Ben. "Daumier's Spirit in American Art." *Print Review*, no. 11 (1980), pp. 127–44.

Gray, Cleve. "Anniversary Album." *Art in America* 51 (February 1963), pp. 70–71.

Guest, Barbara. "Reviews and Previews: Will Barnet." *Art News* 52 (March 1953), p. 36.

Guitar, Mary Anne. "Close-up of the Artist: Will Barnet." *Famous Artists Magazine* 11 (Autumn 1962), pp. 14–17, 28.

Haas, Irwin. "The Print Collector: Art Students League Prints." *Art News* 49 (March 1950), p. 60.

Hammond, Sally. "In the Art Galleries." *New York Post*, June 25, 1961, p. 18.

Henry, Gerrit. "Review of Exhibitions: Will Barnet at Dintenfass." *Art in America* 71 (March 1983), pp. 153–54.

Hertel, François. "Will Barnet." *Rythmes et Couleurs*, no. 19 (September–October 1960), pp. 25–29.

Hoffman, Andrea. "Art." *The Tribune* (San Diego, California), January 15, 1982, p. A-24.

Horowitz, Leonard. "Abstract and Concrete." *Art Voices* 4 (Summer 1965), pp. 51–52.

Iglehart, Ruth. "Handsome Tribute to an Artist's Maturity." *Ann Arbor News*, March 26, 1978, p. B-2

Inman, Pauline W. "A History of the Society of American Graphic Artists." *Artists' Proof* 3 (Fall–Winter 1963–64), pp. 40–45.

Jacobs, Jay. "Pertinent and Impertinent: Printmaker." *The Art Gallery* 16 (October 1972), pp. 9–10.

Katz, Bob. "Coming Home." *North Shore: Sunday* (Beverly, Massachusetts), September 21, 1980, pp. 3–8.

Katz, Paul, and Jackson, Ward, eds. "Will Barnet." *Art Now: New York* 2 (June 1970), p. 2.

Kistler, Aline. "Prints of the Moment." *Prints* 8 (October 1937), pp. 34–37.

————. "Barnet Preaches No Angry Propaganda." *The Art*

Digest 13 (December 1938), p. 17.

————. "New Exhibitions of the Week." *Art News*, December 1938, p. 23.

Lansdell, Sarah. "Strip Art of Its Junk, Will Barnet Urges." *The Courier-Journal* (Louisville, Kentucky), October 6, 1977, p. C-6.

Lansford, Alonzo. "Childlike, Not Childish." *The Art Digest* 21 (February 1947), p. 16.

Lewis, Cynthia. "Will Barnet: American Artist." *The Dallas Opera Magazine* 4 (November 1981), p. 68.

Longaker, Jon D. "Art in Richmond." *Richmond Times-Dispatch*, May 24, 1964, p. L-2.

Loupe, Valerie. "The World of Art." *New Orleans Times-Picayune*, March 2, 1978, p. 11.

McCoy, Garnett, ed. "The Will Barnet Papers." *Archives of American Art Journal* 13, no. 2 (1973), pp. 25–27.

McLaughlin, Lillian. "Artist Finds Unique Beauty in Iowa." *Des Moines Tribune*, June 21, 1965, p. 9.

Mellow, James R. "In the Galleries: Will Barnet." *Arts* 34 (February 1960), pp. 58–59.

Morse, John D., ed. "Will Barnet." *Art Students League News* 2 (April 1, 1949), p. 3.

Neilson, Winthrop. "The Complete Individualist: Will Barnet." *American Artist* 37 (June 1973), cover, pp. 38–45, 72.

Northrup, Guy, Jr. "Will Barnet to Lecture, Show Work." *The Commercial Appeal* (Memphis, Tennessee), November 23, 1952, p. 10.

O'Beil, Hedy. "Contemporary Aubusson Tapestries." *Arts Magazine* 52 (April 1978), p. 18.

————. "Will Barnet." *Arts Magazine* 55 (May 1981), p. 15.

Piene, Nan R. "New York: Gallery Notes." *Art in America* 54 (January 1966), p. 120.

Poroner, Palmer. "Will Barnet Finds the Public Is Its Own Tastemaker." *Artspeak* 3 (February 12, 1981), p. 7.

Preston, Malcolm. "Art/Contemporary Prints." *Newsday*, October 12, 1978, p. 24.

Preston, Stuart. "Printmaker's Art." *New York Times Magazine*, April 29, 1956, pp. 28–29.

————. "Points of View." *New York Times*, February 14, 1960, p. 18X.

"Prints and Drawings Exhibited at Hudson D. Walker Gallery." *Daily Worker* (New York), December 8, 1938, p. 7.

Purdie, James. "Barnet Finds Human Depth on a Flat Canvas." *The Globe and Mail* (Toronto), January 17, 1977, p. 12.

Ratcliff, Carter. "Will Barnet (Waddell Gallery)." *Art International* 14 (May 1970), p. 78.

Raynor, Vivien. "In the Galleries: Graphics." *Arts Magazine* 37 (March 1963), p. 72.

————. "20 Years of Will Barnet at Neuberger." *New York Times*, November 18, 1979, p. 35.

Reed, Judith K. "World of Childhood." *The Art Digest* 24 (November 1949), p. 19.

Reilly, Richard. "Will Barnet Exhibit Paints a Mood of Mystery." *The San Diego Union*, February 7, 1982, p. E-10.

"Reviews and Previews: Will Barnet." *Art News* 45 (February 1947), p. 47.

"Reviews and Previews: Will Barnet." *Art News* 47 (March 1948), p. 49.

Riley, Maude. "Fifty-Seventh Street in Review: Will Barnet New Prints." *The Art Digest* 18 (October 1943), p. 19.

————. "The Passing Shows." *Art News*, January 1945, p. 26.

Rosenberg, Jakob. "Recent Acquisitions of the Department of Prints." *The Bulletin of the Fogg Museum of Art* 9 (November 1941), pp. 103–6.

Rosenblum, Robert. "Will Barnet." *The Art Digest* 29 (April 1955), p. 22.

Russell, John. "Will Barnet." *New York Times*, December 28, 1979, p. C-15.

Sandler, Irving. "Reviews and Previews: Will Barnet." *Art News* 56 (April 1957), p. 55.

Schiff, Bennett. "In the Art Galleries." *New York Post*, February 14, 1960, p. M-12.

Schjeldahl, Peter. "Reviews and Previews: Will Barnet." *Art News* 65 (October 1966), p. 10.

Schuyler, James. "Reviews and Previews: Will Barnet." *Art News* 57 (October 1958), p. 14.

Seckler, Dorothy. "Reviews and Previews: Will Barnet." *Art News* 48 (October 1949), p. 46.

————. "Can Painting Be Taught? Barnet Answers." *Art News* 49 (November 1950), pp. 44–45, 64.

————. "Reviews and Previews: Will Barnet." *Art News* 50 (November 1951), p. 46.

————. "Will Barnet Makes a Lithograph." *Art News* 51 (April 1952), pp. 38–40, 62–64.

"Some Reproductions from the Thirty-Third Annual Exhibition (The Society of American Etchers, Gravers, Lithographers and Woodcutters, Inc.)." *The Print Collector's Quarterly* 29 (February 1949), p. 16.

Steiner, Paul. "Eloquence in Art." *Cat Fancy* 13 (September–October 1970), pp. 18–19.

Stretch, Bonnie Barrett. "The Art Market: A New Deal for WPA Prints." *Portfolio* 5 (May–June 1983), p. 27.

Taylor, Robert. "Solo Show Limns Moods of Barnet." *The Boston Sunday Herald*, August 27, 1961, p. 6.

————. "Events in Art: Will Barnet Show at the Harriman." *The Boston Herald*, November 21, 1963, p. 18.

————. "Boston Made Them." *Boston Sunday Globe Maga-*

zine, February 25, 1979, p. 4.

Tillem, Sidney. "In the Galleries: Will Barnet." *Arts Magazine* 36 (March 1962), p. 54.

Trucco, Terry. "Will Barnet: A Part of and Apart from His Times." *Art News* 81 (December 1982), pp. 94–98.

Tucker, Marcia. "Reviews and Previews: Will Barnet." *Art News* 64 (February 1966), p. 13.

Tully, Judd. "Barnet's Fine Tuning." *Art World,* New York, November 1982, p. 6.

Wolff, Millie. "Will Barnet Doesn't Want to Lose Physical Feeling of Art." *Palm Beach Daily News,* April 1, 1978, p. 4.

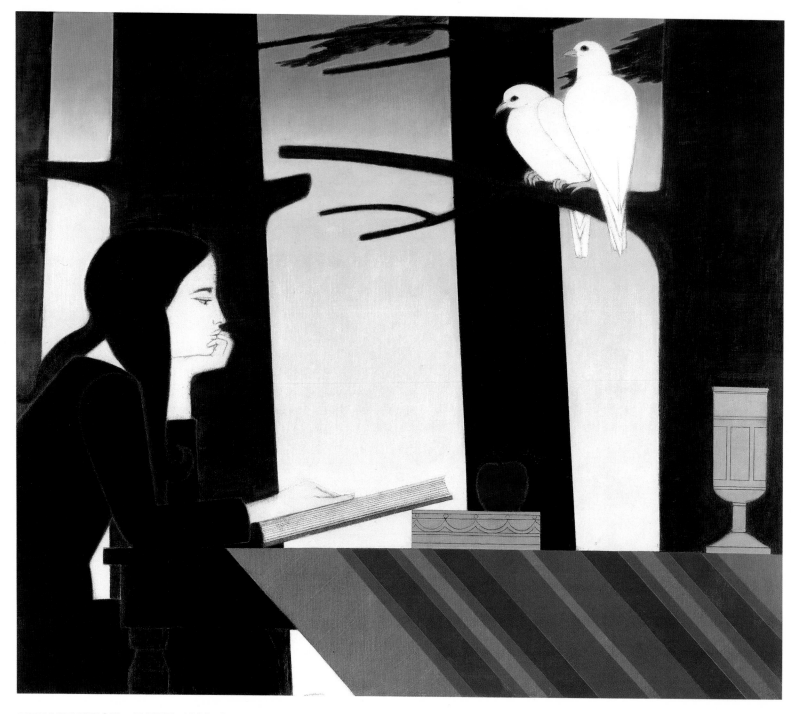

INTROSPECTION—MAINE. 1980. Oil on canvas, 32 × 42". Private collection

WORKS IN PUBLIC COLLECTIONS

Albright-Knox Art Gallery, Buffalo
Allentown Art Museum, Pennsylvania
Anchorage Historical and Fine Arts Museum, Alaska
Art Students League, New York
Art Museum, University of Wyoming, Laramie
The Brooklyn Museum
Brooks Memorial Art Gallery, Memphis, Tennessee
The Butler Institute of American Art, Youngstown, Ohio
Cincinnati Art Museum
Columbia University School of Law, New York
Columbus Museum of Art, Ohio
The Corcoran Gallery of Art, Washington, D.C.
Essex Institute, Salem, Massachusetts
Fogg Art Museum, Harvard University, Cambridge,
 Massachusetts
Georgia Museum of Art, The University of Georgia,
 Athens
The Solomon R. Guggenheim Museum, New York
Honolulu Academy of Arts
Housatonic Museum of Art, Bridgeport, Connecticut
The Library of Congress, Washington, D.C.
Los Angeles County Museum of Art
The Mead Art Museum, Amherst College, Massachusetts
The Metropolitan Museum of Art, New York
The Minneapolis Institute of Arts
Minnesota Museum of Art, Saint Paul
Mississippi Museum of Art, Jackson
Montana State College, Bozeman
Munson-Williams-Proctor Institute, Utica, New York
Museo Municipal des Artes Graficas, Caracas, Venezuela
Museum of Art, Carnegie Institute, Pittsburgh
Museum of Fine Arts, Boston

The Museum of Modern Art, New York
National Academy of Design, New York
National Collection of Fine Arts, Smithsonian Institution,
 Washington, D.C.
National Gallery of Art, Washington, D.C.
Neuberger Museum, State University of New York, College
 at Purchase
The New Britain Museum of American Art, Connecticut
New School for Social Research, New York
The New York Public Library
New York University Art Collection
The Newark Museum, New Jersey
Oklahoma Art Center, Oklahoma City
Pennsylvania Academy of the Fine Arts, Philadelphia
Philadelphia Museum of Art
The Phillips Collection, Washington, D.C.
San Francisco Museum of Modern Art
Sara Roby Foundation, New York
Seattle Art Museum
The Snite Museum of Art, University of Notre Dame,
 Notre Dame, Indiana
The Spencer Museum of Art, University of Kansas,
 Lawrence
Tweed Gallery, University of Minnesota, Duluth
University Art Museum, University of California, Berkeley
The University of Iowa Museum of Art, Iowa City
University of Massachusetts, Amherst
University of Nebraska, Lincoln
The University of Texas Art Museum, Austin
Washington University Art Collection, St. Louis, Missouri
Whitney Museum of American Art, New York
Worcester Art Museum, Massachusetts

INDEX

PHOTOGRAPHIC CREDITS

The publishers wish to express their appreciation to the following individuals and institutions, who kindly provided photographs:

Will Brown, Philadelphia: page 112
Louis Checkman, Jersey City: pages 108–9
Circle Fine Art Corporation, Chicago: page 97
Geoffrey Clements, New York: pages 52, 61, 104, 105, 106, 107
Carmelo Guadagno and David Heald, New York: page 60
Hirschl and Adler Galleries, New York: pages 117, 118–19, 120, 124, 129, 138
Kennedy Galleries, New York: pages 142–43
Otto Nelson, New York: pages 6, 24, 36, 39, 44–45, 48–49, 56, 62, 63, 74, 75, 78–79, 83, 98, 123, 131, 149, 158, 162
Edward Peterson, Astoria, New York: page 101
Steven Sloman, New York: pages 2–3, 34–35, 64, 73, 77, 121, 134–35
E. M. Weil, Albany: page 95
Wichita Art Museum, Kansas: page 136

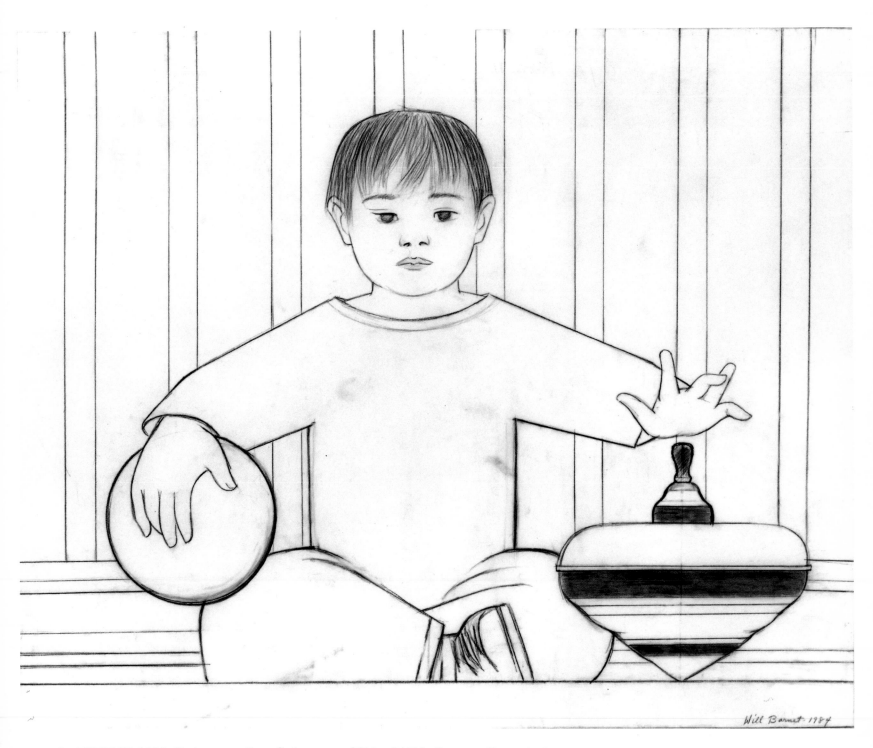

Study for THE TOP. 1984. Carbon pencil on Swiss paper, 28¼ × 34¾". Courtesy Kennedy Galleries, Inc., New York